Norman Rockwell Encyclopedia

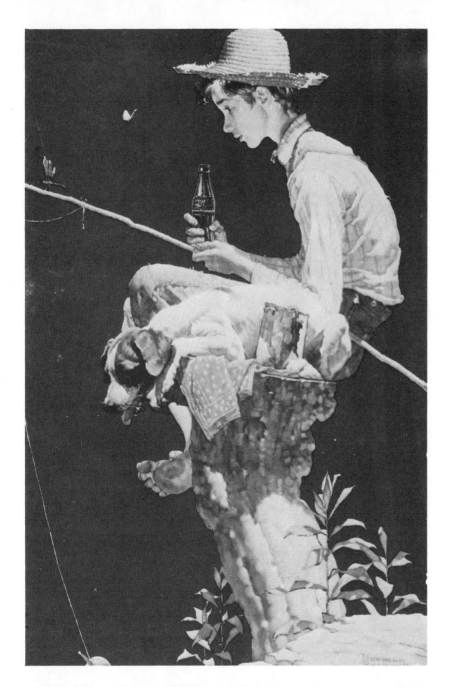

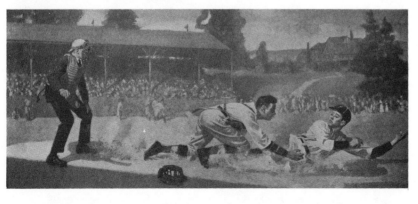

Norman Rockwell Encyclopedia

A Chronological Catalog of the Artist's Work
1910 -1978

Mary Moline

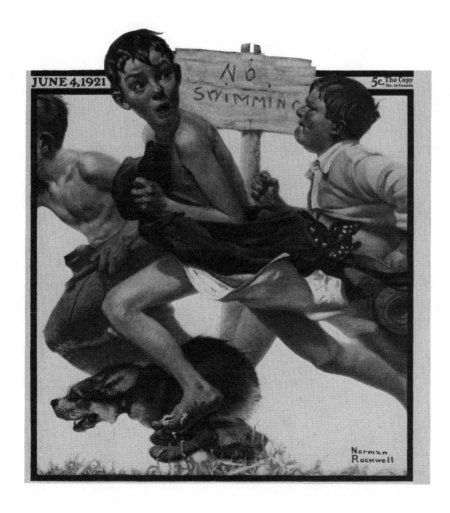

The Curtis Publishing Company
Indianapolis, Indiana

THE CURTIS PUBLISHING COMPANY

Norman Rockwell Encyclopedia
Art Director and Designer: Caroline M. Capehart

Dedicated to Dawn Ellen Moline

Acknowledgments

A book of the scope and complexity of this volume cannot, in a broad sense, be produced by one person. Hundreds of people over a ten-year period aided the author by contributing much of the information found here. Needless to say, whatever errors or shortcomings appear in this book are the responsibility of the author and not those who have so generously assisted in its compilation.

Chiefly I am indebted to my seventeen-year-old daughter who tirelessly sat with me in dimly lit libraries and library basements, examining stacks of dusty magazines looking for elusive "Rockwells." Her good eyesight and her young clear mind retained the necessary facts, and her fingers typed this manuscript—twice. This volume is dedicated to Dawn Ellen for her unending enthusiasm and profound knowledge of the subject.

Special thanks are due to my good friends and fellow researchers, Diane Tisch, Neleda Jones, and Steven Lomazow for the loan of their Rockwell collections and for their additions and corrections to this manuscript, and to the many corporations who kindly granted permission for the reproduction of their advertisements.

Other friends and organizations whose generous assistance and knowledge contributed to the completion of this ambitious project are: Arthur F. Abelman; Randolph Bonnist; Gordon F. Chamberlin II; Grace H. Coutant; Ada L. Fitzsimmons; Bill Franson; William S. Gardiner; Clifford Graves; Mary Litwinenco; John R. Low; Seth Mattingly; Neal Moline; Gary Monnich; Mellville B. Nimmer; Brian Jeffrey Radder; Norman Rockwell; Gary Satre U.S.N.; Linda Stillabower; Roy Stone; Adolph Vargas; Betty Vasin; Martha Wheeler and Eileene Winters; also American Heritage Graphics; the American Red Cross; Brown & Bigelow Division of Standard Packaging Corporation; the University of California; Ford Motor Company; Hallmark Cards Incorporated; the Kansas City Public Library; the Los Angeles Public Library; Massachusetts Mutual Life Insurance Company; the New York Public Library and Stanford University.

Contents

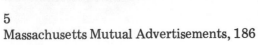

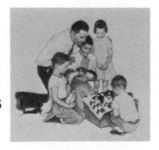

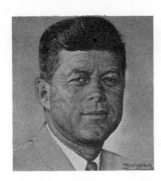

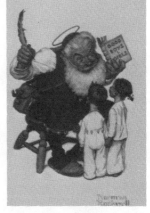

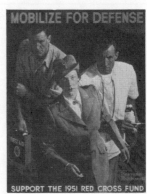

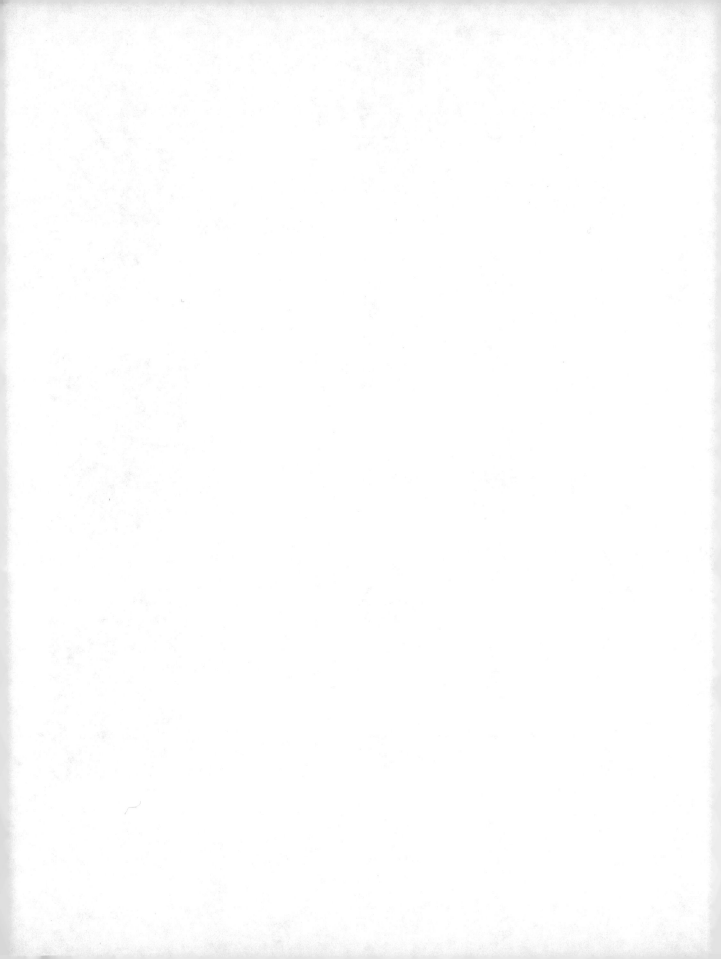

Introduction

Norman Rockwell began his illustrious career with a commercial success. He painted Christmas cards for his first commission before he was sixteen and illustrated his first book at seventeen. In 1911, aglow with success, the determined young man signed his name in blood, swearing never to do advertising jobs. He kept that promise until 1914 when his first known advertisement (for H. J. Heinz Company Pork 'n Beans) appeared in the 1914 edition of the *Boy Scout Handbook*.

The first advertisement by Norman Rockwell to appear in *The Saturday Evening Post* is dated January 13, 1917. His first *Post* cover was published on May 20, 1916.

The exact number of illustrations, advertisements and magazine covers Mr. Rockwell painted is unknown because his Vermont studio burned to the ground in 1943. His personal records were destroyed at that time, along with many irreplaceable original paintings and drawings. This book attempts to recreate a chronological record of his work between 1910 and 1978.

Most of Rockwell's prodigious output was painted for magazine reproduction and not intended to provide enduring examples of his work. Due to his technique of using a special compound between layers of paint, some of his originals have yellowed with age. However, his popularity has not diminished, nor has the demand for his work.

After many years of being scorned as an unworthy imitator, Norman Rockwell's human interpretation of the American scene survived the criticism to come back as the hero of two generations of Rockwell watchers, those who recall and those too young to remember. Because Rockwell's art is based on humanity, duty, and visual truth, the American dream of the twenties and forties is back for a second frame in the seventies. Perhaps it is the echo of gentler times that stirs our souls when we see a "Rockwell." And increasingly in his work we are beginning to recognize the artist behind the illustrator.

When President Roosevelt and Prime Minister Churchill met to formulate the Atlantic Charter, art was probably far from their minds. However, as a by-product of their talks came a great challenge for the artists of the world—the task of creating pictorial symbols for

the Four Freedoms: Speech, Religion, Want, and Fear. It was President Roosevelt's belief that, through the medium of the arts, a far greater number of people could be brought to understand the concept of the Four Freedoms.

Without question, no paintings by an American were ever published on such global scale as Rockwell's "Four Freedoms." They first appeared in *The Saturday Evening Post* and were distributed by the millions as reprints. The originals were used by the Treasury Department in the Four Freedoms War Bond Shows to illustrate what the famous Atlantic Charter meant in human terms. The "Four Freedoms" will doubtless stand as Rockwell's most impressive work.

A great deal has been written about Rockwell's art in recent years, some of it sounding like saccharine gush. There has also been a great deal of comment about artists and illustrators and their differences. Today, no one denies that Norman Rockwell is the best-known and the most-loved American artist of all time. He is ranked with the finest by a growing number of art circles which are just beginning to realize that, because of his accurate portrayal of real Americans, he made an impressive and important contribution to our vanishing folkways. The art critics of the world have not granted such acknowledgment easily. But the mood of this country has unknowingly conspired to eliminate a key objection to Rockwell's work—that he was a realist in an age of abstraction. Today there is renewed interest in realism.

Defenders of Rockwell's brand of "Hometown America" rebut the allegation that he took on only pleasant and humorous subjects, ignoring tough scenes in favor of sentimentality, by suggesting a close study of one of his finest pieces, "Breaking Home Ties." This painting is a classic example of Rockwell's unique ability to express humility, duty, and visual truth—the intangibles of art form.

At first glance one sees a farmer and his son sitting on the running board of a Model "A" Ford in anticipation of an approaching train. The father, in faded overalls, looks off into the distance as though unwilling to acknowledge that the time has come to say good-bye. The young man, in suit and tie, looks anxiously off in the direction of the train. He appears to be ready for the future. "Breaking Home Ties" is not a whimsical painting. Its statement is strong, vital, and poignant.

Rockwell made no secret of his lifetime preference for countrified realism . ."Things happen in the country, but you don't see them. In the city you are constantly confronted by unpleasantness. I find it sordid and unsettling."

He believed that the time he spent in the country as a child was a great influence on his idyllic approach to storytelling on canvas. Though Rockwell was unrepentant about his rural preference, he was surprisingly charitable toward contemporaries who shunned his technique in favor of modern art.

In a discussion about the purpose of art, Rockwell inquired of his son, Thomas: "Don't artists have an obligation to humanity? The world's falling apart. Does an artist live on an island all by himself? Is it his only obligation to express his own insides, or does he have an obligation to keep?"

Turn those questions into positive statements and therein lies the

demonstrated philosophy behind the brush strokes of what out-
wardly appears to be a talented but plain and simple man. Future
historians who will attempt to analyze Mr. Rockwell and his work
will learn that, not unlike Abraham Lincoln, Mark Twain,
Thomas Edison, and others, Norman Rockwell could not have made
so great a contribution to the history of our country had he been just
a plain and simple man.

Although Rockwell was best known for his storytelling covers for
The Saturday Evening Post, advertisers were anxious to use his
creative talent to promote their products. His ability to "get the
point across" in one picture made him a favorite of the
advertising industry.

In 1952 Mr. Rockwell was asked to illustrate a commemorative
calendar in celebration of the Ford Motor Company's Fiftieth
Anniversary. Ben Donaldson, Ford's institutional director, recalls
that he had a difficult time getting the artist to agree to do the
work—that is, until the subject of the Model "T" came up. Accord-
ing to Donaldson, the original agreement was to have Mr. Rockwell
do four illustrations, with three months represented on each page.
Donaldson gathered up a bundle of photographs and useful materials
and went to Vermont to discuss the idea with Mr. Rockwell, who
reluctantly agreed to do the job. Ben Donaldson returned to
Vermont a few weeks later to find that Mr. Rockwell had not yet
started to work on the assignment.

Of that second meeting, Donaldson said, "I sat and listened to him
tell me about all the work he had to do, and pretty soon we got to
reminiscing about Ford, the Model 'T,' and Ford's first workshop
behind his house. I kept showing him a lot of pictures so that by the
time I was ready to leave, Mr. Rockwell said, 'I'll see what I can do.'
By the middle of the following week, his wife Mary came to my
office in Detroit with six of the drawings."

In his autobiography, Mr. Rockwell attributes his flair for pains-
taking detail to his maternal grandfather's side of the family. His
grandfather painted animal portraits in realistic true-to-life manner,
but, unfortunately, was unable to make a living from this type of art.
Consequently, Mr. Rockwell's grandfather resorted to other work,
including the painting of "pot-boilers"—sentimental subjects which
he duplicated in an assembly-line fashion. Each member of the
family was assigned a specific portion of the picture to paint. The
painting was then passed along the table, each taking his turn at
painting his portion of the picture.

"My grandfather was the real inventor of the assembly line; Henry
Ford just got all the credit," wrote Mr. Rockwell.

It is understandable that in his quest to paint the common man in
ordinary situations, he unknowingly included more Fords in his art
than any other automobile. A search of his work reveals a number of
identifiable Fords. When his Ford favoritism was brought to his
attention, Rockwell was surprised. The only Ford he could recall
painting was the *Post* cover (July 31, 1920) of a Model "T" passing a
Rolls Royce on a hill. Rockwell seemed particularly pleased with his
timely interpretation of what the little Ford was doing to the
established market.

Mr. Rockwell admitted to being a storyteller of sorts. He did have

the uncanny genius of turning a thought-provoking idea into a realistic work of art. Every artist has his own peculiar way of looking at life. Rockwell used impeccable taste in avoiding the ugly and unpleasant. He painted life as he wanted to see it, always avoiding the disrespectful.

The universal appeal of Rockwell's work prompted the Massachusetts Mutual Life Insurance Company of Springfield, Massachusetts, to commission him to draw a series of national consumer advertisements between the years 1950 and 1960. A collection numbering seventy-eight original drawings was accumulated during this period. It is believed to be one of the largest collections of Rockwell originals in existence.

Because of the warm, human appeal so characteristic of Mr. Rockwell's work, many of these illustrations were used in more than one life insurance advertisement. Two drawings in this collection, those for "Thanksgiving" and "Easter," were used annually for several years. Since they were originally prepared for use in the early 1950s, the fashion details and the models' clothing became conspicuously out-of-date. In 1963 the artist retouched both of these drawings. He narrowed the wide lapels and broad tie for the father who sits with head bowed at the Thanksgiving table. For the Easter illustration he updated the mother's Easter bonnet and coiffure as well as the shoulder line on her Easter suit.

Recognition of this outstanding advertising program was given by the Freedoms Foundation at Valley Forge, which awarded its George Washington medal to the Massachusetts Mutual Life Insurance Company in 1959 for the Thanksgiving ad with its now traditional Rockwell illustration.

Rockwell's advertising work was almost a sideline compared to the large number of magazine covers he painted. Rockwell illustrations have appeared on more than sixty-five different magazines, including 322 for *The Saturday Evening Post*. A little known fact is that Rockwell painted at least 50 covers for the *Literary Digest*. The subjects of these covers were less humorous than his *Post* covers, but the lack of humor only served to point out the depth of thought Rockwell gave to his work. However, the greatest feature of some of these covers is Rockwell's successful, sometimes brilliant attempt at showing character through facial expressions. He has proven to be a master at getting into the character of the characters in his stories.

When he was allowed to choose his own subjects to tell his stories, he painted ordinary people in ordinary situations. In the case of story illustrations, the characters and situations were well defined by the author, so Rockwell painted the characters accordingly. Some of his story illustrations are unlike the Rockwells with which we have become familiar, particularly the very early paintings and those in the 1930s.

Norman Rockwell did not sign all of his work. Campbell's Soup, Budweiser and Listerine are advertising examples of no signature, but there are not many of them. In Rockwell's very early work he signed his name Norman P. Rockwell, N. P. R., Norman Rockwell in various forms, but in the December 1914 issue of *Everyland* magazine he signed his name with bold backward reversed initials (R. P. N. also reversed). There is no apparent logic to the varying

signatures found on Norman Rockwell's work; but, more often than not, it is apparent that his signature reflected his mood or feeling about his work on the subject at hand. This is especially true when he signed a piece "N. R." Norman Percevel Rockwell and Norman P. Rockwell appear on only his earliest work. Most often, in doing a series of illustrations for one story, the first (cover story or frontispiece) would carry a bold Norman Rockwell, but the secondary pieces would be signed "N. R."

There is no way of knowing the exact number of portraits Norman Rockwell painted. Only those which have been published or mentioned in print are listed here. Considering this limitation, an enormous number of portraits were painted. And, surprisingly, Rockwell included himself in his work at least 25 times.

Rockwell sketched a portrait of President John F. Kennedy for use in the 1963 Red Cross national fund-raising campaign. [*see fig. 6-8*]. The President liked the sketch so much that he asked for the original. The following details of the presentation by the Red Cross were found in the American Red Cross archives, dated February 28, 1963:

". . .As you will recall, Norman Rockwell did a special sketch of President Kennedy last fall for our use in our 1963 national magazine and newspaper advertisement. President Kennedy liked the sketch so much that he asked for the original, and the White House has now completed arrangements for Mr. Rockwell to present it to him at 11:30 a.m. on Tuesday, March 5, 1963.

"General Gruenther is to accompany Mr. and Mrs. Rockwell to the White House. They will arrive in Washington on Monday night, and we have arranged for them to stay at the Statler Hotel.

"The presentation will probably take place in the President's office, and according to Andrew Hatcher, Associate Press Secretary, it will be a very simple affair requiring no more than ten minutes. Reporters and photographers will be present, and we anticipate that the resulting coverage will be mostly photographic, although we and the White House will provide a brief press background statement and a proof of the national advertisement.

"Very briefly, Mr. Rockwell decided to do a new sketch of Mr. Kennedy when J. Walter Thompson Company, our volunteer advertising agency, approached him for permission to use in the ARC 1963 campaign Presidential advertisement the portrait of Mr. Kennedy which he painted for *The Saturday Evening Post* cover in 1960. Mr. Rockwell replied that he didn't think the painting was appropriate for this purpose and stated that if we could wait a few weeks, he would like to do a special pencil sketch of Mr. Kennedy for his Red Cross magazine and newspaper message. We very gladly accepted.

"When we saw how good the sketch was, we decided, with the approval of the White House, to use it also as the illustration for the 1963 campaign national magazine ad. Mr. Hatcher and others at the White House feel that it is probably the best likeness of the President prepared thus far. . ."

Future historians will find little sensationalism in the story of Norman Rockwell's life. His record is a colorful look at humanity as it passed his way. Rockwell was at his best when he was allowed to

paint his own stories, his own characters. Norman Percevel Rockwell worked very hard for his success. His reputation as America's most loved artist will long endure. How fortunate for America that as Henry Ford helped to change our way of life with his Model "T" and Edison lighted our world with his inventions, Norman Rockwell followed with his brushes to capture the changing American scene on canvas.

Mary Moline
1979

Chronology

1894:
Norman Percevel Rockwell is born on February 3, in New York.

1903:
The Rockwells move from New York to suburban Mamaroneck. This is the beginning of his love affair with the country.

1904:
Rockwell develops a keen interest in Charles Dickens. He forgets his own shortcomings by getting lost in the troubles of Oliver Twist and Little Nell.

1907:
To compensate for his lack of athletic prowess, Rockwell dedicates himself to becoming an illustrator.

1910:
Paints four Christmas cards at a good profit. Quits high school in his sophomore year to study full time at the National Academy of Design in New York. George Bridgman and Thomas Fogarty, two of his art instructors, are great influences when he attends the Art Students League.

1911:
He signs his name in blood swearing never to prostitute his art, never to do advertising jobs, never to allow himself to earn more than $50.00 a week. Illustrates first book, *Tell Me Why Stories.*

1913:
Appointed art director for *Boys' Life* magazine at age 19.

1916:
First *Saturday Evening Post* cover appears on May 20, 1916. He marries Irene O'Connor. His style changes as he begins doing more work for adult magazines.

1917-1918:
Enlists in the Navy in July. Continues to contribute to commercial periodicals as well as illustrate cartoons for the base bulletin. His popularity as a portrait painter helps him to get an early discharge.

1920:
He works long and hard at painting covers, advertisements, and illustrations.

1926:
Paints the first full four-color cover to appear on *The Saturday Evening Post.*

1929:
A divorce from Irene.

1930:
Marries Mary Barstow.

1931:
The Rockwells now live in New Rochelle, N.Y.

1936:
Illustrates Mark Twain's *Tom Sawyer* for the Heritage Press.

1939:
The Rockwells move to a farm in Vermont.

1943:
Illustrates the "Four Freedoms." Studio and records destroyed by fire.

1948:
Receives an honorary Doctor of Fine Arts degree from the University of Vermont.

1951:
Paints one of his finest pictures, "Saying Grace."

1952:
Paints Dwight D. Eisenhower for the October 11 issue of *The Saturday Evening Post.*

1953:
Moves to Stockbridge, Massachusetts.

1956:
Paints another portrait of Eisenhower; also one of Adlai Stevenson.

1959:
Mary Rockwell, Norman's second wife, dies. Rockwell completes painting one of his most difficult pieces, "The Family Tree." Mary is shown at the top of the painting.

1960:
Writes his autobiography, *My Adventures as an Illustrator.*

1961:
Marries Molly Punderson.

1963:
Leaves *The Saturday Evening Post* and contributes heavily to *Look* magazine.

1966:
Illustrates several portraits of the characters in the movie "Stagecoach." He also plays a minor part. His movie career is short-lived when he decides to return to painting.

1969:
The *Post* and *Look* cease publication.

1970:
Continues to produce, especially portraits of famous Americans.

1971:
The *Post* is revived. Rockwell appears on the first cover, in a photograph of him with a young boy.

1972:
Illustrates postage stamp honoring the 100th anniversary of Mark Twain's novel, *Tom Sawyer.* Narrates and stars in the film, "Norman Rockwell's World, An American Dream." This film was nominated for an Academy Award.

1973:
Receives the Franklin Award from the printing industry. Rockwell is honored by the Boy Scouts of America for having painted their calendar each year from 1925 to 1976, with the exception of 1928 and 1930.

1978:
Norman Percevel Rockwell dies at his home in Stockbridge, Massachusetts. On his easel is an unfinished painting of a Christian missionary trying to convert a Stockbridge Indian chief.

Norman Rockwell Encyclopedia

Magazine Covers

Norman Rockwell once commented that *Saturday Evening Post* covers were easy to do because they were (until 1941) silhouetted against a white background. "I worked, but I didn't stew over how I painted the pictures." In all, Rockwell painted 322 story-telling covers for *The Saturday Evening Post*.

The *Post* was only one of 80 magazines to use his cover illustrations. He completed 47 for *The Literary Digest*, 28 for the old *Life* magazine, 34 for *The Country Gentleman* and 30 for *Boys' Life*, which were also used for the Boy Scout calendars—many of which are reproduced in Chapter Eight.

His first cover, entitled,

"Waves of the Moon," was published by *Boys' Life*, September, 1913. His last, "Celebration," for *American Artist*, appeared in 1976.

Rockwell's most popular *Post* covers are "Doctor and Doll," "Breaking Home Ties," and "Saying Grace."

AMERICAN Magazine:

1918, Nov.:
Gentleman and a lady

1919, April:
Boy playing flute

1919, July:
Boy and girl singing

1921, May:
Boy yawning

1921, Oct.:
Boy eating sandwich

1922, Feb.:
First lipstick

1923, March:
Boy, blanket and medicine bottle

AMERICAN ARTIST:

1964, Sept.:
Portrait sketch of a Russian

1976, July:
"Celebration" (Rockwell and Liberty Bell)
[see fig. 10-1C]

AMERICAN BOY Magazine:

1916, Dec.:
"Over the Border"

1917, June:
Future musicians

1917, July:
"Ready for His Turn"

1917, Dec.:
"To Grandpa from Jack"

1920, April:
A box full of puppies

1920, Dec.:
A Christmas entanglement

AMERICAN LEGION:

1978, July:
　"Over There"

AMERICAN WEEKLY:

1951, Feb. 25:
　"Support the Red Cross"

ARGOSY:

1974, Nov.:
　John Wayne portrait

BOYS' LIFE:

1913, Sept.:
　"Waves of the Moon"
　[fig. 1-1]

1913, Oct.:
　"The Secret Full-Back"
　[fig. 1-2]

1913, Nov.:
　"The Cruise of the Pegasus"
　[fig. 1-3]

1913, Dec.:
　Two Boy Scouts helping
　Santa out of the snow
　[fig. 1-4]

1914, Jan.:
　Boy skating
　[fig. 1-5]

PRESIDENT WILSON'S MESSAGE TO 9,000,000 SCHOOL BOYS

BOYS' LIFE

THE BOY SCOUTS' MAGAZINE

"Waves of the Moon"
By John Fleming Wilson

September, 1913
PUBLISHED BY THE BOY SCOUTS OF AMERICA

1-1

1914, Feb.:
　Boy on horse fighting wolves
　[fig. 1-6]

1914, March:
　Two boys wrestling
　[fig. 1-7]

1914, April:
　Boy Scout with dog
　[fig. 1-8 see page 14]

1914, June:
　Two boys with hunting rifles
　[fig. 1-9 see page 14]

1914, Dec.:
　"Christmas" (unsigned)

1915, May:
　A boy called "Don"

1915, Aug.:
　"Head First"

1919, Feb.:
　Scout helping man
　cross street

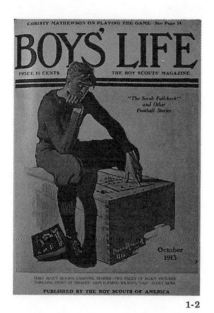

1-2

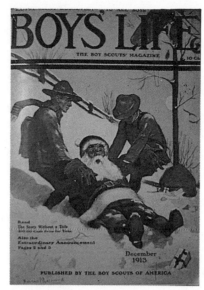

1-4

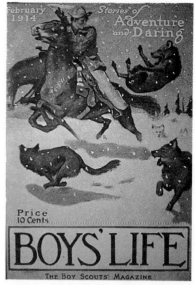

1-6

1-3

1-5

1-7

1919, July:
 Head of Boy Scout

1919, Aug.:
 Four Scouts around a
 campfire

1921, July:
 Boy carrying bass drum
 while drummer beats

1926, Feb.:
 "A Good Turn"

1927, Feb.:
 "Good Friends"

1929, Feb.:
 "Spirit of America"

1931, Feb.:
 "Scout Memories"

1932, Feb.:
 "Out of Defeat" or
 "A Scout is Loyal"

1933, Feb.:
 "Scouts of the World" or
 "An Army of Friendship"

1934, Feb.:
 "Carry On"

1934, April:
 Boy going fishing

1935, Feb.:
 "A Good Scout"

1-9

1-8

1942, Feb.:
"A Scout is Loyal"

1944, Feb.:
"We Too Have a Job To Do"

1947, Feb.:
"All Together"

1948, Feb.:
"Men of Tomorrow"

1950, Feb.:
"Our Heritage"

1951, Feb.:
"Forward America"
41st Anniversary

1952, Feb.:
"The Adventure Trail"

1953, Feb.:
"On My Honor"

1955, Feb.:
"The Right Way"

1956, Feb.:
"The Scoutmaster"

1935, July:
"On to Washington"

1936, Feb.:
"The Campfire Story"

1937, Feb.:
"Scouts of Many Trails"

1938, Feb.:
"America Builds for
Tomorrow"

1939, Feb.:
"The Scouting Trail"

1940, Feb.:
"A Scout is Reverent"

1941, Feb.:
"A Scout is Helpful"

1957, June:
"High Adventure"

1958, Feb.:
"Mighty Proud"

1959, Feb.:
"Tomorrow's Leader"

1960, Jan.:
Reproductions of 12
earlier covers—1913 to 1959

1960, Feb.:
"Ever Onward"

1961, Feb.:
"Homecoming"

1962, Feb.:
"Pointing the Way"

1963, Feb.:
"A Good Sign All Over
the World"

1964, Feb.:
"To Keep Myself
Physically Strong"

1965, Feb.:
"A Great Moment"

1971, March:
60th Anniversary
[fig. 1-10]

CHICAGO TRIBUNE:

1975, Sept. 7:
Matthew Brady
photographing Abraham
Lincoln

1976, July 4:
Benjamin Franklin

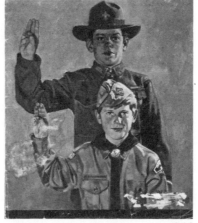
1-10

CHILD LIFE Magazine:

1955, Dec.:
"Santa"

CHILDREN'S DIGEST:

1973, July:
"Tom Sawyer Painting
a Fence"

CHRISTIAN HERALD:

1937, June:
Boy Scout jamboree

CLUES Magazine:

1953, July-August:
Ford Motor Company,
"A Farmer Takes A Ride"

COLLIER'S:

1919, March 1:
Welcome home hero

1919, March 29:
Free fashions

1919, April 19:
Fancy couple and a dog

1919, June 28:
Angry baseball players

COUNTRY GENTLEMAN:

1917, Aug. 25:
"Cousin Reginald Goes to
the Country"
[fig. 1-11]

1-11

1917, Sept. 8:
"Cousin Reginald Goes
Swimming"
[fig. 1-12 *next page*]

1917, Oct. 6:
"Cousin Reginald Goes
Fishing"
[fig. 1-13 *next page*]

DRAINING THE SOUTH OF LABOR

1-12

Beginning the OLD MAN CRABTREE Stories

1-14

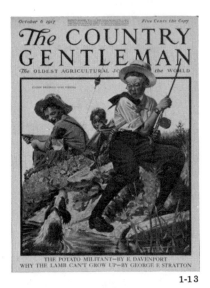

THE POTATO MILITANT—BY E. DAVENPORT
WHY THE LAMB CAN'T GROW UP—BY GEORGE F. STRATTON

1-13

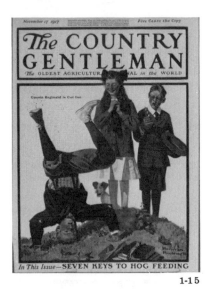

In This Issue—SEVEN KEYS TO HOG FEEDING

1-15

In This Issue—WAR WHEAT PLUNGERS—By Randall R. Howard

1-17

In This Issue—SECRETARY HOUSTON LOOKS AHEAD

1-18

1917, Nov. 3:
"Cousin Reginald Plays
Pirates"
[fig. 1-14]

1917, Nov. 17:
"Cousin Reginald is Cut Out"
[fig. 1-15]

1917, Dec. 1:
"Cousin Reginald
Catches Thanksgiving
Turkey"
[fig. 1-16]

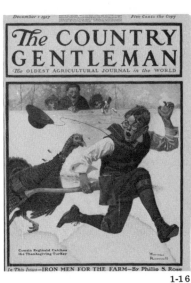

In This Issue—IRON MEN FOR THE FARM—By Philip S. Rose

1-16

1917, Dec. 22:
"Cousin Reginald Under the
Mistletoe"
[fig. 1-17]

1918, Jan. 19:
"Cousin Reginald Plays
Tickly Bender"
[fig. 1-18]

1918, Feb. 9:
"Cousin Reginald Spells
'Peloponnesus'"
[fig. 1-19]

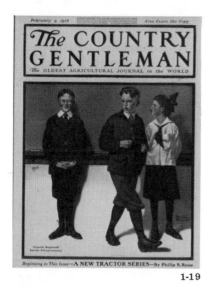

1-19

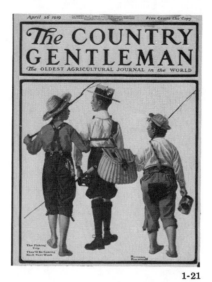

1-21

1-24

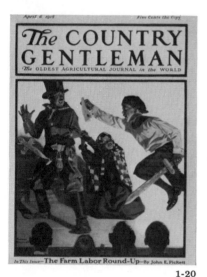

1-20

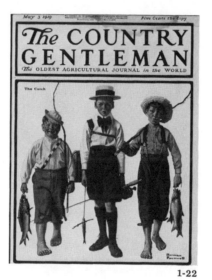

1-22

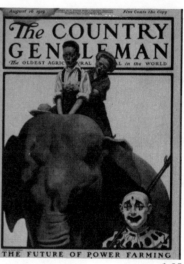

1-25

1918, April 6:
 "School Play"
 [fig. 1-20]

1919, April 26:
 "Cousin Reginald: The
 Fishing Trip" (before)
 [fig. 1-21]

1919, May 3:
 "Cousin Reginald: The
 Catch" (after)
 [fig. 1-22]

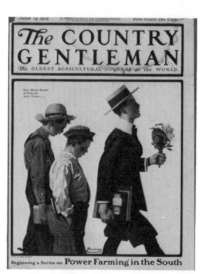

1-23

1919, June 14:
 "One More Week of School"
 (before)
 [fig. 1-23]

1919, June 21:
 "Vacation!" (after)
 [fig. 1-24]

1919, Aug. 16:
 Circus: boys on elephant
 with clown
 [fig. 1-25]

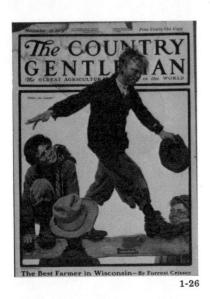

The Best Farmer in Wisconsin—By Forrest Crissey

1-26

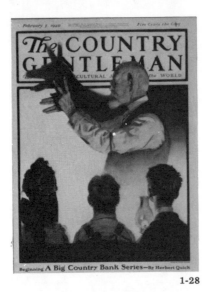

Beginning A Big Country Bank Series—By Herbert Quick

1-28

SCRAPING THE WORLD'S FEED BINS

1-31

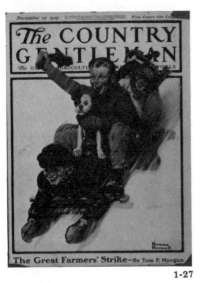

The Great Farmers' Strike—By Tom P. Morgan

1-27

CLOVERLAND—By P. S. LOVEJOY

1-29

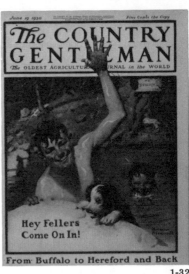

Hey Fellers Come On In!

From Buffalo to Hereford and Back

1-32

1919, Nov. 15:
"Foller the Leader"
[fig. 1-26]

1919, Dec. 27:
"Downhill Daring"
[fig. 1-27]

1920, Feb. 7:
"Shadow Pictures"
[fig. 1-28]

1920, Feb. 28:
Skating
[fig. 1-29]

POCO MOONSHINE

1-30

1920, May 8:
"Behind the Barn"
(before)
[fig. 1-30]

1920, May 15:
"Behind the Barn"
(after)
[fig. 1-31]

1920, June 19:
"Hey, Fellers
Come On In!"
[fig. 1-32]

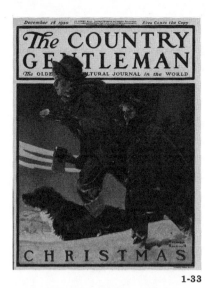

1-33

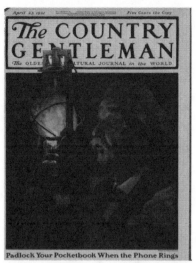

1-35

1-38

1-34

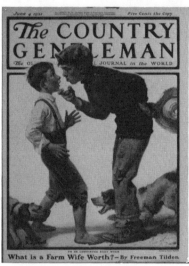

1-36

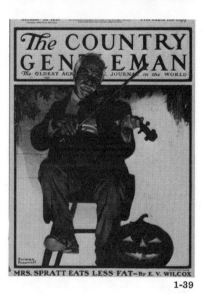

1-39

1-37

1920, July 31:
 Monkey grinder and kids

1920, Dec. 18:
 "Christmas Tree Cutting"
 [fig. 1-33]

1921, Feb. 19:
 Old gent skating
 [fig. 1-34]

1921, April 23:
 Man lighting kerosene
 lantern
 [fig. 1-35]

1921, June 4:
 "The Bully" (before)
 [fig. 1-36]

1921, June 11:
 "The Bully" (after)
 [fig. 1-37]

1921, July 2:
 Civil War vet shooting
 flintlock
 [fig. 1-38]

1921, Oct. 22:
 "Violinist at Halloween" or
 "Harvest Dance"
 [fig. 1-39]

Another Year of Farm Bureau Achievement

1-40

Farmer Ringer Has a Strike—By Freeman Tilden

1-43

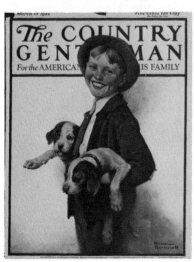

1-42

1921, Nov. 19:
"Thanksgiving Wishbone
Pulling"
[fig. 1-40]

1921, Dec. 17:
"Santa Claus"
[fig. 1-41]

1922, March 18:
"A Country Gentleman Boy"
[fig. 1-42]

1922, April 29:
"Auctioneer"
[fig. 1-43]

CREST:

1953, Oct. 1:
Motorola Dealers Magazine

DISABLED VETERANS
Magazine:

1974, Oct.:
"The American Way"

ELKS Magazine:

1922, Dec.:
Boy looking into the fire-
place

1928, July:
Flier with cap and goggles

EVERYLAND Magazine:

1916, Oct.:
"Under the Flag"

FAMILY CIRCLE:

1967, Dec.:
Santa holding a rag doll and
a space helmet

1968, Dec.:
Santa eating cookie with
note from little girl.

FAMILY WEEKLY Newspaper
Supplement:

1973, Jan. 14:
Portrait of President and
Mrs. Richard M. Nixon

FAMOUS ARTIST Magazine:

1970, Vol. 18:
Russian classroom

FARM AND FIRESIDE:

1918, May:
Boy, fishing pole and unwanted dog

1919, April:
"Shaving With a Straight Razor"
[fig. 1-44]

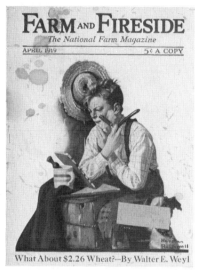

FARM AND FIRESIDE
The National Farm Magazine
APRIL 1919 5¢ A COPY

What About $2.26 Wheat?—By Walter E. Weyl

1-44

1919, May:
"Caught Smoking"

1919, Oct.:
"Two in a Swing"

1922, Dec.:
"Day after Christmas"

FISK CLUB NEWS:

1917, May:
Boy on bicycle recruiting members

FORD LIFE Magazine:

1973, Jan. - Feb.:
Triple-portrait: Henry Ford, Edsel Ford and Henry Ford II

FORD NYT:

1953, June:
Ford Motor Company, "The Inventor"
[fig. 1-45]

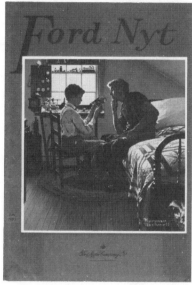

1-45

FORD TIMES:

1953, July:
"The Street Was Never the Same"
[fig. 1-46]

FORDWERELD:

1953, Jan.:
Ford Motor Company, "The Inventor"

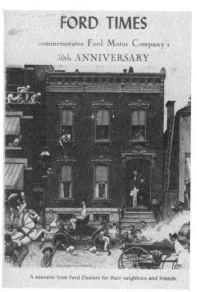

FORD TIMES
commemorates Ford Motor Company's
50th ANNIVERSARY

A souvenir from Ford Dealers for their neighbors and friends.

1-46

1953, March:
Ford Motor Company, "Henry Ford Workshop"

1953, May:
Ford Motor Company, "The Street Was Never the Same"

1953, July:
Ford Motor Company, "Farmer Takes a Ride"

1953, Sept.:
Ford Motor Company, "Center City"
[fig. 1-47 *next page*]

1953, Nov.:
Ford Motor Company, "Henry Ford II"
[fig. 1-48 *next page*]

FRANKLIN MINT ALMANAC:

1972, Feb.:
Boy Scout paintings

1-47

1-48

1978, Sept.:
 "No Swimming" sign—boys
 running, carrying clothes

GRADE TEACHERS
 Magazine:

1946, June:
 "Barefoot Boy"

1946, Nov.:
 "Dreams in the Antique
 Shop"

1946, Dec.:
 "The Night Before
 Christmas"

1947, June:
 "The Lighthouse Keeper"

JACK AND JILL:

1974, Dec.:
 "Tiny Tim"

JOURNAL OF AMERICAN
 OPTOMETRIC
 ASSOCIATION:

1972, April:
 "The Optometrist"

JOURNAL OF THE
 AMERICAN MEDICAL
 ASSOCIATION:

1973, Aug.:
 "The Art Critic"

JOURNEY THROUGH
 NEW ENGLAND:

1972:
 "A Guide"

JUDGE:

1917, Jan. 13:
 "Two A.M., Watch
 Your Step"

1917, July 7:
 "Excuse Me!"

1918, Feb. 19:
 "Stolen Goods"

1918, May 25:
 "A Trench Spade"
 [fig. 1-49]

1-49

1918, June 1:
 "Petticoats and Pants"
 [fig. 1-50]

1-50

1918, Aug. 10:
 "A Tribute from France"

LADIES' HOME JOURNAL:

1928, April:
 "On Top of the World"

1932, April:
 Two girls walking

LESLIE'S:

1916, Oct. 5:
 "Schoolitis"
 [fig. 1-51]

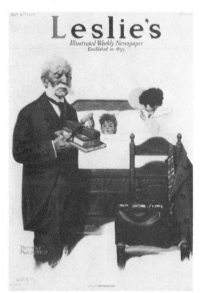

1-51

1917, Jan. 11:
 "Fact and Fiction"

1917, Feb. 1:
 "Helping Mother"

1917, Dec. 22:
 "They Remembered Me!"
 [fig. 1-52]

1918, March 30:
 "Easter"
 [fig. 1-53]

1919, March 22:
 "The Party Wire"
 [fig. 1-54]

1-52

1-53

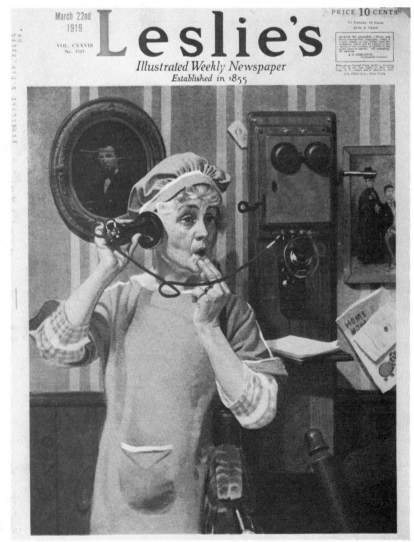

1-54

1-55

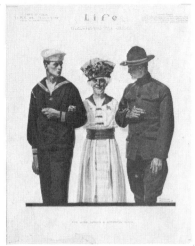

1-57

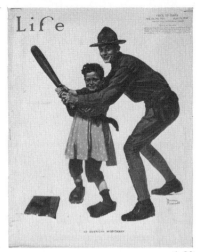

1-60

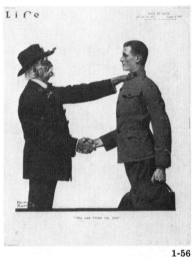

1-56

1-58

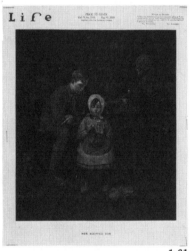

1-61

LIFE Magazine:

1917, May 10:
"Tain't You"
[fig. 1-55]

1917, Aug. 9:
"You Can Trust Me, Dad"
[fig. 1-56]

1917, Nov. 8:
"The Lord Loveth a Cheerful
Giver"
[fig. 1-57]

1917, Nov. 22:
"Polly Voos Fransay?"
[fig. 1-58]

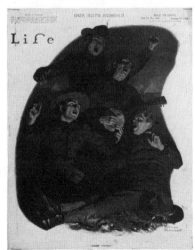

1-59

1918, Jan. 31:
"Over There"
[fig. 1-59]

1918, April 18:
"An American Missionary"
[fig. 1-60]

1918, May 30:
"Her Adopted Son"
[fig. 1-61]

1918, June 13:
"If Mother Could Only
See Me Now"
[fig. 1-62]

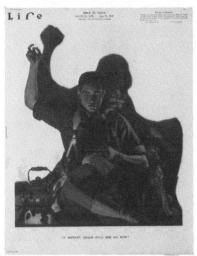

1-62

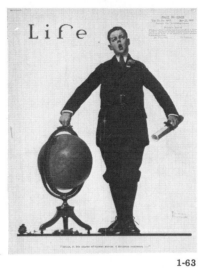

1-63

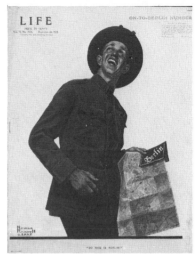

1-64

1-66

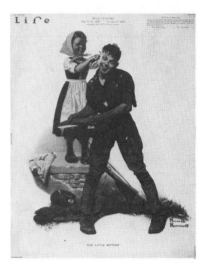

1-65

1918, June 27:
 "When, in the Course . . ."
 [fig. 1-63]

1918, Aug. 15:
 " 'Til the Boys Come Home"

1918, Sept. 26:
 "So This is Berlin"
 [fig. 1-64]

1918, Nov. 7:
 "The Little Mother"
 [fig. 1-65]

1918, Nov. 28:
 "Are We Downhearted?"
 [fig. 1-66]

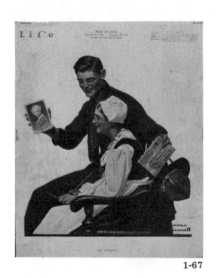

1-67

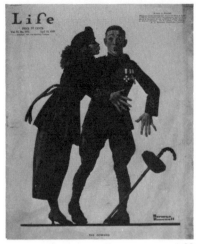

1-69

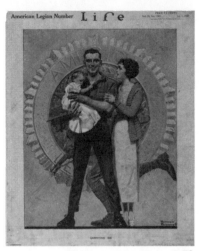

1-72

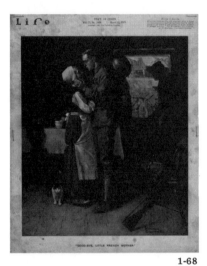

1-68

1-70

1-73

1918, Dec. 19:
 "My Mother"
 [fig. 1-67]

1919, March 13:
 "Good-bye, Little French
 Mother"
 [fig. 1-68]

1919, April 10:
 "The Coward"
 [fig. 1-69]

1920, Jan. 8:
 "The Wallflower"
 [fig. 1-70]

1-71

1920, Feb. 5:
 "The Hero-Worshiper"
 [fig. 1-71]

1920, July 1:
 "Carrying On"
 [fig. 1-72]

1920, Aug. 12:
 "A Light Haired Woman Will
 Cross Your Path"
 [fig. 1-73]

1920, Nov. 11:
 "The Music Master"
 [fig. 1-74]

1920, Dec. 16:
 "Is He Coming?"

1-74

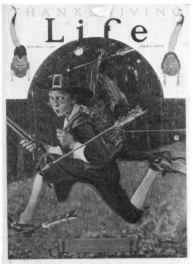

1-75

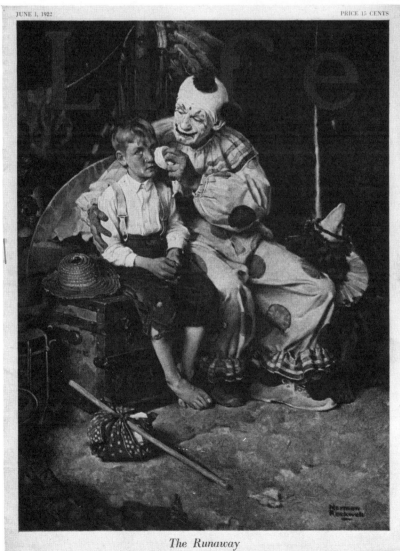

The Runaway

1-77

1-76

1921, Nov. 17:
"A Pilgrim's Progress"
[fig. 1-75]

1922, March 23:
"Don't Say I Said It"
[fig. 1-76]

1922, June 1:
"The Runaway"
[fig. 1-77]

1923, Aug. 23:
"Home Sweet Home"
[fig. 1-78]

1-78

1923, Nov. 22:
"Ye Glutton"
(Thanksgiving)

1924, Nov. 6:
"Good Scouts"
[fig. 1-79]

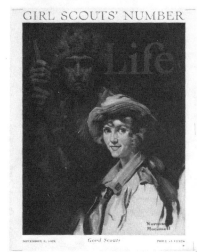

1-79

LITERARY DIGEST:

1918, Aug. 17:
Boy with W.W.I button
collection

1918, Nov. 9:
"Keep Them Smiling"

1918, Dec. 14:
"In Redeemed Belgium"

1919, Feb. 8:
"Oh Boy"

1919, March 1:
"The Story of the Lost
Battalion"

1919, April 19:
"Smiles in Belgium
Once More"
[fig. 1-80]

1919, June 14:
"Back to His Old Job"

1-80

1-81

1-82

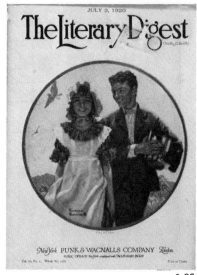

1-83

1919, July 26:
"Taking Mother Over
the Top"

1919, Sept. 6:
"First Day of School"

1919, Sept. 20:
"When the Literary Digest
'Topics of Day' Flashed on
Screen"

1919, Nov. 22:
"Thanksgiving"

1919, Dec. 20:
"Under the Mistletoe"

1920, Jan. 17:
"Below Zero"

1920, Feb. 21:
"Grandpa Listening in on the
Wireless"
[fig. 1-81]

1920, May 8:
"Planning the Home"
[fig. 1-82]

1920, July 3:
"Vacation"
[fig. 1-83]

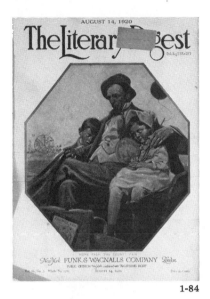

1-84

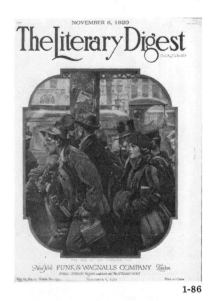

1-86

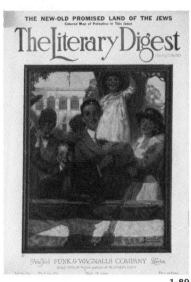

1-89

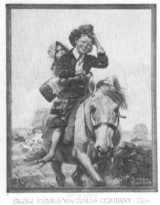

1-85

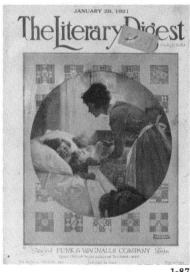

1-87

1-88

1920, Aug. 14:
 "Home From the
 County Fair"
 [fig. 1-84]

1920, Sept. 4:
 "Off to School"
 [fig. 1-85]

1920, Nov. 6:
 "The End of the
 Working Day"
 [fig. 1-86]

1920, Nov. 20:
 "The Toy Maker"

1920, Dec. 18:
 Looking at the toys in the
 window at Christmas

1921, Jan. 29:
 "A Mother's Love"
 [fig. 1-87]

1921, Feb. 26:
 "First of the Month"
 [fig. 1-88]

1921, March 26:
 "Woman and Daughter in
 Church"

1921, April 30:
 "Shoemaker and the Doll's
 Shoe"

1921, May 28:
 "The Parade"
 [fig. 1-89]

1921, June 25:
 "Memories"
 [fig. 1-90 next page]

1921, July 30:
 "Gone Fishin"

1-90

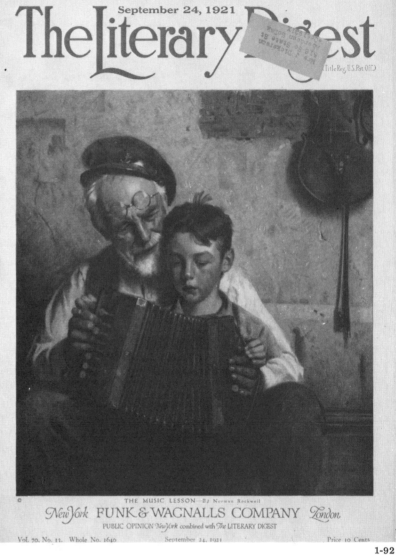

1-92

1-91

1-93

1921, Aug. 27:
"Vacation's Over"
[fig. 1-91]

1921, Sept. 24:
"The Music Lesson"
[fig. 1-92]

1921, Oct. 22:
"A Girl Scout"
[fig. 1-93]

1921, Nov. 26:
"Thanksgiving Turkey"

1921, Dec. 24:
"Grandpa and the Children"

1922, Feb. 25:
"The Old Master"

1922, March 25:
"The Reading Hour"

1922, April 15:
"The Old Couple"

1922, May 27:
"Mending the Flag"
[fig. 1-94]

1-94

1-96

The Literary Digest
December 22, 1923

1-99

The Literary Digest
June 24, 1922

1-95

The Literary Digest
September 23, 1922

1-97

1922, June 24:
 "Settling an Argument"
 [fig. 1-95]

1922, July 29:
 Barefoot boy resting
 against tree
 [fig. 1-96]

1922, Sept. 23:
 "The Artist's Daughter"
 [fig. 1-97]

1922, Oct. 28:
 "While the Audience Waits"

1-98

1922, Dec. 2:
 "For a Good Boy"

1923, Jan. 13:
 "A Hopeless Case"

1923, March 31:
 "Bedtime"

1923, July 28:
 "The Lighthouse Keeper's
 Daughter"
 [fig. 1-98]

1923, Nov. 17:
 "Dreams in the
 Antique Shop"

1923, Dec. 22:
 Child waiting for Santa
 [fig. 1-99]

LOOK Magazine:

1964, July 14:
 J.F.K., "A Time For
 Greatness"
 [see fig. 2-32]

1966, June 14:
"J.F.K.'s Legacy: The Peace
Corps"
[see fig. 2-34C]

McCALL'S:

1964, Dec.:
"Christmas Eve: Upstairs-
Downstairs"

MODERN MEDICINE:

1976, Jan. 1:
"Are You Ready
for the Future?"

NEWSWEEK:

1970, Dec. 28:
An enlarged Santa holding
tiny boy in his fingers

NEW YORK TIMES:

1975:
Book review section

PARENTS Magazine:

1939, Jan.:
Triple portrait of Rockwell
children

1951, May:
Mother with children

1-100

1-101

1-102

PEOPLE'S POPULAR
MONTHLY (The):

1917, May:
"No Credit Given"
[fig. 1-100]

1917, June:
"Homemade Ice Cream
and Lickin' the Beater"
[fig. 1-101]

1917, Dec.:
"Getting Used to a New
Christmas Doll"
[fig. 1-102]

PERSIMMON HILL (National
Cowboy Hall of Fame):

1974, Vol. 4 No. 3:
Portrait of John Wayne

POPULAR Magazine (The):

1916, Nov. 20:
"Presto" the magician
[fig. 1-103]

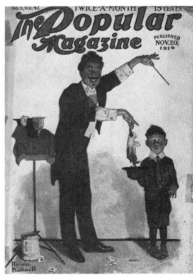

1-103

POPULAR SCIENCE MONTHLY:

1920, Oct.:
 "The Ferris Wheel Fixer"
 or "Perpetual Motion"
 [fig. 1-104]

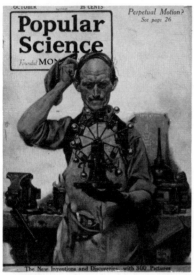

1-104

1921, April:
 Old man welding tea kettle

PUBLISHERS WEEKLY:

1970, May 4:
 "The Most Complete Lavish
 Rockwell"

RAMPARTS:

1967, May:
 Portrait of Bertrand Russell
 [fig. 1-105]

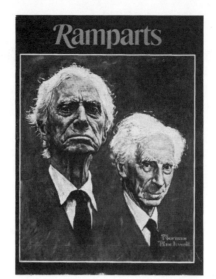

1-105

RECREATION Magazine:

1915, Jan.:
 Man skiing

1916, May:
 Man fishing

1917, Sept.:
 "A Good Joke!"

RED CROSS Magazine:

1918, April:
 Uncle Sam and children in a
 parade
 [fig. 1-106]

1918, June:
 "Blue + Gray = Khaki"
 [fig. 1-107]

1919, July:
 "Letter from the Red Cross"
 [fig. 1-108]

1920, March:
 Ice skaters
 [fig. 1-109 *next page*]

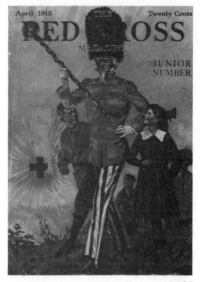

1-106

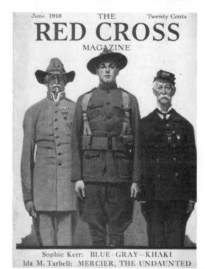

Sophie Kerr: BLUE·GRAY—KHAKI
Ida M. Tarbell: MERCIER, THE UNDAUNTED

1-107

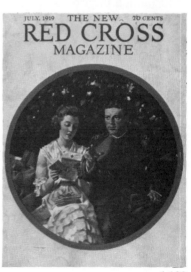

1-108

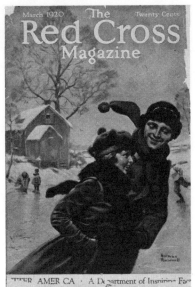

1-109

ROTARIAN:

1938, June:
Boy playing flute

1961, Dec.:
"The Music Makers"

ST. NICHOLAS Magazine:

1915, Oct.:
"Chained Lightning"
(unpublished)

1915, Nov.:
End of the road

1916, Jan.:
Winter

1918, Aug.:
Man, woman and birds

1919, Aug.:
Going fishing

SAN FRANCISCO CHRONICLE:

1972, Sept. 3:
"This World" Section
"de Young's Rockwell
Retrospective"

SATURDAY EVENING POST:

1916, May 20:
"The Baby Carriage" or
"Mother's Day Off"
[fig. 1-110]

1916, June 3:
"The Circus Barker"
(Sandow, the strong man)
[fig. 1-111]

1916, Aug. 5:
"Low and Outside"
[fig. 1-112]

1916, Sept. 16:
"Backfence Graffiti" or
"Red Head"
[fig. 1-113]

1916, Oct. 14:
"Family Night Out"
[fig. 1-114]

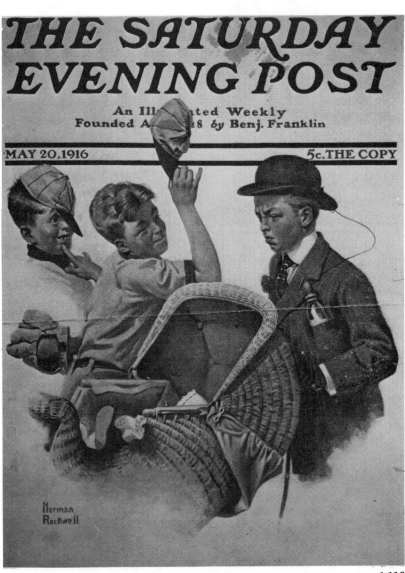

1-110

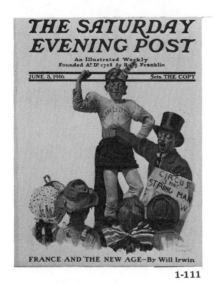

1-111

1-114

1-117

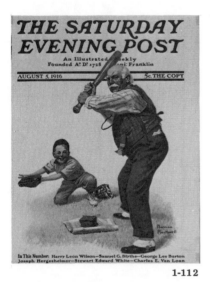

1-112

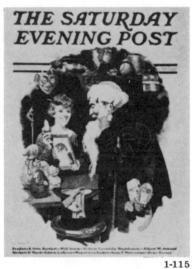

1-115

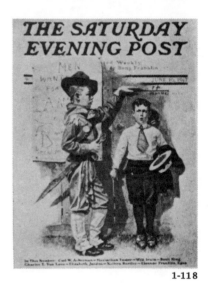

1-118

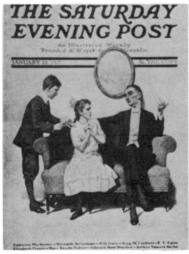

1-113

1-116

1916, Dec. 9:
 "Dressing Up" or
 "Playing Santa"
 [fig. 1-115]

1917, Jan. 13:
 "The Suitor" or
 "Shall We Dance?"
 [fig. 1-116]

1917, May 12:
 "A Salute to the Colors"
 [fig. 1-117]

1917, June 16:
 "The Clubhouse
 Examination"
 [fig. 1-118]

FOLLOWING THE RED CROSS—By Elizabeth Frazer

1-119

All American—By Irvin S. Cobb

1-121

Edith Wharton—Octavus Roy Cohen—Peter Clark Macfarlane
Isaac F. Marcosson—Basil King—Albert W. Atwood—Rob Wagner

1-124

Captain Schlatterwertz—by Sarah Tarkington. England After the War—by Isaac F. Marcosson

1-120

Donald Stanley Lee—Edward N. Hurley—Wallace Irwin—Arthur Train
Sinclair Lewis—Neville Taylor Cherwell—Frederick Orin Bartlett

1-122

So This is Germany—By George Pattullo

1-125

1917, Oct. 27:
 "After School" or
 "Knowledge is Power"
 [fig. 1-119]

1918, Jan. 26:
 "Pardon Me"
 [fig. 1-120]

1918, May 18:
 "Meeting the Clown"
 [fig. 1-121]

1918, Aug. 10:
 "The First Hair Cut" or
 "The Hair Cut"
 [fig. 1-122]

THE ZERO HOUR—BY GEORGE PATTULLO

1-123

1918, Sept. 21:
 "Giving to the Red Cross"
 [fig. 1-123]

1919, Jan. 18:
 "Reminiscing" or
 "Thinking of the Girl
 Back Home"
 [fig. 1-124]

1919, Feb. 22:
 "When Johnny Comes
 Marching Home Again"
 [fig. 1-125]

1-126

1-128

1-131

1-127

1-129

1-132

1919, March 22:
"Courting Under the Clock
at Midnight"
[fig. 1-126]

1919, April 26:
"Playing Party Games"
[fig. 1-127]

1919, June 14:
"The Recitation"
[fig. 1-128]

1919, June 28:
"Leap Frog"
[fig. 1-129]

1-130

1919, Aug. 9:
"Runaway Pants"
[fig. 1-130]

1919, Sept. 6:
"Taking a Break" or
"Lazy Bones"
[fig. 1-131]

1919, Sept. 20:
"Important Appointment"
or "Gone On
Important Business"
[fig. 1-132]

1-133

1-135

1-138

1-134

1-136

1-139

1-137

1919, Oct. 4:
"Dog Gone It"
[fig. 1-133]

1919, Dec. 20:
"Gramps"
[fig. 1-134]

1920, Jan. 17:
"Pen Pals" or
"Love Letters"
[fig. 1-135]

1920, Feb. 7:
"The Skating Lesson"
[fig. 1-136]

1920, March 27:
"The Housekeeper"
[fig. 1-137]

1920, May 1:
"Ouija Board"
[fig. 1-138]

1920, May 15:
"The Stowaway"
[fig. 1-139]

1920, June 19:
"Three's Company"
[fig. 1-140]

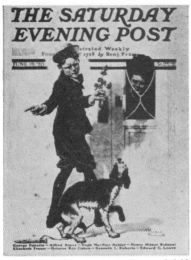

1-140

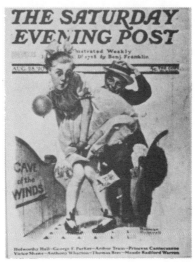

1-142

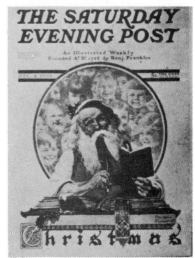

1-145

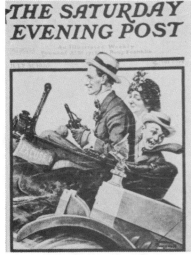

1-141

1-143

1-146

1920, July 31:
"Excuse My Dust"
[fig. 1-141]

1920, Aug. 28:
"The Cave of the Winds"
[fig. 1-142]

1920, Oct. 9:
"Political Opponents" or
"The Debate"
[fig. 1-143]

1-144

1920, Oct. 23:
"Halloween"
[fig. 1-144]

1920, Dec. 4:
"Santa's Children" or
"Santa" or
"Faces of Christmas"
[fig. 1-145]

1921, Jan. 29:
"Mom's Helper"
[fig. 1-146]

1-147

1-149

1-152

1-148

1-150

1-153

1921, March 12:
"The Fortune Teller"
[fig. 1-147]

1921, June 4:
"No Swimming"
[fig. 1-148]

1921, July 9:
"The Portrait"
[fig. 1-149]

1921, Aug. 13:
"Distortion"
[fig. 1-150]

1-151

1921, Oct. 1:
"God Bless You" or
"Sneezing Spy"
[fig. 1-151]

1921, Dec. 3:
"Merrie Christmas"
[fig. 1-152]

1922, Jan. 14:
"Stereoscope"
[fig. 1-153]

1-154

1-156

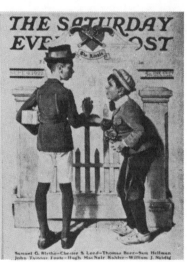

1-159

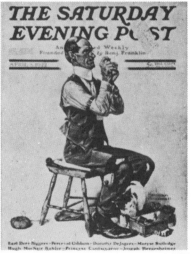

1-155

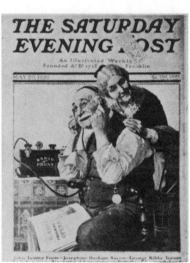

1-157

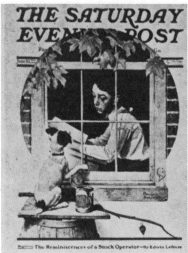

1-160

1922, Feb. 18:
 "Keeping Up with the News"
 [fig. 1-154]

1922, April 8:
 "Threading the Needle"
 [fig. 1-155]

1922, April 29:
 "The Champ"
 [fig. 1-156]

1-158

1922, May 20:
 "Listen, Ma!" or
 "The Wonders of Radio"
 [fig. 1-157]

1922, June 10:
 "A Patient Friend"
 [fig. 1-158]

1922, Aug. 19:
 "Ship Ahoy" or
 "Setting One's Sights"
 [fig. 1-159]

1922, Sept. 9:
 "The Rivals"
 [fig. 1-160]

1-161

1-163

1-166

1-162

1-164

1-167

1922, Nov. 4:
 "Daydreams"
 [fig. 1-161]

1922, Dec. 2:
 "Santa's Helpers" or
 "Christmas: Santa
 With Elves"
 [fig. 1-162]

1923, Feb. 3:
 "Dancing Partner"
 [fig. 1-163]

1923, March 10:
 "Puppy Love"
 [fig. 1-164]

1-165

1923, April 28:
 "The Virtuoso"
 [fig. 1-165]

1923, May 26:
 "Between the Acts"
 [fig. 1-166]

1923, June 23:
 "Summer Vacation"
 [fig. 1-167]

1923, Aug. 18:
 "Harvest Time" or
 "Farmer and the Bird"
 [fig. 1-168]

1-168

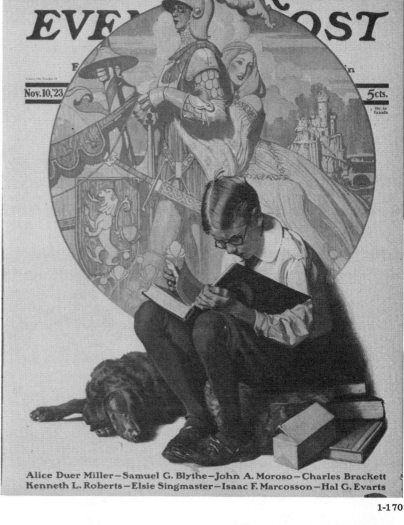

Alice Duer Miller—Samuel G. Blythe—John A. Moroso—Charles Brackett
Kenneth L. Roberts—Elsie Singmaster—Isaac F. Marcosson—Hal G. Evarts

1-170

1-169

1923, Sept. 8:
 "The Ocean Voyage" or
 "The Cruise"
 [fig. 1-169]

1923, Nov. 10:
 "Lands of Enchantment"
 [fig. 1-170]

1923, Dec. 8:
 "The Christmas Trio"
 [fig. 1-171]

1924, March 1:
 "Needlepoint"
 [fig. 1-172]

1-171

1-172

1-173

1-175

1-178

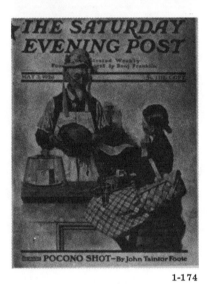

1-174

1-176

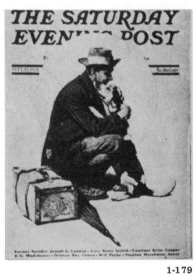

1-179

1924, April 5:
 "Cupid's Visit"
 [fig. 1-173]

1924, May 3:
 "The Thoughtful Shopper"
 [fig. 1-174]

1924, June 7:
 "Escape to Adventure" or
 "Daydreamer"
 [fig. 1-175]

1924, June 14:
 "Thoughts of Home"
 [fig. 1-176]

1-177

1924, July 19:
 "Speeding Along"
 [fig. 1-177]

1924, Aug. 30:
 "Serenade" or
 "The Accordionist"
 [fig. 1-178]

1924, Sept. 27:
 "Pals"
 [fig. 1-179]

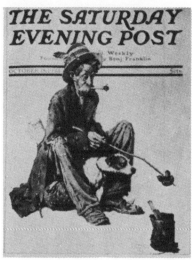

1-180

1-182

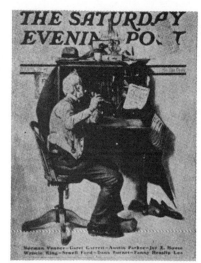

1-185

1-181

1-183

1-186

1924, Oct. 18:
 "The Hobo"
 [fig. 1-180]

1924, Nov. 8:
 "Grand Reception"
 [fig. 1-181]

1924, Dec. 6:
 "Santa's Good Boys"
 [fig. 1-182]

1-184

1925, Jan. 31:
 "Crossword Puzzles" or
 "The Puzzle"
 [fig. 1-183]

1925, April 18:
 "The Self Portrait"
 [fig. 1-184]

1925, May 16:
 "The Flutist March" or
 "Spring Song"
 [fig. 1-185]

1925, June 27:
 "Candy"
 [fig. 1-186]

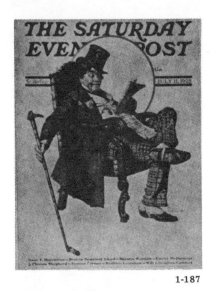

1-187

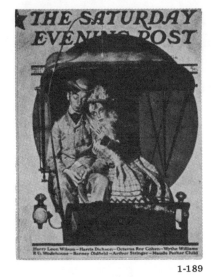

1-189

1-191

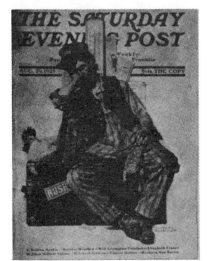

1-188

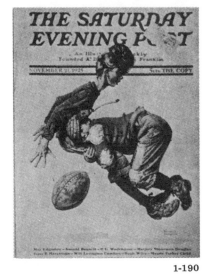

1-190

1-192

1925, July 11:
 "The Country Gentleman"
 [fig. 1-187]

1925, Aug. 29:
 "Hot Spell" or
 "Asleep on the Job"
 [fig. 1-188]

1925, Sept. 19:
 "Moonlight Buggy Ride"
 [fig. 1-189]

1925, Nov. 21:
 "Fumble" or
 "Tackled"
 [fig. 1-190]

1925, Dec. 5:
 "The London Coach"
 [fig. 1-191]

1926, Jan. 9:
 "Look Out Below" or
 "Racer"
 [fig. 1-192]

1926, Feb. 6:
 "The Old Sign Painter"
 [fig. 1-193]

1926, March 27:
 "The Phrenologist"
 [fig. 1-194]

1926, April 24:
 "The Little Spooners" or
 "Puppy Love"
 [fig. 1-195]

1926, May 29:
 "Ben Franklin"
 [fig. 1-196]

1926, June 26:
 "First in His Class" or
 "The Scholar"
 [fig. 1-197]

1926, Aug. 14:
 "The Bookworm"
 [fig. 1-198]

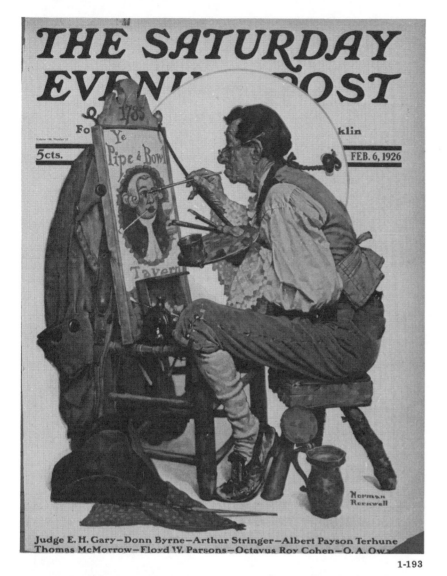

1-193

1-196

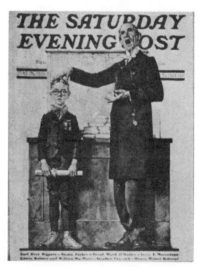

1-197

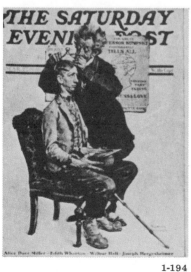

1-194

1-195

1-198

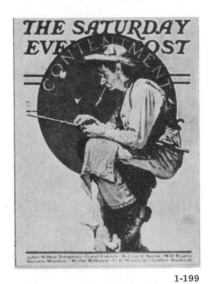

1-199

1-201

1-204

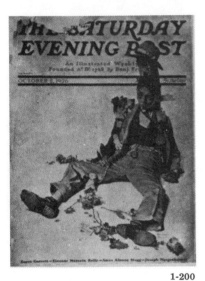

1-200

1-202

1-205

1926, Aug. 28:
 "Contentment"
 [fig. 1-199]

1926, Oct. 2:
 "The Defeated Suitor"
 [fig. 1-200]

1926, Dec. 4:
 "Santa Planning His Annual
 Visit"
 [fig. 1-201]

1927, Jan. 8:
 "Back to School" or
 "Vacation's End"
 [fig. 1-202]

1-203

1927, Feb. 19:
 "The Law Student"
 [fig. 1-203]

1927, March 12:
 "The Plot Thickens"
 [fig. 1-204]

1927, April 16:
 "Springtime of '27"
 [fig. 1-205]

1927, June 4:
 "The Young Artist"
 [fig. 1-206]

1-206

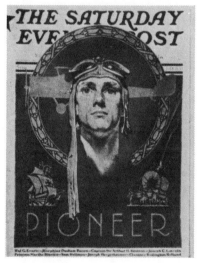

1-207

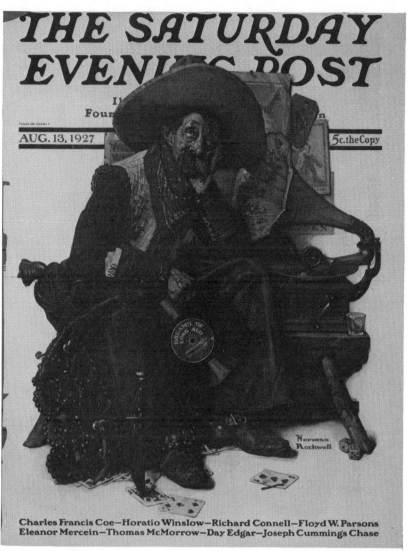

Charles Francis Coe—Horatio Winslow—Richard Connell—Floyd W. Parsons
Eleanor Mercein—Thomas McMorrow—Day Edgar—Joseph Cummings Chase

1-208

1927, July 23:
 "Charles Lindbergh,"
 "Pioneer" or
 "Spirit of Lindbergh"
 [fig. 1-207]

1927, Aug. 13:
 "Dreams of Long Ago"
 [fig. 1-208]

1927, Sept. 24:
 "The Silhouette Maker"
 [fig. 1-209]

1927, Oct. 22:
 "Tea for Two" or
 "Tea Time"
 [fig. 1-210]

1-209

1-210

1-211

1-213

1-216

1-212

1-214

1-217

1927, Dec. 3:
"Christmas 1927"
[fig. 1-211]

1928, Jan. 21:
"Flying Uncle Sam"
[fig. 1-212]

1928, April 14:
"Adventurers"
[fig. 1-213]

1928, May 5:
"The Hikers"
[fig. 1-214]

1-215

1928, May 26:
"Gilding the Eagle" or
"Painting the Flagpole"
[fig. 1-215]

1928, June 23:
"The Wedding March"
[fig. 1-216]

1928, July 21:
"Hayseed Critic"
[fig. 1-217]

1-218

1-220

1-223

1-219

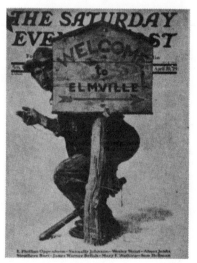

1-221

1-224

1928, Aug. 18:
 "Hobo Stealing a Pie"
 [fig. 1-218]

1928, Sept. 22:
 "The Serenade"
 [fig. 1-219]

1928, Dec. 8:
 "Merry Christmas"
 [fig. 1-220]

1929, Jan. 12:
 "The Gossips"
 [fig. 1-221]

1-222

1929, Feb. 16:
 "Dreams"
 [fig. 1-222]

1929, March 9:
 "Doctor and Doll"
 [fig. 1-223]

1929, April 20:
 "Welcome to Elmville"
 [fig. 1-224]

1-225

1-228

1-229

1-226

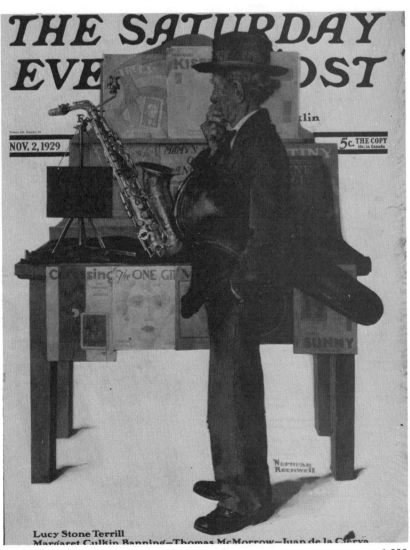

1-230

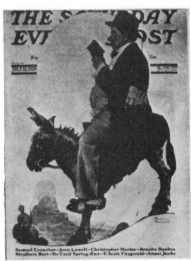

1-227

1929, May 4:
 "The Suitor"
 [fig. 1-225]

1929, June 15:
 "No Peeking"
 [fig. 1-226]

1929, July 13:
 "Man on Burro" or
 "Burro Ride"
 [fig. 1-227]

1929, Aug. 3:
 "Catching the Big One"
 [fig. 1-228]

1929, Sept. 28:
 "Raleigh Rockwell Travels"
 or "Raleigh the Dog"
 [fig. 1-229]

1929, Nov. 2:
 "Jazz It Up"
 [fig. 1-230]

1929, Dec. 7:
 "Merrie Christmas" or
 "The Coachman"
 [fig. 1-231]

1930, Jan. 18:
 "Stock Exchange
 Quotations"
 [fig. 1-232]

1930, March 22:
 "The Magician"
 [fig. 1-233]

1930, April 12:
 "Wet Paint"
 [fig. 1-234]

1930, May 24:
 "Gary Cooper as the Texan"
 [fig. 1-235]

1930, July 19:
 "Gone Fishing"
 [fig. 1-236]

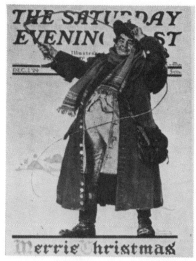

1-231

1-234

1-232

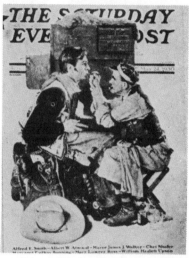

1-235

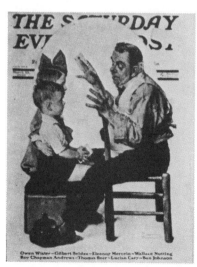

1-233

1-236

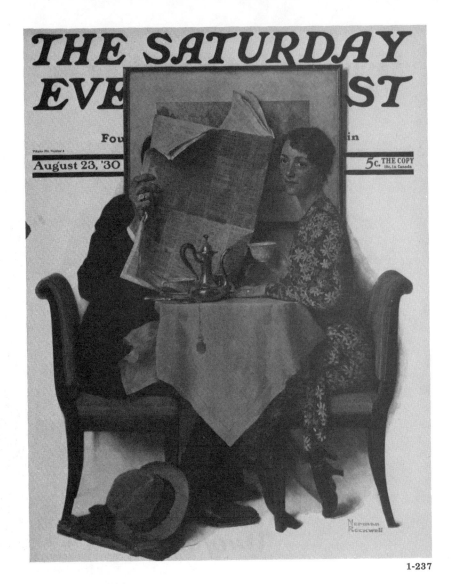

1-237

1-240

1-241

1-238

1-239

1-242

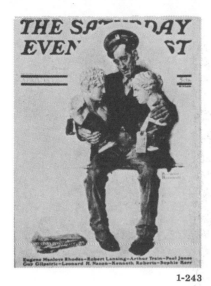

1-243

1-245

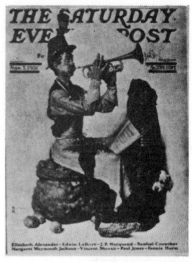

1-247

1-244

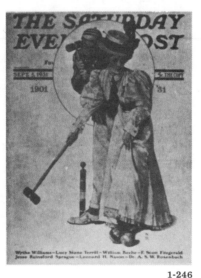

1-246

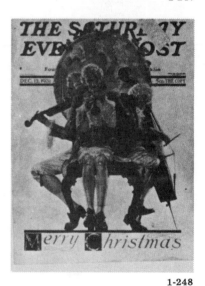

1-248

1930, Aug. 23:
 "The Breakfast Table"
 [fig. 1-237]

1930, Sept. 13:
 "Home From Vacation"
 [fig. 1-238]

1930, Nov. 8:
 "The Yarn Spinner"
 [fig. 1-239]

1930, Dec. 6:
 "Christmas"
 [fig. 1-240]

1931, Jan. 31:
 "The Dressmaker"
 [fig. 1-241]

1931, March 28:
 "To the Rescue"
 [fig. 1-242]

1931, April 18:
 "Delivering Two Busts"
 [fig. 1-243]

1931, June 13:
 "Cramming"
 [fig. 1-244]

1931, July 25:
 "The Milkmaid"
 [fig. 1-245]

1931, Sept. 5:
 "Wicket Thoughts"
 [fig. 1-246]

1931, Nov. 7:
 "The Trumpeter"
 [fig. 1-247]

1931, Dec. 12:
 "Merry Christmas" or
 "Baskets Brimming"
 [fig. 1-248]

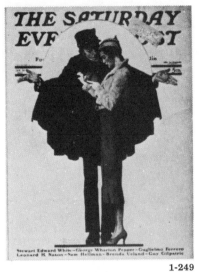

1-249

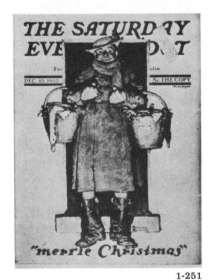

1-251

1-254

1-250

1-252

1-255

1932, Jan. 30:
"Lost in Paris"
[fig. 1-249]

1932, Oct. 22:
"The Marionettes"
[fig. 1-250]

1932, Dec. 10:
"Merrie Christmas"
[fig. 1-251]

1933, April 8:
"Springtime"
[fig. 1-252]

1-253

1933, June 17:
"The Diary"
[fig. 1-253]

1933, Aug. 5:
"Summertime, 1933"
[fig. 1-254]

1933, Oct. 21:
"Going Out"
[fig. 1-255]

1933, Nov. 25:
"Mother Spanking
Her Child"
[fig. 1-256]

1-256

1-258

1-261

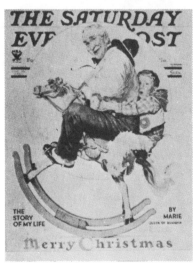

1-257

1-259

1-262

1-260

1933, Dec. 16:
 "Gramps Joins in the Fun"
 or "Grandpa and
 Rockinghorse"
 [fig. 1-257]

1934, March 17:
 "Thrown From a Horse"
 [fig. 1-258]

1934, April 21:
 "The Spirit of Education"
 [fig. 1-259]

1934, May 19:
 "Bargaining with
 the Antique Dealer"
 [fig. 1-260]

1934, June 30:
 "Vacation"
 [fig. 1-261]

1934, Sept. 22:
 "Moviestars"
 [fig. 1-262]

MAURICE WALSH · BOOTH TARKINGTON · RED GRANGE

1-263

MANUEL KOMROFF · GILBERT SELDES · J. ROY STOCKTON

1-266

"God bless us every one" said Tiny Tim

1-264

SPRINGTIME

JOHN TAINTOR FOOTE · GUY GILPATRIC · JOSEPH HERGESHEIMER

1-267

AGATHA CHRISTIE · JIM COLLINS · GENERAL JOHNSON

1-265

BEGINNING IN THIS ISSUE
PAMPA JOE
By C. E. SCOGGINS

SINCLAIR LEWIS
J. P. MARQUAND
F. SCOTT FITZGERALD

1-268

1934, Oct. 20:
"On Top of the World"
or "The Weathervane"
[fig. 1-263]

1934, Dec. 15:
"Tiny Tim"
[fig. 1-264]

1935, Feb. 9:
"The Signpainter"
[fig. 1-265]

1935, March 9:
"The Partygoers"
[fig. 1-266]

1935, April 27:
"Springtime, 1935"
[fig. 1-267]

1935, July 13:
"Exhilaration"
[fig. 1-268]

1935, Sept. 14:
"School Days" or
"First Day of School"
[fig. 1-269]

1935, Nov. 16:
"An Autumn Stroll"
[fig. 1-270]

1935, Dec. 21:
"Dear Santa"
[fig. 1-271]

1936, Jan. 25:
"The Big Moment"
[fig. 1-272]

1936, March 7:
"Hollywood Starlet"
[fig. 1-273]

1936, April 25:
"Springtime, 1936"
[fig. 1-274]

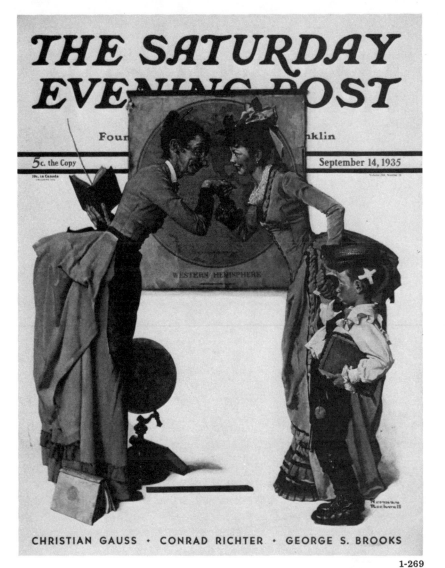

THE SATURDAY EVENING POST

Four... ...nklin

5c. the Copy

September 14, 1935

WESTERN HEMISPHERE

CHRISTIAN GAUSS • CONRAD RICHTER • GEORGE S. BROOKS

1-269

CONRAD RICHTER • ROBERT MOSES • J. P. McEVOY

1-272

ROSE WILDER LANE • FRANK P. STOCKBRIDGE

1-273

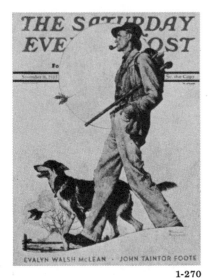

EVALYN WALSH McLEAN • JOHN TAINTOR FOOTE

1-270

THE SATURDAY EVENING POST

Christmas

WILLIAM HAZLETT UPSON • FRANK H. SIMONDS

1-271

Springtime

VINCENT SHEEAN • J. P. McEVOY • EDDIE CANTOR

1-274

1-275

1-276

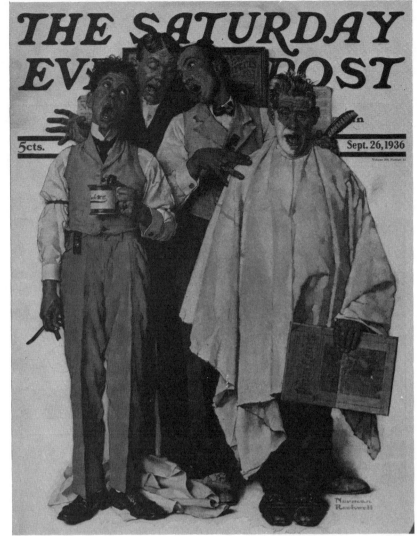

1-277

1936, May 30:
 "Take Your Medicine"
 [fig. 1-275]

1936, July 11:
 "Young Love"
 [fig. 1-276]

1936, Sept. 26:
 "Barbershop Quartet"
 [fig. 1-277]

1936, Oct. 24:
 "Exasperated Nannie"
 [fig. 1-278]

1936, Nov. 21:
 "Overheard Lovers"
 [fig. 1-279]

1936, Dec. 19:
 "Feast for a Traveler"
 [fig. 1-280]

1937, Jan. 23:
 "Missing the Dance"
 [fig. 1-281]

1937, April 24:
 "Ticket Agent"
 [fig. 1-282]

1937, June 12:
 "Gaiety Dance Team"
 [fig. 1-283]

1937, July 31:
 "At the Auction" or
 "Found Treasure"
 [fig. 1-284]

1937, Oct. 2:
 "Spilled Paint"
 [fig. 1-285]

1937, Dec. 25:
 "Christmas" or
 "White Christmas"
 [fig. 1-286]

THE DEVIL
AND DANIEL WEBSTER—BY STEPHEN VINCENT BENÉT

1-278

BEGINNING PADEREWSKI'S LIFE STORY

1-281

WHITE-HOUSE TOMMY—By ALVA JOHNSTON

1-284

FOOTBALL
WIFE
BY VIRGINIA BLACK

LIFER—BY CHARLES FRANCIS COE

1-279

THE $47,000,000,000 BLIGHT—By SENATOR VANDENBERG

1-282

Beginning AND ONE WAS BEAUTIFUL By ALICE DUER MILLER

1-285

SWING BUSINESS · HENRY ANTON STEIG

TISH GOES TO JAIL · MARY ROBERTS RINEHART

1-280

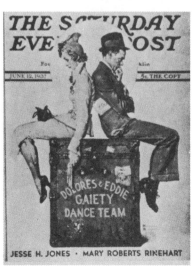

DOLORES & EDDIE
GAIETY
DANCE TEAM

JESSE H. JONES · MARY ROBERTS RINEHART

1-283

CHRISTMAS

MORE THAN
3,000,000 AVERAGE NET PAID CIRCULATION IN 1937

1-286

1-287

1-290

1-288

1-291

1-289

1-292

1938, Feb. 19:
"The Moviestar"
(Robert Taylor)
[fig. 1-287]

1938, April 23:
"See America First"
[fig. 1-288]

1938, June 4:
"First Plane Trip"
[fig. 1-289]

1938, Oct. 8:
"Self-Portrait"
(Norman Rockwell)
[fig. 1-290]

1938, Nov. 19:
"The Letterman"
[fig. 1-291]

1938, Dec. 17:
"Merrie Christmas" or
"Muggleton Coach"
[fig. 1-292]

1939, Feb. 11:
"Jester"
[fig. 1-293]

1939, March 18:
"The Druggist" or
"The Pharmacist"
[fig. 1-294]

1939, April 29:
"Sport"
[fig. 1-295]

1939, July 8:
"100th Year of Baseball"
[fig. 1-296]

1939, Aug. 5:
"Summer Stock"
[fig. 1-297]

1939, Sept. 2:
"Knuckles Down"
[fig. 1-298]

NOT SO FREE AIR—BY STANLEY HIGH

1-293

BEGINNING
ESCAPE
A NOVEL OF TODAY'S REIGN OF TERROR

1-296

THE CRISIS IN CHRISTIANITY By WILL DURANT

1-297

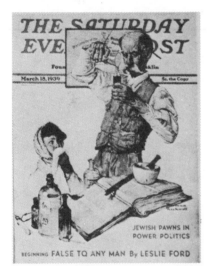

JEWISH PAWNS IN
POWER POLITICS

BEGINNING FALSE TO ANY MAN By LESLIE FORD

1-294

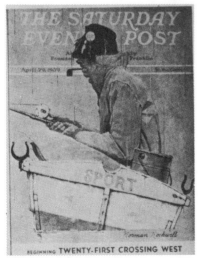

BEGINNING TWENTY-FIRST CROSSING WEST

1-295

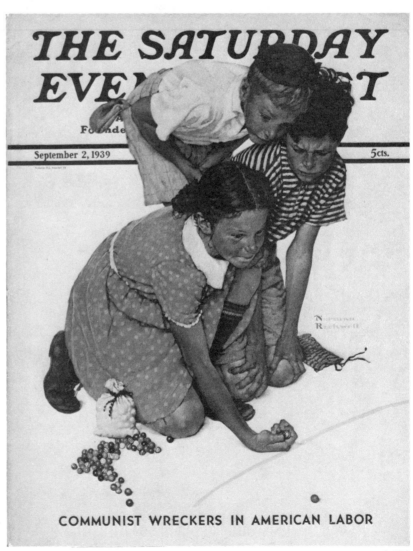

COMMUNIST WRECKERS IN AMERICAN LABOR

1-298

1-299

1-300

1-301

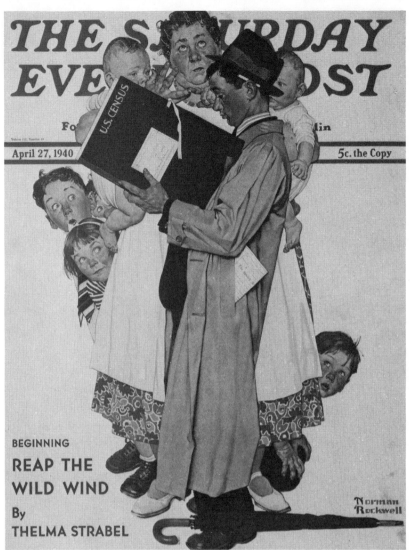

1-302

1-303

1-304

1-305

1-307

1-309

1-306

1-308

1-310

1939, Nov. 4:
"Sheriff and Prisoner"
[fig. 1-299]

1939, Dec. 16:
"Extra Good Boys and Girls"
[fig. 1-300]

1940, March 30:
"The Decorator"
[fig. 1-301]

1940, April 27:
"The Census" or "The
Census Taker"
[fig. 1-302]

1940, May 18:
"The Full Treatment"
[fig. 1-303]

1940, July 13:
"Melting Ice Cream" or "The
Joys of Summer"
[fig. 1-304]

1940, Aug. 24:
"Home From Camp" or "Re-
turning Home From Camp"
[fig. 1-305]

1940, Nov. 30:
"The Hitchhiker"
[fig. 1-306]

1940, Dec. 28:
"Santa on Train"
[fig. 1-307]

1941, March 1:
"Cover Girl"
[fig. 1-308]

1941, May 3:
"The Hat Check Girl"
[fig. 1-309]

1941, July 26:
"The Flirts"
[fig. 1-310]

1-311

1-313

1-312

1942, Oct. 4:
 "Package From Home"
 [fig. 1-311]

1941, Nov. 29:
 "Willie Gillis Home
 On Leave"
 [fig. 1-312]

1941, Dec. 20:
 "Newsstand in the Snow"
 [fig. 1-313]

1942, Feb. 7:
 "Willie Gillis at U.S.O."
 [fig. 1-314]

1942, March 21:
 "The Diary"
 [fig. 1-315]

1942, April 11:
 "Willie Gillis on K.P."
 [fig. 1-316]

1942, June 27:
 "Willie Gillis in a
 Blackout"
 [fig. 1-317]

1942, July 25:
 "Willie Gillis in Church"
 [fig. 1-318]

1942, Sept. 5:
 "Double Trouble for Willie
 Gillis"
 [fig. 1-319]

1942, Nov. 28:
 "Thanksgiving Day Blues"
 [fig. 1-320]

1942, Dec. 26:
 "Santa's in the News"
 [fig. 1-321]

1943, April 3:
 "April Fool"
 [fig. 1-322]

1-314

1-317

1-320

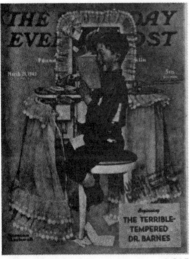

1-315

1-318

1-321

1-316

1-319

1-322

1-323

1-324

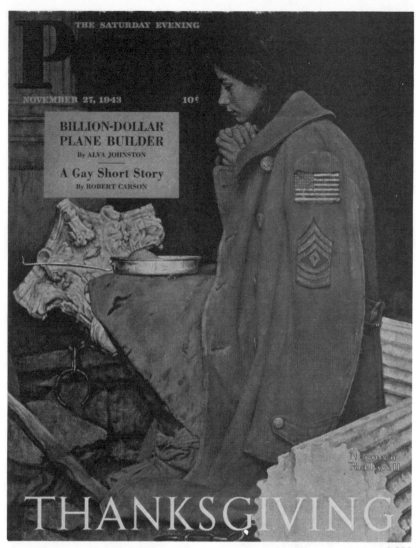

1-326

1-325

1-327

1-328

1943, May 29:
 "Rosie the Riveter"
 [fig. 1-323]

1943, June 26:
 "Willie's Rope Trick"
 [fig. 1-324]

1943, Sept. 4:
 "Rosie to the Rescue"
 [fig. 1-325]

1943, Nov. 27:
 "Thanksgiving"
 [fig. 1-326]

1944, Jan. 1:
 "New Year's Eve"
 [fig. 1-327]

1944, March 4:
 "The Tattooist" or "The
 Tattoo Artist"
 [fig. 1-328]

1944, April 29:
 "Armchair General"
 [fig. 1-329]

1944, May 27:
 "Fireman"
 [fig. 1-330]

1944, July 1:
 "The War Bond"
 [fig. 1-331]

1944, Aug. 12:
 "Travel Experience"
 or "Train Trip"
 [fig. 1-332]

1944, Sept. 16:
 "Willie Gillis
 'Generations' "
 [fig. 1-333]

1944, Nov. 4:
 "Undecided"
 [fig. 1-334]

1-329

1-332

1-330

1-333

1-331

1-334

1-335

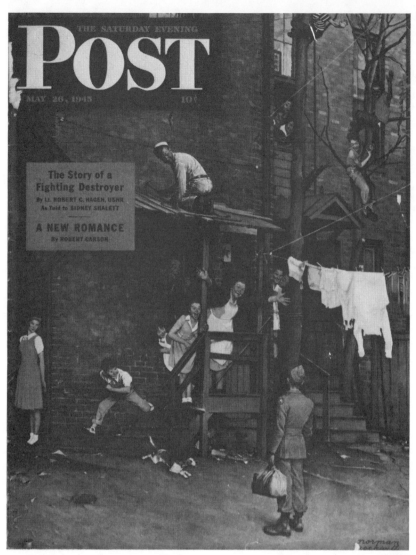

1-338

1-336

1-337

1-339

1-340

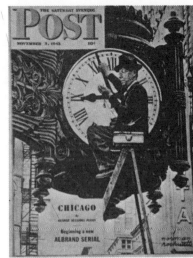

1-342

1-343

1-341

1944, Dec. 23:
 "Union Station, Chicago, at
 Christmas"
 [fig. 1-335]

1945, March 17:
 "It's Income Tax Time,
 Again?"
 [fig. 1-336]

1945, March 31:
 "April Fool"
 [fig. 1-337]

1945, May 26:
 "The Homecoming"
 [fig. 1-338]

1945, Aug. 11:
 "The Swimming Hole"
 [fig. 1-339]

1945, Sept. 15:
 "On Leave"
 [fig. 1-340]

1945, Oct. 13:
 "Homecoming Marine"
 [fig. 1-341]

1945, Nov. 3:
 "Clock Repairman"
 [fig. 1-342]

1945, Nov. 24:
 "Home for Thanksgiving"
 [fig. 1-343]

1-344

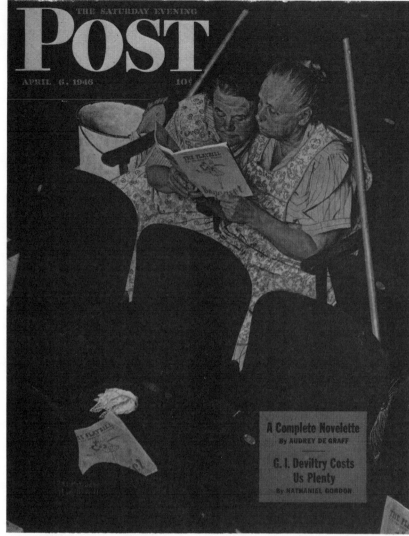

1-347

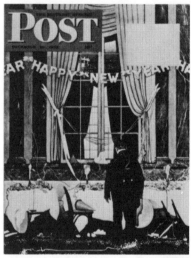

1-345

1-346

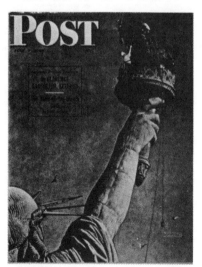

1-348

1-349

1945, Dec. 15:
"An Imperfect Fit"
[fig. 1-344]

1945, Dec. 29:
"The Party's Over" or
"Happy New Year"
[fig. 1-345]

1946, March 2:
"Museum Worker" or "The
Picture Hanger"
[fig. 1-346]

1946, April 6:
"The Charwomen"
or "The Chars"
[fig. 1-347]

1946, July 6:
"The Statue of Liberty"
[fig. 1-348]

1946, Aug. 3:
"Fixing a Flat"
[fig. 1-349]

1946, Oct. 5:
"Willie Gillis in College"
[fig. 1-350]

1946, Nov. 16:
"Commuters"
[fig. 1-351]

1946, Dec. 7:
"New York Central Diner"
[fig. 1-352]

1947, Jan. 11:
"The Piano Tuner"
[fig. 1-353]

1947, March 22:
"The First Flower"
[fig. 1-354]

1947, May 3:
"The Circus Artist"
[fig. 1-355]

1-350

1-353

1-351

1-354

1-352

1-355

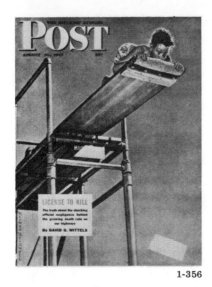

1-356

1-358

1-359

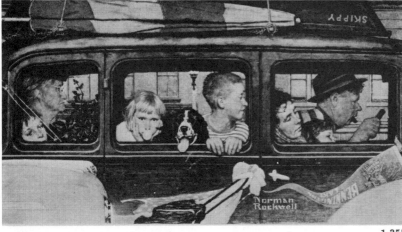

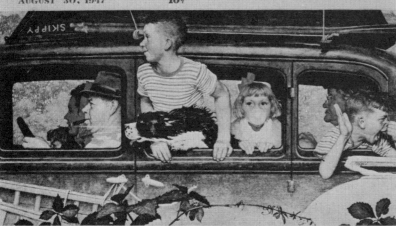

1-357

1-360

1947, Aug. 16:
"Young Boy on a High Dive
Board" or "The High Dive"
[fig. 1-356]

1947, Aug. 30:
"The Outing"
[fig. 1-357]

1947, Nov. 8:
"The Babysitter"
[fig. 1-358]

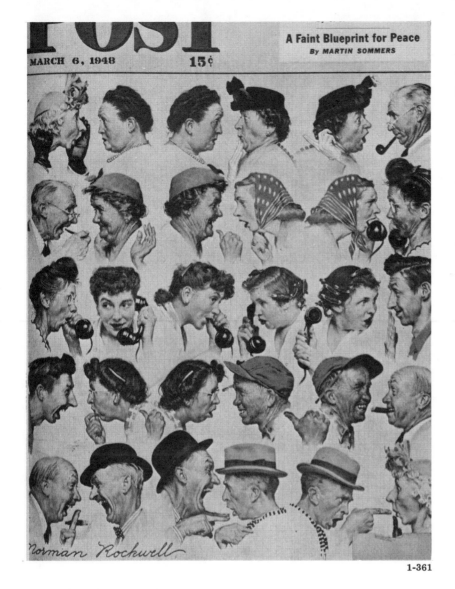

1-361

1-362

1-363

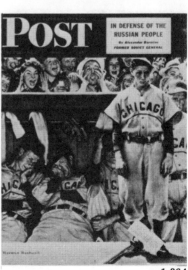

1-364

1947, Dec. 27:
"Santa's Helper"
[fig. 1-359]

1948, Jan. 24:
"Trip on a Ski Train"
[fig. 1-360]

1948, March 6:
"The Gossips"
[fig. 1-361]

1948, April 3:
"April Fool"
[fig. 1-362]

1948, May 15:
"The Bridge Game"
[fig. 1-363]

1948, Sept. 4:
"The Dugout"
[fig. 1-364]

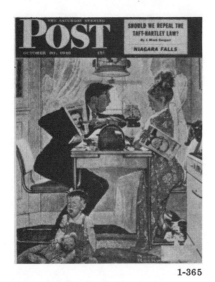

1-365

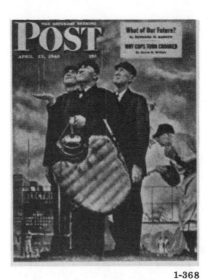

1-368

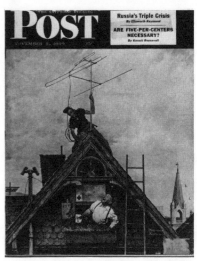

1-371

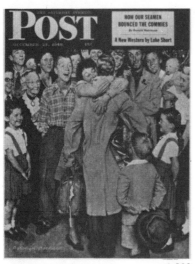

1-366

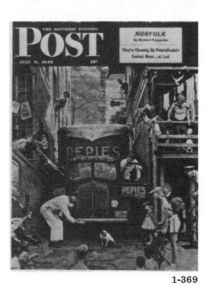

1-369

1-372

1-367

1-370

1-373

1-374

1-375

1-376

1948, Oct. 30:
 "Dewey vs. Truman"
 [fig. 1-365]

1948, Dec. 25:
 "Homecoming"
 [fig. 1-366]

1949, March 19:
 "The Prom Dress"
 [fig. 1-367]

1949, April 23:
 "Game Called (Off) Because
 of Rain" or "The Three
 Umpires"
 [fig. 1-368]

1949, July 9:
 "Traffic Conditions" or
 "Road Block"
 [fig. 1-369]

1949, Sept. 24:
 "Before the Date"
 [fig. 1-370]

1949, Nov. 5:
 "The New Television Set"
 [fig. 1-371]

1950, April 29:
 "Shuffleton's Barbershop"
 [fig. 1-372]

1950, Aug. 19:
 "The Travelling Salesman"
 [fig. 1-373]

1950, Oct. 21:
 "The Toss-up"
 [fig. 1-374]

1950, Nov. 18:
 "The Trumpeter"
 [fig. 1-375]

1951, June 2:
 "The Plumbers"
 [fig. 1-376]

1-377

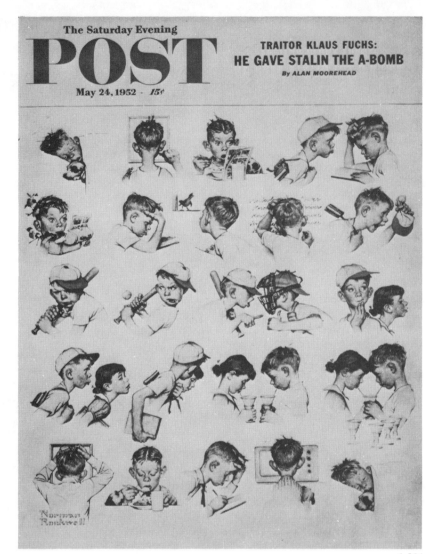

1-381

1-378

1-379

1-380

1951, July 14:
 "The Facts of Life"
 [fig. 1-377]

1951, Nov. 24:
 "Saying Grace"
 [fig. 1-378]

1952, Feb. 16:
 "Losing the Game"
 [fig. 1-379]

1-382

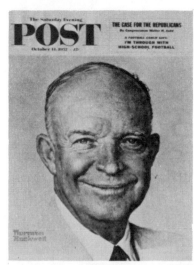

1-383

1-384

1952, March 29:
 "Waiting at the Vet's"
 [fig. 1-380]

1952, May 24:
 "A Day in the Life of a Boy"
 [fig. 1-381]

1952, Aug. 30:
 "A Day in the Life of a Girl"
 [fig. 1-382]

1952, Oct. 11:
 "President Eisenhower"
 [fig. 1-383]

1953, Jan. 3:
 "The Baker" or "Weighty
 Matters"
 [fig. 1-384]

1953, April 4:
 "Walking to Church"
 [fig. 1-385]

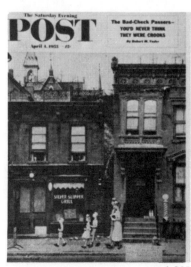

1-385

The Saturday Evening
POST
May 23, 1953 - 15¢

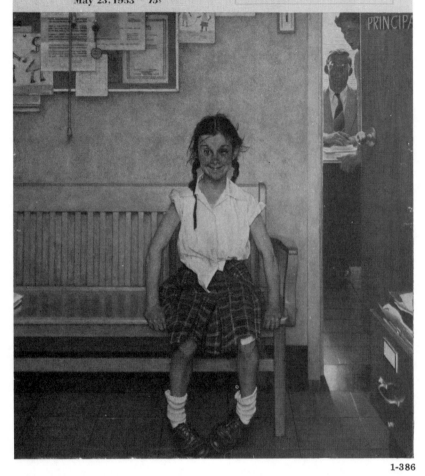

1-386

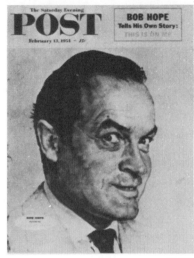

1-389

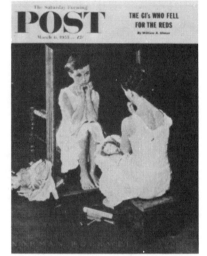

1-390

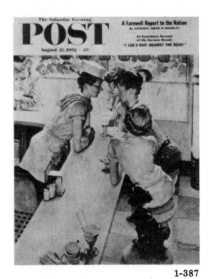

1-387

1-388

1-391

1953, May 23:
"Outside the
Principal's Office"
[fig. 1-386]

1953, Aug. 22:
"The Soda Shop"
[fig. 1-387]

1954, Jan. 9:
"The Lion Keeper"
[fig. 1-388]

1954, Feb. 13:
"Bob Hope"
[fig. 1-389]

1954, March 6:
"Girl at the Mirror"
[fig. 1-390]

1954, April 17:
"The Choir Boy"
[fig. 1-391]

1954, Aug. 21:
"Construction Crew"
[fig. 1-392]

1954, Sept. 25:
"Breaking Home Ties"
[fig. 1-393]

1955, March 12:
Nine previously published
Rockwell covers

1955, April 16:
"The Critic"
[fig. 1-394]

1955, June 11:
"Marriage License"
[fig. 1-395]

1955, Aug. 20:
"The Mermaid"
[fig. 1-396]

1956, March 17:
"Happy Birthday,
Miss Jones"
[fig. 1-397]

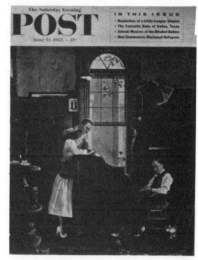

1-392

1-395

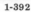

1-393

1-396

1-394

1-397

1-398

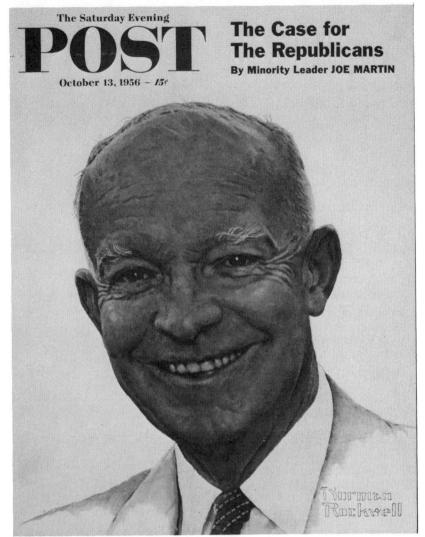

1-400

1-399

1956, May 19:
"The Examination"
[fig. 1-398]

1956, Oct. 6:
"Adlai Stevenson"
[fig. 1-399]

1956, Oct. 13:
"Dwight D. Eisenhower"
[fig. 1-400]

1956, Dec. 29:
"The Discovery"
[fig. 1-401]

1957, March 2:
"The Locker Room"
[fig. 1-402]

1957, May 25:
"After the Prom"
[fig. 1-403]

1957, June 29:
"Just Married"
[fig. 1-404]

1957, Sept. 7:
"The Missing Tooth"
[fig. 1-405]

1957, Nov. 30:
"Balancing the Account"
[fig. 1-406]

1958, March 15:
"Before the Shot"
[fig. 1-407]

1958, June 28:
"(Jockey) Weighing In"
(Eddie Arcaro)
[fig. 1-408]

1958, Aug. 30:
"Knothole Baseball"
[fig. 1-409]

1-401

1-404

1-407

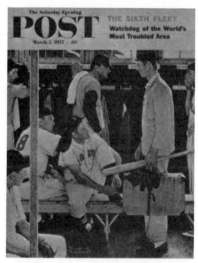

1-402

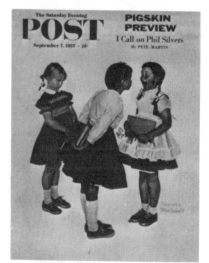

1-405

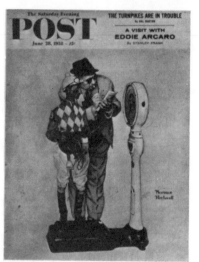

1-408

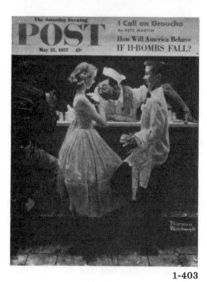

1-403

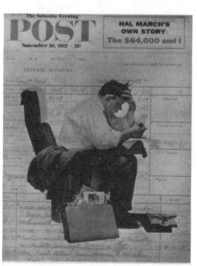

1-406

1-409

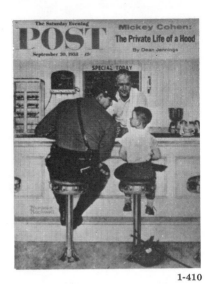

1-410

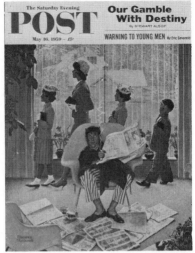

1-413

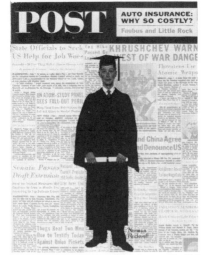

1-414

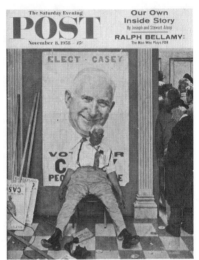

1-411

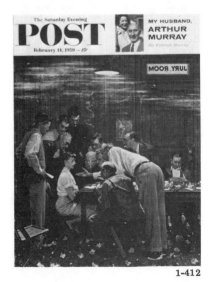

1-412

1-415

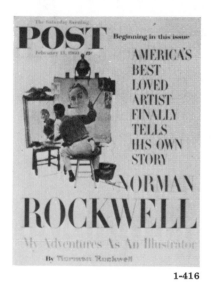

1-416

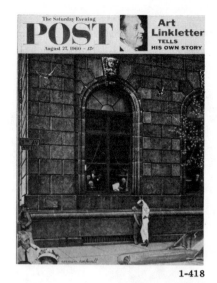

1-418

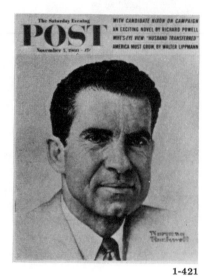

1-420

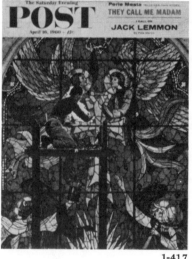

1-417

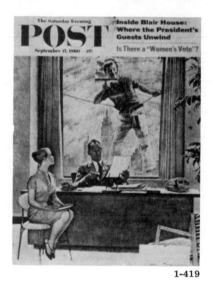

1-419

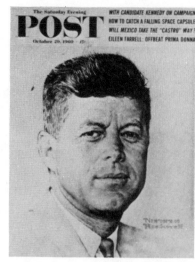

1-421

1958, Sept. 20:
"The Runaway"
[fig. 1-410]

1958, Nov. 8:
"Vote for Casey"
[fig. 1-411]

1959, Feb. 14:
"The Holdout"
[fig. 1-412]

1959, May 16:
"Sunday Morning"
[fig. 1-413]

1959, June 6:
"The Graduate"
[fig. 1-414]

1959, Oct. 24:
"A Family Tree"
[fig. 1-415]

1960, Feb. 13:
"Triple Self-Portrait"
[fig. 1-416]

1960, April 16:
"Repairing Stained Glass"
[fig. 1-417]

1960, Aug. 27:
"University Club"
[fig. 1-418]

1960, Sept. 17:
"The Window Washer"
[fig. 1-419]

1960, Oct. 29:
"John F. Kennedy"
[fig. 1-420]

1960, Nov. 5:
"Richard M. Nixon"
[fig. 1-421]

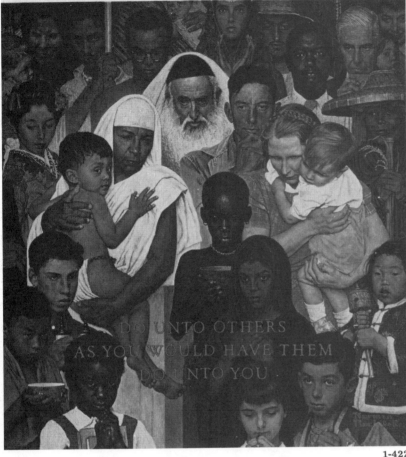

The Saturday Evening **POST**

THE **NEW** UTAH
My Adventures Among the U.S. Senators
By DEAN ACHESON

April 1, 1961 · 15¢

DO UNTO OTHERS
AS YOU WOULD HAVE THEM
DO UNTO YOU

1-422

1-425

1-426

1-423

1-424

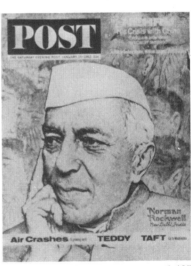

1-427

1961, April 1:
 "The Golden Rule"
 [fig. 1-422]

1961, Sept. 16:
 "Artist at Work"
 [fig. 1-423]

1961, Nov. 25:
 "The Cheerleader"
 [fig. 1-424]

1962, Jan. 13:
 "The Connoisseur" or
 "Abstract and Concrete"
 [fig. 1-425]

1962, Nov. 3:
 "Armor"
 [fig. 1-426]

1963, Jan. 19:
 "Nehru"
 [fig. 1-427]

1963, March 2:
 "Jack Benny"
 [fig. 1-428]

1963, April 6:
 "John F. Kennedy"
 [fig. 1-429]

1963, May 25:
 "Nasser"
 [fig. 1-430]

1963, Dec. 14:
 "John F. Kennedy
 1917-1963" (*Post*
 cover 10-29-60)

1972, Summer:
 "100th Anniversary of Base-
 ball" (*Post* cover 7-8-38)

1973, Winter:
 "Downhill Daring" (*Country
 Gentleman* cover 12-27-19)

1975, Sept.:
 "John F. Kennedy" (*Post*
 cover 10-29-60)

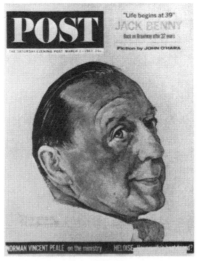

1-428

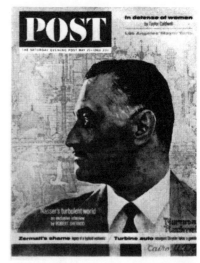

1-430

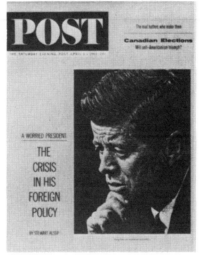

1-429

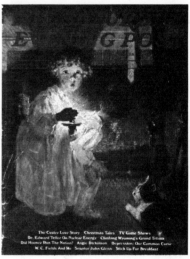

1-431

1975, Dec.:
 "Stockings Were Hung"
 [fig. 1-431]

1976, Oct.:
 "The Toss" (*Post*
 cover 10-21-50)

1976, Nov.:
 "Exhilaration" (*Post*
 cover 7-13-36)

1976, Dec.:
 "Extra Good Boys and Girls"
 (*Post* cover 12-16-39)

1977, July-Aug.:
 "Special 250th Anniversary
 Issue"
 (story illustration 9-21-40)

1977, Dec.:
 "Dear Santa" (*Post*
 cover 12-21-35)

1978, Jan.-Feb.:
 "A Very Special Issue on
 Norman Rockwell" (*Post*
 cover 2-13-60)

SCHOLASTIC NEWS - EXPLORER:

1972, Sept. 18:
 "Storybook Stamp" (Tom Sawyer illustration)

SCOUT ADMINISTRATOR:

1953, Nov.:
 Scout with American Eagle

SCOUT EXECUTIVE Magazine:

1934, Nov.:
 Same as 1934 Boy Scout calendar, "Carry On"

SCOUTING Magazine:

1930, May:
 "Around the Campfire"

1934, Feb.:
 Same as 1932 Boy Scout calendar, "A Scout is Loyal"

1936, Jan.:
 Same as Jamboree cover, "America Builds for Tomorrow"

1936, June:
 Boy Scout Jamboree

1937, March:
 Photo of Boy Scout

1939, April:
 Boy Scouts, New York World's Fair

1940, Feb.:
 Same as 1940 Boy Scout calendar, "A Boy Scout is Reverent"

1941, Jan.:
 Same as 1941 Boy Scout calendar, "A Scout is Helpful"

1944, Feb.:
 Same as 1944 Boy Scout calendar, "We, too, Have a Job to Do"

1944, Dec.:
 Same as 1939 Boy Scout calendar, "The Scouting Trail"

1948, Sept.:
 Same as 1948 Boy Scout calendar, "Men of Tomorrow"

1953, Oct.:
 "It's Red Feather Time"

1959, Dec.:
 Boy Scout holding handbook

1963, Feb.:
 Norman Rockwell painting Scout calendar

1967, July-Aug.:
 Same as 1967 Boy Scout calendar, "Breakthrough for Freedom"

1968, Feb.:
 "Meeting House"

1969, Jan.:
 "Beyond the Easel"

SENATOR Magazine:

1939, Jan. 28, Vol. 1, No.1:
 A portrait

SIGNS OF OUR TIMES:

1940, May 7:
 Boy Scout kneeling in church

SPORTING GOODS DEALER:

1971, Oct.:
 Brooks Robinson signing autographs
 [fig. 1-432]

1-432

STAR LEDGER SPECTRUM:

1972, Dec. 3:
 "Rockwell Showing"

THE TAMPA TRIBUNE
TV GUIDE:

1970, March 15:
 "Wizard of Oz" (Judy Gar-
 land as Dorothy)

———————————

THIS WEEK:

1935, Sept. 1:
 Harvest moon

1936, Feb. 23:
 "Echoes of Romance"

1937, July 18:
 "Old Swimming Hole"

1947, Dec. 27:
 Ice skaters

———————————

TODAY:

1973, April 29:
 (no title)

———————————

TRUSTS & ESTATES:

1972, Oct.:
 "Looking Out to Sea" or
 "Outward Bound"

———————————

T.V. GUIDE:

1955, Jan. 8:
 Arthur Godfrey

1970, May 16:
 Spiro Agnew

1970, Aug. 15:
 Johnny Carson

———————————

VERMONT LIFE:

1947, Summer:
 "The Horseshoe Forging
 Contest"

———————————

WINGFOOT CLAN
 (Goodyear Rubber Co.):

1962, Dec.:
 "Christmas"

1963, Dec.:
 "Christmas"

1964, Dec.:
 "Christmas"

1965, Dec.:
 "Christmas"

———————————

YANKEE Magazine:

1972, Aug.:
 "Outward Bound" or
 "Looking Out to Sea"

———————————

YOUTH'S COMPANION:

1916, Feb. 24:
 "Pride-O-Body"

1916, March 30:
 "A New Standard"

1916, Aug. 3:
 "Under the Bluebird"

1917, April 26:
 "The Plattsburgers"

1917, July 26:
 "Absent Treatment"

———————————

2
Magazine Illustrations

"A little boy in bed with the mumps looking out the window at 4th of July fireworks," is the description Mr. Rockwell gives of his first illustrations at age seventeen, his first year at the Art Students League.

At eighteen he painted Santa Clauses, children, and angels for a Christmas booklet for the Paulist Fathers of New York. That same year he illustrated parts of the human body for medical textbooks, including a three week project of drawing the human fetus in various stages of development.

Norman Rockwell learned early in his career to satisfy his client as well as himself by expressing a specific idea so that a large number of people could understand. He knew there must be no mistake as to what he was trying to convey.

Assignments like the *Boy Scout Hike Book* with over 100 illustrations set the pattern for this very graphic art form.

It took six months for him to paint the "Four Freedoms." They were published in *The Saturday Evening Post* in 1943; not as covers, but as feature illustrations. Each "Freedom" was accompanied by a short essay describing what Rockwell was attempting to say on canvas.

His work appeared in at least sixty national publications. Most impressive in numbers were his contributions to *Boys' Life* magazine. He illustrated 96 stories between 1913 and 1917. Prolific indeed!

AFLOAT AND ASHORE
Bulletin:

1917, July-1918, Nov.:

Norman Rockwell published many cartoons and illustrations while serving in the United States Navy. Much of his output appeared in the bulletin *Afloat and Ashore*, a joint venture between the *Charleston News Courier* and the naval base at Charleston, South Carolina. Specific illustrations are not listed here because neither the base library nor the *Courier* kept back issues. *Afloat and Ashore* was the base newspaper, not a national publication of the United States Navy.

AMERICAN Magazine:

1918, Nov.:
 "Ramsey Milholland"

1918, Dec.:
 "Ramsey Milholland"

1919, Jan.:
 "Ramsey Milholland"

1919, Feb.:
 "Ramsey Milholland"

1920, June:
 "Stealing Cleopatra's Stuff"

1921, May:
 "Sketch"

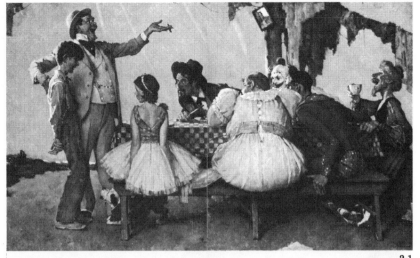

2-1

2-3

2-2

2-4

1934, May:
"Fishes Like Neckties"

1935, Jan.:
"Willie Takes a Step"
[fig. 2-1]

1935, April:
"Peach Crop"

1935, Dec.:
"The Ferry Over"
[fig. 2-2]

1936, March:
"Men Are Fish"

1936, June:
"Love Ouanga"
(a church pew)

1936, May:
"Commonplace"

1936, May:
Guest editorial writer-
Norman Rockwell

1936, Oct.:
"Tides of Memory"
[fig. 2-3]

1937, May:
"Sing Loudly in the Sun"

1937, July:
"Dark Blizzard"
[fig. 2-4]

1937, Oct.:
"Turn of the Tide"

1938, July:
"Robin Hill"
[fig. 2-5 *next page*]

1938, Aug.:
"Heavy Static"

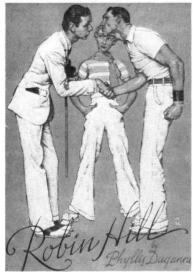

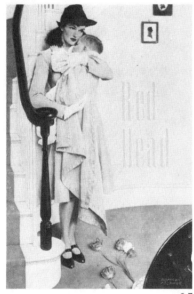

2-5

2-7

2-6

1938, Nov.:
 "Swords at Weehawken"
 [fig. 2-6]

1939, April:
 "Give Me a Boy"

1939, July:
 "Second Holiday"

1939, Oct.:
 "The First Fourth"

1940, Feb.:
 "District Office 22"

1940, May:
 "Proud Professor"

1940, July:
 "Guilt"

1940, Nov.:
 "Red Head"
 [fig. 2-7]

1941, Jan.:
 "Christmas in the Heart"
 [fig. 2-8]

1941, Feb.:
 "The Bartender's Birthday"
 [fig. 2-9]

2-8

2-10

2-11

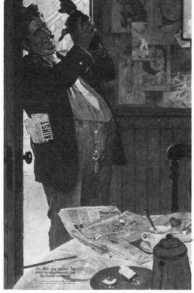

2-9

2-12

1941, March:
"Men Shake Hands"
[fig. 2-10]

1941, June:
"Strictly a Sharpshooter"
[fig. 2-11]

1941, Sept.:
"Second Fiddle"

1942, March:
"Beginning of Wisdom"

1942, July:
"Johnny Comes Marching
Home"
[fig. 2-12]

1942, Dec.:
"The New Lady"
[fig. 2-13 *next page*]

1947, May:
"Hoodlum Street"

1964, Sept.:
"Portrait Sketches of
Norman Rockwell"

AMERICAN ARTIST:

1964, Sept.:
Eight portrait sketches

2-13

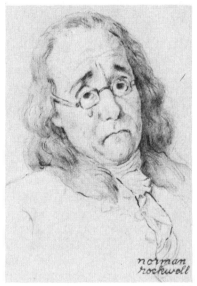

2-14

BOYS' LIFE:

1913, Jan.:
"Partners"

1913, March:
"Sam Brown's Ride to Save Saint Paul"

1913, May:
"The Yellow Streak"

1913, May:
"Crossed Signals"

1913, Sept.:
"Big Benton's Fighting Blood"

1913, Sept.:
"Waves of the Moon"

1913, Sept.:
"The Trail to El Dorado"

1913, Oct.:
"The Secret Full-Back"

1913, Oct.:
"Prepared"

1913, Oct.:
"The Trail to El Dorado"

1913, Nov.:
"The Cruise of the Pegasus"

1913, Nov.:
"The Secret Half-Back"

1913, Nov.:
"The Trail to El Dorado"

1913, Dec.:
"The Cruise of the Pegasus"

1913, Dec.:
"The Trail to El Dorado"

1913, Dec.:
"Joe's Christmas Eve"

1913, Dec.:
"Tropic Smugglers"

1914, Jan.:
"A Narrow Escape"

1914, Jan.:
"Tropic Smugglers"

1914, Jan.:
"The Trail to El Dorado"

1914, Jan.:
"The Secret of the Sea"

1914, Feb.:
"The Ghost Ball"

1914, Feb.:
"Bobby's Twilight Dance"

1914, Feb.:
"Follow Your Leader"

1914, March:
"The Hazing of Kid Burnham"

1914, March:
"The Mystery of the River Cave"

1914, March:
"The Ghost Ball"

1914, April:
"The Hook Slide"

1914, April:
"Ned Beal, Tenderfoot Scout"

1914, April:
"The Mystery of the River Cave"

1914, April:
"A Narrow Escape from Sawyer"

1914, April:
"The Other Fellow's Game"

1914, May:
"Peter and the Game of War"

1914, May:
"Cinders"

1914, May:
"The Mystery of the River Cave"

1914, May:
Photo of young Norman Rockwell at his easel (age 20)

1914, June:
"Scouting with Daniel Boone"

1914, July:
"Scouting with Daniel Boone"

1914, July:
"A Pitcher's Pluck"

1914, July:
"At the Other End of the Wire"

1914, July:
"The Great Raft Race"

1914, Aug.:
"Scouting with Daniel Boone"

1914, Aug.:
"Preparation"

1914, Aug.:
"A Midnight Surprise"

1914, Sept.:
"Scouting with Daniel Boone"

1914, Sept.:
"Wahbo, the Ghost Beast"

1914, Sept.:
"The Unwelcome Scoop"

1914, Oct.:
"The Haunted Hollow"

1914, Oct.:
"Scouting with Daniel
Boone"

1914, Nov.:
"Scouting with Daniel
Boone"

1914, Dec.:
"Dan of the Mountains"

1914, Dec.:
"Scouting with Daniel
Boone"

1914, Dec.:
"Our Lonesome Corner"

1915, Jan.:
"The Moonshiners in
the Jungle"

1915, Jan.:
"Scouting with Daniel
Boone"

1915, Jan.:
"Pancake Jim"

1915, Feb.:
"The Boy Scout
Smoke-Eaters"

1915, Feb.:
"The Moonshiners in
the Jungle"

1915, Feb.:
"A Scout is Brave"

1915, March:
"Lefty's Climb to
Happiness"

1915, March:
"The Moonshiners in the
Jungle"

1915, March:
"Tresse"

1915, April:
"For the Honor of
Uncle Sam"

1915, April:
"A Treasure Hunt for Real
Gold"

1915, April:
"The Moonshiners in the
Jungle"

1915, May:
"Don Strong of the Wolf
Patrol"

1915, May:
"The Moonshiners in the
Jungle"

1915, June:
"Don Strong of the Wolf
Patrol"

1915, June:
"The Moonshiners in the
Jungle"

1915, June:
"The Great Scout
Snipe Hunt"

1915, July:
"Quarry Troop's Fourth of
July"

1915, July:
"Don Strong of the Wolf
Patrol"

1915, July:
"The Moonshiners in the
Jungle"

1915, Aug.:
"The Quarry Troop Life
Guards"

1915, Aug.:
"Don Strong of the Wolf
Patrol"

1915, Aug.:
"The Moonshiners in the
Jungle"

1915, Sept.:
"The Quarry Troop Life
Guards"

1915, Sept.:
"Don Strong of the Wolf
Patrol"

1915, Sept.:
"Red Gilly Reelfoot
Fisherboy"

1915, Oct.:
"Saved by the
Rolling Hitch"

1915, Oct.:
"Don Strong of the Wolf
Patrol"

1915, Oct.:
"A Strenuous Afternoon"

1915, Nov.:
"In the Land of Gold"

1915, Nov.:
"Don Strong of the Wolf
Patrol"

1915, Dec.:
"In the Land of Gold"

1915, Dec.:
"Don Strong of the Wolf
Patrol"

1915, Dec.:
"The Medal He Lost"

1916, Jan.:
"Don Strong of the Wolf
Patrol"

1916, Feb.:
"Don Strong of the Wolf
Patrol"

1916, March:
"Black Water Dave"

1916, March:
"Don Strong of the Wolf Patrol"

1916, April:
"Hi-Yi-Deels"

1916, April:
"Bill's Bill"

1916, May:
"Bill's Bill," Part II

1916, June:
"The Indian Sign"

1916, June:
"Star Spangled Banner"

CHICAGO ART GALLERIES AUCTION Magazine:

1974:
"It's a Best-Ever Suit—y'Betcha!"

CLUES Magazine:

1953, June:
"A Man and An Idea"

CORONET Magazine:

1946, April:
"How Yankee Doodle Went to Town"

2-15

COUNTRY GENTLEMAN:

1917, Aug. 25:
5 sketches introducing Rockwell's new series. [fig. 2-15]

1919, May 3:
"A Pair of Covers" (4-26-19 and 5-3-19)

1919, June 21:
"Vacation—Who's Glad?" (6-14-19 and 6-21-19 covers)

ESQUIRE:

1962, Jan.:
Portrait of Richard Nixon

EVERYLAND Magazine:

1913, Dec.:
"The Worker in Sandalwood"

1913, Dec.:
"The Little Brown House"

1914, June:
"The Strongest Tie"

1914, June:
"Boy Scouts"

1914, Sept.:
"Across the Threshold"

1914, Dec.:
"The King's Son and the Hermit" (signed with initials R.P.N. reversed)

1914, Dec.:
"Puzzles and Jingles"

1915, March:
"The Cross on the Dent du Chien"

1915, March:
 "Puzzles and Jingles"
 (same as Dec. 1914)

1915, June:
 same as Dec. 1914

1915, Sept.:
 same as Dec. 1914

1916, Oct.:
 "Under the Flag," Part I

1916, Nov.:
 "Under the Flag," Part II

1916, Dec.:
 "Under the Flag," Part III

FORBES Magazine:

1972, June 1:
 "Faces Behind the Figures"

FORD'S GOUDEN FEEST
COURANT:

1953, April:
 Ford Family Triple Portrait

FORD LIFE Magazine:

1972, Jan.:
 "Ford Illustrations of
 Norman Rockwell"

FORD NYT:

1953, June:
 "Henry Ford's Workshop"

FORD TIMES:

1963, July:
 "Henry Ford Centennial,
 1863-1963"

GOLF Magazine:

1974, Dec.:
 Arnold Palmer portrait

GOOD HOUSEKEEPING:

1924, Oct.:
 "Little Boy Afraid of the
 Dark" (poem)

1929, Feb.:
 "House with a Real Charm"

1942, Sept.:
 "The Meeting"

1970, Dec.:
 "Norman Rockwell's
 America"

1975, Nov.:
 "A Thanksgiving Portfolio"

1976, April:
 "At Home with the Norman
 Rockwells"

1976, July:
 "Remember When Home
 Cooking. . ."

1977, Nov.:
 "John Wayne's America"

GREAT AMERICAN
ILLUSTRATOR:

1976:
 Montgomery Gallery

HOBBIES:

1964, Sept.:
 Hallmark Cards, "The Jolly
 Postman"

1964, Sept.:
 "The Postman Cometh,"
 1963 postage stamp

JOURNAL OF AMERICAN
MEDICAL ASSOCIATION:

1972, Nov. 20:
 "Saying Grace" (editorial)

LADIES' HOME JOURNAL:

1921, Oct.:
 "Pompadour Days"

1926, Dec.:
 "The Love Story"

1927, May:
 "Treasures"
 [fig. 2-16]

1927, July:
 "The Book of Romance"
 [fig. 2-17]

1927, Oct.:
 "The Stay at Homes"
 [fig. 2-18]

2-16

2-17

2-18

2-20

2-19

2-21

1927, Dec.:
 "A Christmas Reunion"

1928, March:
 "My Neighbors and Myself"
 [fig. 2-19]

1929, July:
 "Checkers"
 [fig. 2-20]

1930, July:
 "Hollywood Dreams"

1930, Dec.:
 "Christmas Coach"

1931, Feb.:
 "Silhouettes"

1931, Oct.:
 "The Philosopher"

1931, Dec.:
 "To Father Christmas"
 [fig. 2-21]

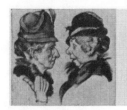

2-23

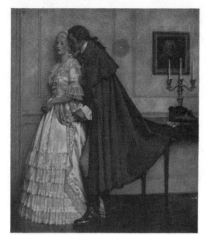

2-22

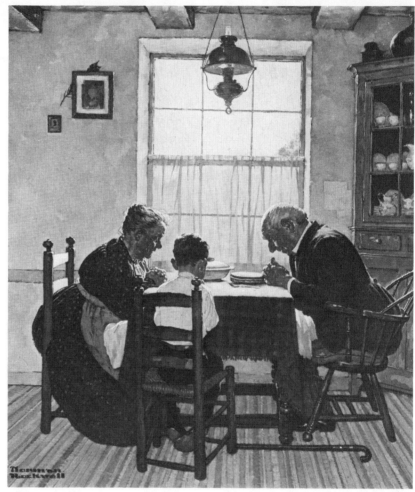

2-24B

2-24A

1932, Feb.:
"Forgotten Facts About
Washington"
[fig. 2-22]

1933, Jan.:
"Will and Bill"

1936, Nov.:
An editorial in pictures by
Norman Rockwell,
"Gossips"
[fig. 2-23]

1938, Aug.:
"Rural Vacation"
[fig. 2-24A, B]

1938, Dec.:
"An Audience of One"
[fig. 2-25A, B]

1939, Feb.:
"A Man's Wife"
[fig. 2-26]

1939, June:
"The Death of the G.A.R."
[fig. 2-27]

1939, Aug.:
"President's Wife"

1941, July:
"Let Nothing You Dismay"
[fig. 2-28]

1942, April:
"Aunt Ella Takes a Trip"

2-25A

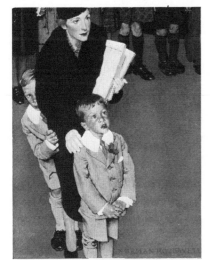

2-25B

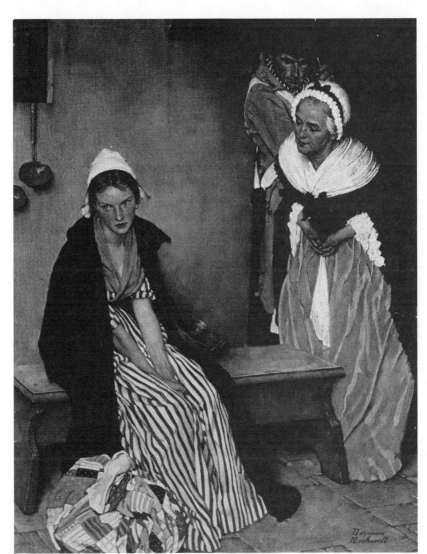

2-26

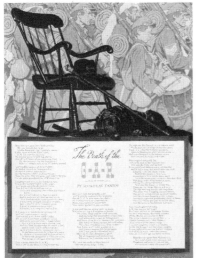

2-27

2-28

2-29A

2-30

LIBERTY Magazine:

1924, Nov. 15:
 "Twenty Years
 on Broadway"
 (George M. Cohan)

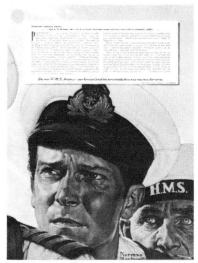

2-29B

2-31

LOOK Magazine:

1964, Jan. 14:
 "The Problem We
 All Live With"

1964, June 21:
 "Southern Justice"
 [fig. 2-31]

1964, July 14:
 "A Time for Greatness"
 [fig. 2-32]

1964, Oct. 20:
 Lyndon Johnson and Barry
 Goldwater portraits

1965, April 20:
 "The Longest Step"

1965, July 27:
 "How Goes the War on
 Poverty?"
 [fig. 2-33]

1943, Oct.:
 "The Ship"
 [fig. 2-29A, B]

1945, Jan.:
 "You'll Marry Me at Noon"
 [fig. 2-30]

1972, July:
 "Come Out and Play"

1972, Nov.:
 "The Candidates and Their
 Wives" (Nixon and
 McGovern)

1973, Nov.:
 "Sinatra, an American
 Classic"

1976, Jan.:
 "Old Fashioned Marriage
 is Back in Style"

1966, Jan. 11:
 "Picasso vs. Sargent"

1966, March 8:
 Bing Crosby in
 "Stagecoach"

1966, June 14:
 "The Peace Corps, J.F.K.'s
 Bold Legacy"
 [fig. 2-34A, B, C, D
 D on next page]

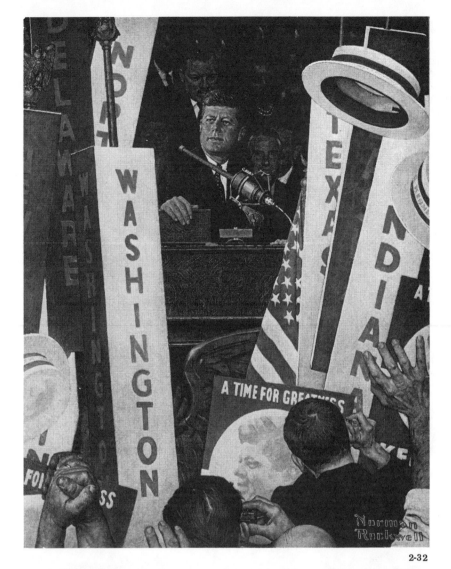

2-32

2-34A

2-34B

2-33

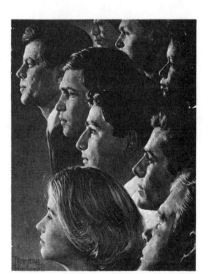

2-34C

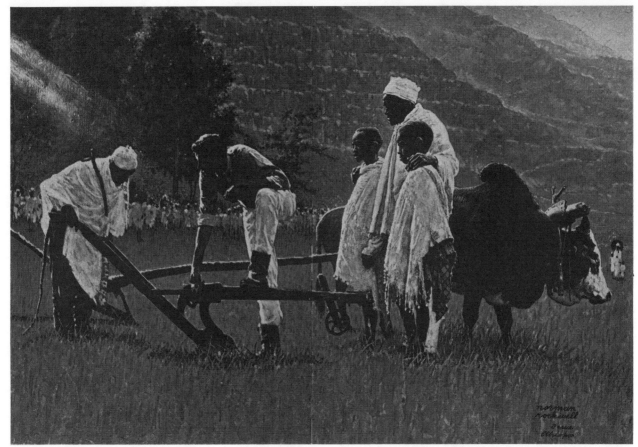

2-34D

2-35A

2-35B

2-35C

2-35D

1966, Sept. 20:
 "The Recruit"

1967, Jan. 10:
 "Astronauts on the Moon"
 [fig. 2-35A, B, C, D]

1967, May 16:
 "New Kids in the
 Neighborhood"

2-36

2-37

2-39 A

1967, Oct. 3:
 "Children in Russian
 Classroom" or "Education"
 [fig. 2-36]

1968, March 5:
 Nixon portrait

1968, April 16:
 Robert F. Kennedy portrait

1968, May 14:
 Nelson Rockefeller portrait

1968, June 25:
 Eugene McCarthy portrait

1968, July 9:
 Hubert Humphrey portrait

1968, July 23:
 Ronald Reagan portrait

1968, Aug. 20:
 "The Right to Know"
 [fig. 2-37]

1968, Aug. 20:
 "The Political Poster Dress"

1969, Feb. 4:
 Richard Nixon portrait

2-38

2-39B

1969, July 15:
"Apollo 11 Space Team"

1969, Sept. 9:
"Willie was Different"

1969, Dec. 30:
"Moon Walk"

1970, Dec. 29:
"Christmas in Bethlehem"

1971, Oct. 19:
"Audubon"
[fig. 2-38]

MARINE'S BULLETIN:

1918, Dec.:
"Pa Wins"
[fig. 2-39A, B]

McCALL'S:

1918, Jan.:
"Diss Honor—A Peg Story"

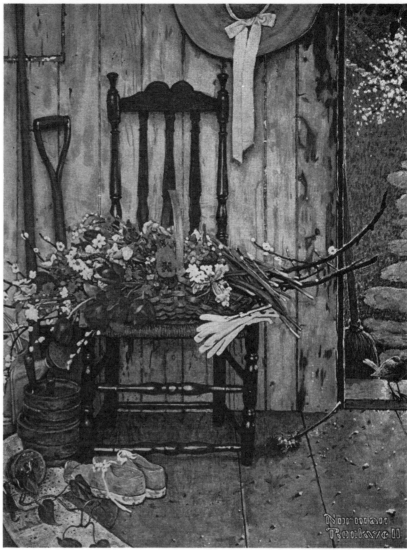

2-40

1920, April:
"Squeeze Play"

1937, April:
"Tom Sawyer"

1942, July:
"Lincoln"

1964, Nov.:
"Norman Rockwell Paints
from the Life of Lady Bird
Johnson and Peggy
Goldwater"

1966, Oct.:
"The Saturday People"

1967, April:
"Willie the Uncommon
Thrush"

1967, Dec.:
"Stockbridge at Christmas"

1969, March:
"Four Words to Remember"

1969, March:
"Lift up Thine Eyes"

1969, May:
"Spring Flowers"
[fig. 2-40]

1977, Dec.:
 "Norman Rockwell's
 Christmas Treasury"

MILESTONES:

1918, Feb.:
 "Casey Goes Through"

MODERN MATURITY:

1969, Oct.-Nov.:
 "Golden Age of Illustration"

NASHUA TELEGRAPH:

1974, Feb. 27:
 "Nashuan was Rockwell's
 'Rosie' in 1943"

NATION Magazine:

1961, April 22:
 "Return of Naturalism"

NATIONAL SUNDAY
 MAGAZINE:

1916, Sept. 10:
 "A Tardy Rebellion"

NEWSWEEK:

1952, Dec. 22:
 "Artists" and about calendars

1958, Sept. 8:
 "Norman Rockwell Astray"

1974, May 6:
 "John Wayne"

NEW YORK SUNDAY NEWS:

1970, July 26:
 "The Vanishing America of
 Norman Rockwell"

NEW YORK TIMES:

1942, Aug. 16:
 "Biography of a Poster"
 (magazine section)

NORTH LIGHT:

1975, Jan.-Feb.:
 "Special Norman Rockwell
 Issue"

OUR HERITAGE IDEALS:

1973, Feb.:
 "Four Freedoms"

PEOPLE Magazine:

1976, Feb. 23:
 "Norman Rockwell,
 Beloved Painter
 of Homespun America"

PERSIMMON HILL - Cowboy
 Hall of Fame:

1970:
 Walter Brennan

1974, Volume 4 No. 3:
 John Wayne - "A Portrait of
 Duke"

PRINTERS INK:

1941, April:
 "Spadework for Next Fall"

PUBLISHERS WEEKLY:

1970, May 4:
 "Yankee Doodle"

RAMPARTS:

1967, May:
 Bertrand Russell portrait
 [fig. 2-41]

1972, Nov.:
 "Capitalist Realism"

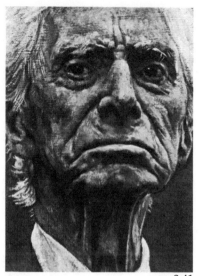

2-41

2-42A

2-42C

READER'S DIGEST:

1969, Feb.:
 Lyndon B. Johnson portrait
 "In Quest of Peace"

1971, April:
 "Norman Rockwell Album"

1974, Sept.:
 Barry Goldwater portrait

2-42B

2-42D

RED CROSS Magazine:

1918, Nov.:
 "Boys Will be. . .Men"
 [fig. 2-42A, B, C, D]

1919, Dec.:
 "Happy Hour" (a poem)

ST. NICHOLAS:

1914, Dec.:
 "The Magic Football"
 [fig. 2-43]

THE MAGIC FOOT-BALL
A Fairy Tale of To-day
By Ralph Henry Barbour
Author of
"THE CRIMSON SWEATER"
"CROFTON CHUMS"etc.

2-43

2-44A

2-44B

1915, Jan.:
 "Thrilling Escapes of
 Wild Animals"

1915, April:
 "Grandfather's Bargain"
 [fig. 2-44A, B]

1915, April:
 "A Feathered St. Patrick"

1915, May:
 "Chained Lightning,"
 Part I

1915, May:
 "A First Class Argument"

1915, June:
 "Chained Lightning,"
 Part II

1915, July:
 "Chained Lightning,"
 Part III

1915, Sept.:
 "A Double Gift"
 [fig. 2-45]

2-45

2-46A

1915, Oct.:
 "Chained Lightning,"
 Part VI

1915, Nov.:
 "End of the Road"

2-46B

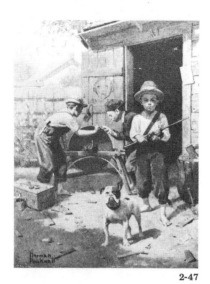

2-47

1915, Dec.:
"Mr. S. Claus' Predicament"

1916, Feb.:
"The Clock Fairy"

1916, March:
"Through the Storm"

1917, Jan.:
"The Ungrateful Man"
(could be C. M. Relyea's
work)

1917, March:
"Norton Wins"

1917, July:
"Making Good in a Boys'
Camp"

1917, Aug.:
"The Burglar and the
Green Apples"

1917, Sept.:
"Along the Trout
Stream"

1918, March:
"George Washington"
(poem)

1918, April:
"Wolf"

1919, June:
"Judgment of Helen"

1920:
"An Old English Christmas"

1925, Dec.:
"Bait-Casting for Boys"

2-48

SATURDAY EVENING POST:

1916, July 8:
"Slim Finnegan" (story)
[fig. 2-46A, B]

1916, Sept. 2:
"A Love Story" (story)
[fig. 2-47]

1928, April 7:
Portrait of Coles Phillips

1934, Dec. 22:
"Land of Enchantment"
[fig. 2-48]

1935, Dec. 28:
"The Christmas Coach"
[fig. 2-49]

2-49

2-50

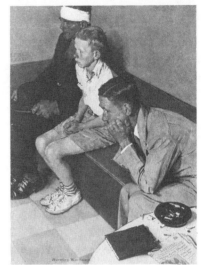

2-51

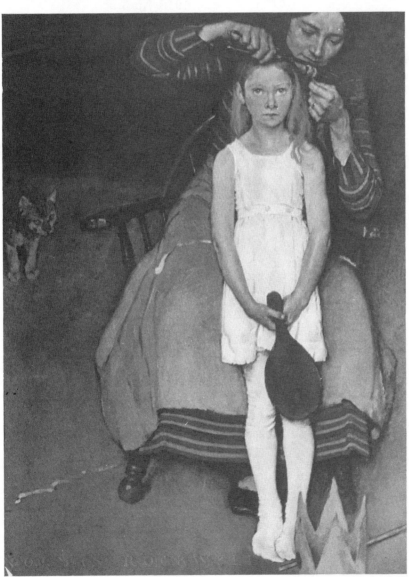

2-52

2-53

2-54

2-55

1936, Feb. 22:
 "The New Tavern Sign"
 [fig. 2-50]

1937, Oct. 16:
 ".22" (story)
 [fig. 2-51]

1937, Dec. 18:
 "Johanna's Christmas Star"
 [fig. 2-52]

1938, March 19:
 "Down-East Ambrosia"
 (article)
 [fig. 2-53]

1938, Dec. 24:
 "Doc Mellhorn and the
 Pearly Gates" (story)
 [fig. 2-54]

1939, May 27:
 "Jeff Raleigh's Piano Solo"
 (story)
 [fig. 2-55]

1939, Oct. 28:
 "Daniel Webster and the
 Ides of March" (story)
 [fig. 2-56]

1940, Jan. 27:
 "Man-Killer" (story)
 [fig. 2-57]

2-56

2-57

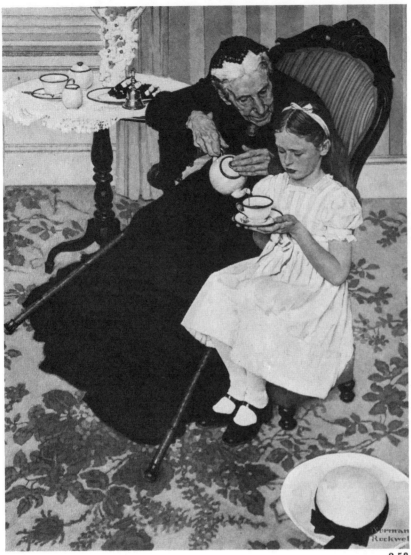

2-58

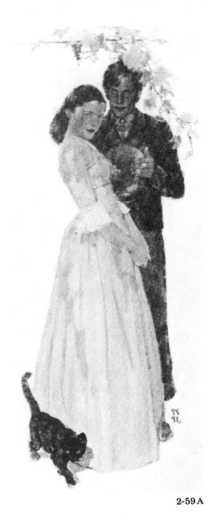

2-59 A

1940, May 11:
 "The Handkerchief" (story)
 [fig. 2-58]

1940, Sept. 21:
 "River Pilot" (story)
 [fig. 2-59 A, B]

1940, Oct. 26:
 "Next Week" mentions
 "Blacksmith's Boy"
 [fig. 2-60]

2-60

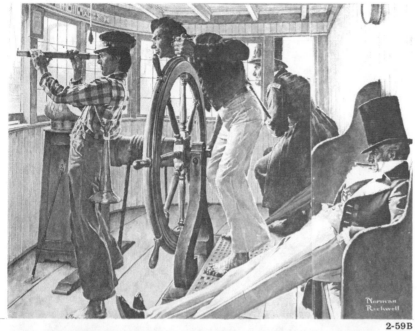

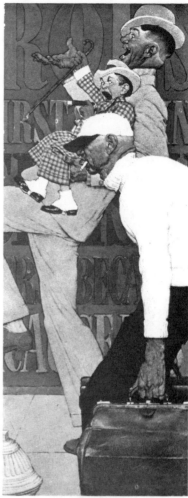

2-59B

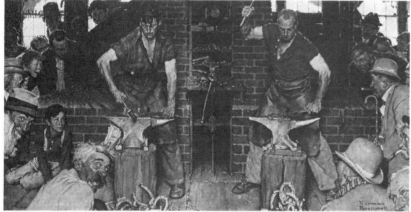

2-61

2-62B

1940, Nov. 2:
"Blacksmith's Boy—Heel
and Toe" (story)
[fig. 2-61]

1941, April 5:
"You Could Look It Up"
(story)
[fig. 2-62A, B, C]

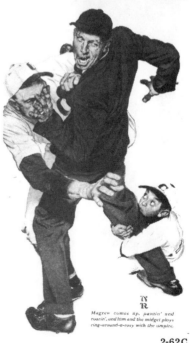

2-62A

2-62C

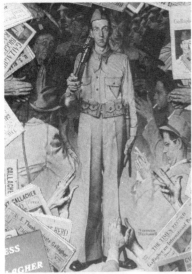

2-63

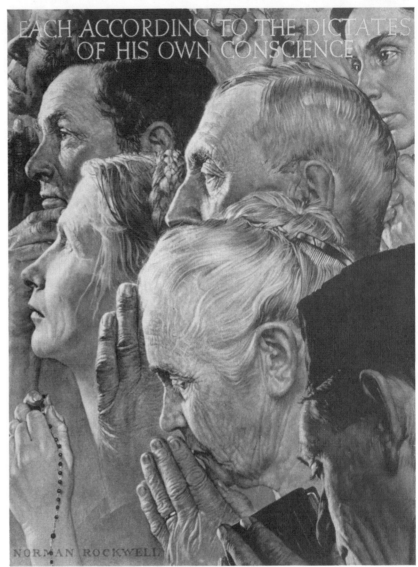

EACH ACCORDING TO THE DICTATES OF HIS OWN CONSCIENCE

NORMAN ROCKWELL

2-66

2-65

2-64

1941, Oct. 11:
 "The Goddess and Pvt.
 Gallagher" (story)
 [fig. 2-63]

1942, June 6:
 "Do You Know a Better
 Man?" (story)
 [fig. 2-64]

1943, Feb. 13:
 "Cover Man" (article about
 Rockwell)

2-67

1943, Feb. 21:
 "Freedom of Speech"
 [fig. 2-65]

1943, Feb. 27:
 "Freedom of Worship"
 [fig. 2-66]

1943, March 6:
 "Freedom from Want"
 [fig. 2-67]

1943, March 13:
 "Freedom from Fear"
 [fig. 2-68]

1943, May 8:
 "Night on a Troop Train"
 (article)
 [fig. 2-69]

1943, May 15:
 "Four Freedoms" shown
 with letter from President
 Roosevelt

1943, June 5:
 Photos showing "Four
 Freedoms" exhibited at
 War Bond show

2-68

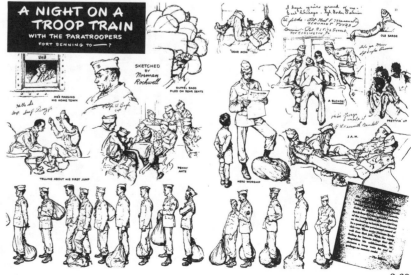

2-69

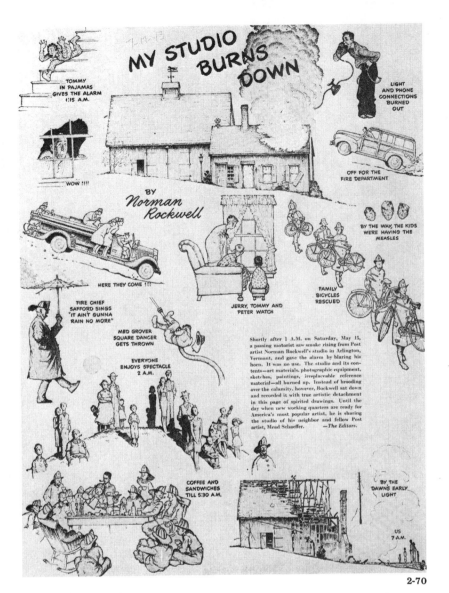

MY STUDIO BURNS DOWN

BY
Norman Rockwell

TOMMY IN PAJAMAS GIVES THE ALARM 1:15 A.M.

WOW !!!!

LIGHT AND PHONE CONNECTIONS BURNED OUT

OFF FOR THE FIRE DEPARTMENT

HERE THEY COME !!!

BY THE WAY, THE KIDS WERE HAVING THE MEASLES

JERRY, TOMMY AND PETER WATCH

FAMILY BICYCLES RESCUED

FIRE CHIEF SAFFORD SINGS "IT AIN'T GUNNA RAIN NO MORE"

MED GROVER SQUARE DANCER GETS THROWN

EVERYONE ENJOYS SPECTACLE 2 A.M.

Shortly after 1 A.M. on Saturday, May 15, a passing motorist saw smoke rising from Post artist Norman Rockwell's studio in Arlington, Vermont, and gave the alarm by blaring his horn. It was no use. The studio and its contents—art materials, photographic equipment, sketches, paintings, irreplaceable reference material—all burned up. Instead of brooding over the calamity, however, Rockwell sat down and recorded it with true artistic detachment in this page of spirited drawings. Until the day when new working quarters are ready for America's most popular artist, he is sharing the studio of his neighbor and fellow Post artist, Mead Schaeffer.
—*The Editors.*

COFFEE AND SANDWICHES TILL 5:30 A.M.

BY THE DAWNS EARLY LIGHT

US 7 A.M.

2-70

SO YOU WANT TO SEE THE PRESIDENT!

By NORMAN ROCKWELL

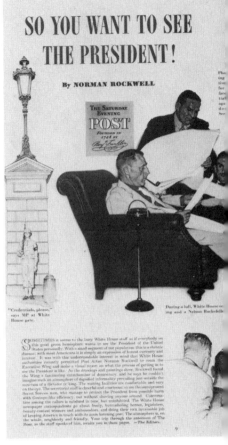

"Credentials, please," says MP at White House gate.

During a lull, White House ... ing a Nelson Rockefelle

SOMETIMES it seems to the busy White House staff as if everybody in the good green hemisphere wants to see the President of the United States personally. With a small segment of our impression this is a chronic disease; with most Americans it is simply an expression of honest curiosity and interest. It was with this understandable interest in mind that White House authorities recently permitted Post Artist Norman Rockwell to roam the Executive Wing and make a visual report on what the process of getting in to see the President is like. As the drawings and paintings show, Rockwell found the Wing's functioning cornucopia of democracy, and he says he couldn't imagine such an atmosphere of dignified informality prevailing just outside the sanctum of a dictator or king. The waiting facilities are comfortable and easy on the eye. The secretarial staff is cheerful and courteous to see the omnipresent Secret Service men, who manage to protect the President from possible harm with Gestapo-like efficiency, yet without shaving anyone around. Conversation among the callers is subdued in tone, but uninhibited. The White House newspaper correspondents go about freely, buttonholing heroes, legislators, beauty-contest winners and ambassadors, and doing their own inestimable job of keeping America in touch with its goings becoming past. The atmosphere is, on the whole, neighborly and friendly. Your trip through the anterooms of The Boss, as the staff speaks of him, awaits you in these pages. —*The Editors.*

2-72

2-73

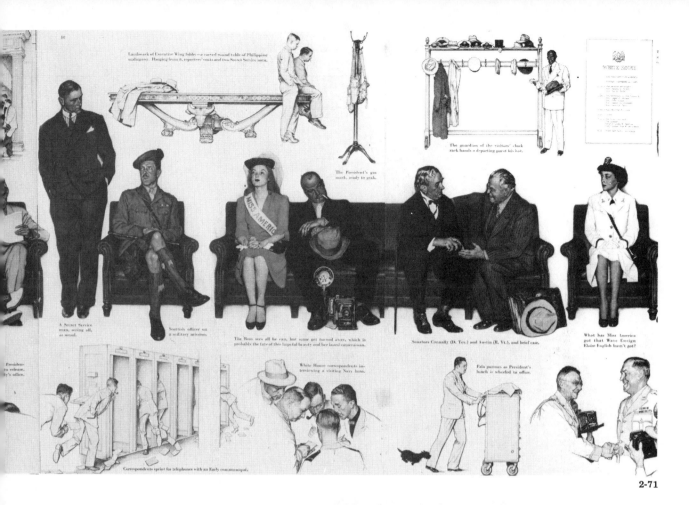

2-71

NORMAN ROCKWELL PAINTS

AMERICA AT THE POLLS

2-74

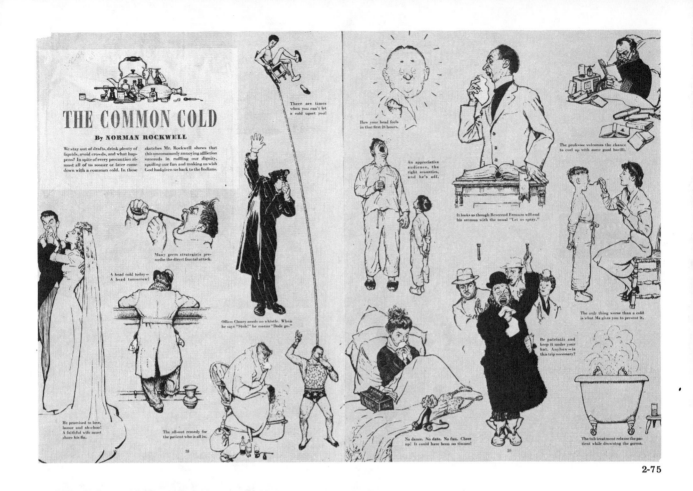

2-75

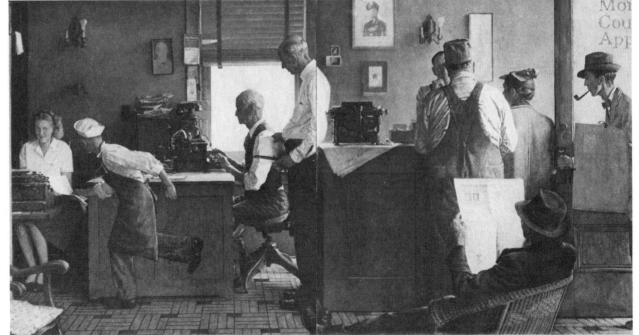

2-77A

2-77B

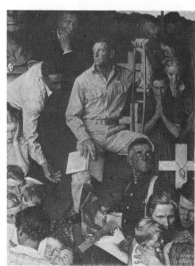

2-76

2-78

1945, Jan. 27:
 "The Common Cold"
 [fig. 2-75]

1945, Feb. 10:
 "The Long Shadow of
 Lincoln" (poem)
 [fig. 2-76]

1946, May 25:
 "Norman Rockwell Visits
 a Country Editor"
 [fig. 2-77A, B]

1946, July 13:
 "Maternity Waiting Room"
 [fig. 2-78]

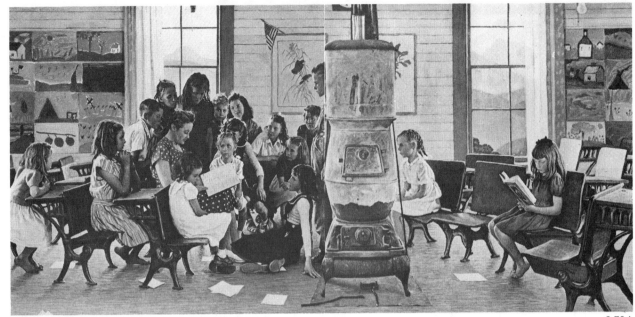

2-79A

2-79B

2-80A

2-80B

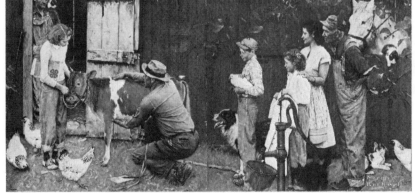

2-81A

2-81B

2-82

1963, Oct. 26:
Portrait of Jackie
Kennedy
[fig. 2-84]

1967, Oct. 21:
"Fifty Years Ago" shows
a 1917 *Post* cover

The following *Saturday
Evening Post* illustrations are
reproductions of previously
published work:

1971, Fall:
"An Essay on Humor in
Politics"

1971, Winter:
"Freedom of Religion"
"Take a Chance on
Democracy"

1972, Spring:
"Story Behind Norman
Rockwell Cover"

1972, Summer:
"P. K. Wrigley: Baseball
Magnate"

1972, Fall:
"The New Life of Norman
Rockwell"
"A Very Good Year"
"The Case for the
Independent College"

1973, March-April:
"The Four Freedoms"

1973, Sept.-Oct.:
Robert Charles Howe and
Norman Rockwell
"The Care and Feeding of
Sacred Cows"

2-83

1973, Winter:
"A Norman Rockwell Idyll: Stockbridge, Mass."

1974, Jan.:
"Doc Mellhorn and the Pearly Gates" (same as 12-24-38)

1974, March:
"Happy Birthday Norman Rockwell"

2-84

1974, Dec.:
"Mother Christmas" (same as 12-18-37)

1975, March:
"Fidgets" (hobo and dog)

1975, July-Aug.:
"200 Years of Girl Watching"

1975, Nov.:
"They Signed Away Their Lives for You"

1976, April:
"You Could Look It Up" (same as 4-5-41)

1976, May-June:
"The Face of a Nation" (60th anniversary)

1976, July-Aug.:
"Eulogy" (J. F. K. portrait)
"Reprieve for Jemmy and James"
"Thus Man Learned to Fly"
"Sports and Pastimes"
"My Boyhood"
"Classic Books of America"

1976, Sept.:
"Beautiful Changes in Different Keys"

1976, Nov.:
"America's Love Affair with the Automobile"

1976, Dec.:
"A Portfolio of Rockwell Santas"
"Merry Christmas"

1977, Feb.:
"How Never to be Late Again"
"Heartland" poem by Paul Engle
"Norman Rockwell Looks at Love"

1977, March:
"Grandparents as Educators" (same as 5-11-40)

1977, April:
"Schoolmaster to a Nation"

1977, July-Aug.:
"Adventures of the Mind"
"Whodunits"
"Conflict"
"My Life as an Illustrator" (excerpt)

1977, Oct.:
"Imperfect Listener"

1977, Nov.:
"You Auto Take This Test"

1978, Jan.-Feb.:
"Artist in the Market Place"
"Sunny Side Up"
"Sew Your Own Cover Quilt"
"Model Americans"
"It Didn't Just Happen"
"The Narrative Element in Painting"

2-85

2-86B

2-87

She came to a sandmill, feeling none of the cold as she read the "delicious words"

2-88B

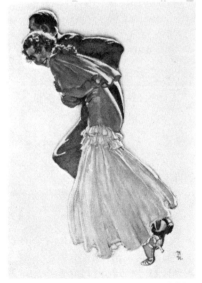

2-86A

But it was a girl!

2-88A

2-88C

2-88D

TRAVEL:

1915:
A series of illustrations
for McBride, Nast & Co.

VERMONT LIFE:

1947, Summer:
"Norman Rockwell's
Vermont"

1948, Spring:
"Freeman's Oath"

WOMAN'S DAY:

1965, June:
"A Sketch Book of Dog
Portraits"
[fig. 2-85]

WOMAN'S HOME
COMPANION:

1933, Nov.:
"When Youth is Beautiful"
[fig. 2-86A, B]

1935, Nov.:
"Private Enterprise"
[fig. 2-87]

1937, Dec.:
"The Most Beloved American
Writer"
[fig. 2-88A, B, C, D]

TIME:

1971, June 14:
"Return of the *Post*"

1976:
"The American Presidents"

The next day was the beginning of a charming idyll

2-89A

Louisa and her publisher, Thomas Niles, were in their relations a good deal like Queen Elizabeth and Sir Francis Walsingham

2-90A

They selected it together

2-89B

2-90B

Saying goodbye that last day in the station in Paris, when a kiss was their last companion

2-89C

2-89D

Her diary chronicled: "See many people, and am very gay for a country mouse"

2-90C

2-91A

2-91B

2-91C

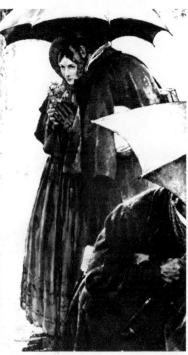

2-92B

2-92C

1938, Jan.:
"The Most Beloved American
Writer"
[fig. 2-89A, B, C, D]

1938, Feb.:
"The Most Beloved American
Writer"
[fig. 2-90A, B, C]

1938, Feb.:
"A Crock of Gold"
[fig. 2-91A, B, C]

1938, March:
"The Most Beloved American
Writer"
[fig. 2-92A, B, C]

2-92A

"How much is that dog?"
Jane asked the blind
man who was not blind

norman rockwell

2-93

2-94

2-95

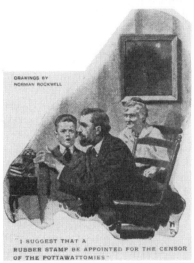

2-96

1917, May 17:
"The Plattsburgers,"
Chapter 5

1917, May 24:
"The Plattsburgers,"
Chapter 6

1917, May 31:
"The Plattsburgers,"
Chapter 7

1917, June 7:
"The Plattsburgers,"
Chapter 8

1917, June 14:
"The Plattsburgers,"
Chapter 9

1917, June 21:
"The Plattsburgers,"
Chapter 10

1917, Aug. 16:
"Sass in White Envelopes"
[fig. 2-96]

1917, April 26:
"The Plattsburgers,"
Chapter 2
[fig. 2-95]

1917, May 3:
"The Plattsburgers,"
Chapter 3

1917, May 10:
"The Plattsburgers,"
Chapter 4

3
Book Illustrations

Norman Rockwell was commissioned to illustrate 36 books between 1912 and 1940. It is interesting to note that he illustrated very few books following the publication in 1936 of *The Adventures of Tom Sawyer* and in 1940 of *Huckleberry Finn*. Known exceptions were *George Horace Lorimer*, *Poor Richard's Almanack*, and *Willy Was Different*, the latter co-authored with his wife Molly in 1967.

Many of the books listed in this chapter contain reproductions of his work previously published on magazine covers, greeting cards, in advertisements, and as story illustrations. The number of illustrations is a count of Rockwell illustrations only; in some cases the books contain numerous illustrations by other artists. See also the books listed in Chapter Twelve, as many of them are illustrated with Rockwell paintings.

1912:
Claudy, C. H.
TELL ME WHY STORIES
Published by McBride Nast
& Company, 1912 and 1913
Eight illustrations
[fig. 3-1]

1912:
Cave, Edward
THE BOY SCOUTS
HIKE BOOK
Published by Doubleday-
Page

1912:
Jackson, Gabrielle
THE MAID OF MIDDIE'S
HAVEN
Published by McBride Nast
and Company
Four illustrations

3-1

1913:
Cave, Edward
THE BOY SCOUTS
HIKE BOOK
Published by Doubleday-
Page
Over 80 illustrations

1913:
Wilson, John Fleming
TAD SHELDON'S
FOURTH OF
JULY
Published by Macmillan
Company, 1913 and 1919
Four illustrations

1914:
Cave, Edward
THE BOY SCOUTS
CAMP BOOK
Published by Doubleday-
Page
Fifty illustrations

1914:
Tomlinson, Everett T.
SCOUTING WITH
DANIEL BOONE
Published by Doubleday-
Page
Second edition published by
Grosset & Dunlap, Inc.
Hardbound,
eight illustrations

1915:
Barbour, Ralph Henry
THE LUCKY SEVENTH
Published by D. Appleton
and Company
Four illustrations

1915:
Barbour, Ralph Henry
THE SECRET PLAY
Published by D. Appleton
and Company
Hardbound,
four illustrations

1915:
Camp, Walter
DANNY THE FRESHMAN
Published by D. Appleton
and Company
Four illustrations

1915:
Dawson, Alec John
JAN: A DOG AND A
ROMANCE
Published by Harper
& Brothers
Hardbound, one illustration

1915:
Gregor, Russell
THE RED ARROW
Published by Harper
& Brothers
Hardbound,
four illustrations

1915:
Heylinger, William
DON STRONG OF THE
WOLF PATROL
Published by D. Appleton
and Company, 1915,
1916, and 1918 for
the Boy Scouts of America
Four illustrations

1915:
Lewis, Sinclair
THE TRAIL OF
THE HAWK
Published by Harper
& Brothers
One illustration

1915:
Paulist Fathers
CHRISTMAS BOOKLET
Published by the Paulist
Fathers
Four illustrations

1915:
Youth's Companion
HANDBOOK ON CAMPING
Published by Youth's
Companion

1916:
Lutz, Grace
VOICE IN THE
WILDERNESS
Published by Harper
& Brothers
One illustration

1916:
Sawyer, Ruth
THIS WAY TO
CHRISTMAS
Published by Harper
& Brothers
One illustration

1917:
Barbour, Ralph Henry
HITTING THE LINE
Published by D. Appleton
and Company
Four illustrations

1917:
Chaney, Edward D.
SCOTT BURTON,
FORESTER
Published by D. Appleton
and Company

1917:
Oursler, Will
THE BOY SCOUT STORY
Published by Doubleday &
Company, Inc.
Hardbound, dust jacket
[fig. 3-2]

3-2

1917:
Pier, Arthur Stanwood
THE PLATTSBURGERS
Published by Houghton
Mifflin Company
Four illustrations

1918:
Barbour, Ralph Henry
KEEPING HIS COURSE
Published by D. Appleton
and Company
Four illustrations

1918:
Barbour, Ralph Henry
THE PURPLE PENNANT
Published by D. Appleton
and Company
Four illustrations

1918:
Comstock, Raymond
LADS WHO DARED
Published by G. P. Putnam's
and Sons
Four illustrations

1918:
Mathiews, Frank K.
BOY SCOUTS
COURAGEOUS
Published by Barse &
Hopkins

1919:
BOY SCOUT YEARBOOK
Published by the Boy
Scouts of America
Four illustrations first
published in RED CROSS
Magazine

1919:
THE SATURDAY
EVENING POST
(One issue of the magazine
in hardcover book form)
Published by the Curtis
Publishing Company
One illustration

1920:
Jackson, Gabrielle E.
PEGGY STEWART NAVY
GIRL, AT HOME
Published by G. P. Putnam's
and Sons
One illustration

1921:
Mathiews, Frank K.
BOY SCOUT BOOK OF
CAMPFIRE STORIES
Published by the Boy Scouts
of America

1921:
U.S. Navy
THE MAN: U.S. NAVY
ACADEMY YEARBOOK
Published by the U.S. Navy
One illustration

1923:
Cave, Edward
BOY SCOUT HIKE BOOK
AND CAMP BOOK
Published by Doubleday-
Page
Over 100 illustrations

1924:
ADVERTISING ARTS AND
CRAFTS
Easter edition
One illustration

1924:
THIRD ANNUAL OF
ADVERTISING ART IN
THE U.S.A.
Published by the Art
Directors Club, New York
Two illustrations

1925:
FOURTH ANNUAL OF
ADVERTISING ART IN
THE U.S.A.
Published by the Art
Directors Club, New York
Three illustrations

1927:
West, James E.
THE LONE SCOUT
OF THE SKY
Published for the Boy Scouts
of America by the John
C. Winston Company
Hardbound, one illustration

1928:
BOY SCOUT HANDBOOK
Published by the Boy Scouts
of America 1928, 1943,
1959—1928 illustration
same as 1929 Boy Scout
calendar; 1943 illustration
same as 1939 Boy Scout
calendar; 1959 illustration
same as 1959 Scouting
Magazine

1929:
THE PAGEANT OF
AMERICA, VOL. VII
Published by Yale University
Press
One illustration

1931:
Douglas, Lester
COLOR IN MODERN
PRINTING
Published by F. H. Levey
Company
One illustration

1935:
SCOUT ADMINISTRATOR
Published by the Boy Scouts
of America
Cover illustration

1936:
Ailer, Stanford, and
Wenterich
COLOPHON
Published by Pynson Printers
Contains the article
"Before, or After?"

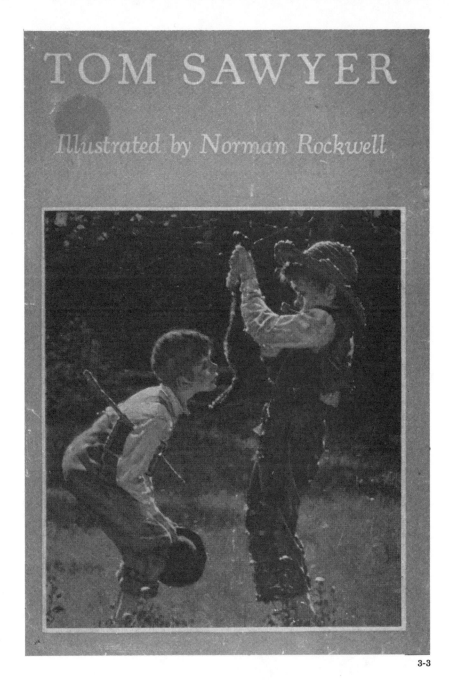

3-4

3-3

1936:
Twain, Mark
THE ADVENTURES OF
TOM SAWYER
Published by Heritage Press
Eight illustrations
[fig. 3-3]

1940:
Twain, Mark
THE ADVENTURES OF
HUCKLEBERRY FINN
Published by Heritage Press
Eight illustrations

1944:
The Saturday Evening Post
POST YARNS
Published by the Curtis
Publishing Company,
1944 and 1945
[fig. 3-4]

1945:
Craine, Aimee, editor
PORTRAIT OF AMERICA
Published by Duell, Sloan
Two illustrations

1948:
Tebbel, John
GEORGE HORACE
LORIMER
Published by Doubleday
& Company, Inc.
Hardbound, several
illustrations

1952:
Twain, Mark
THE ADVENTURES OF
TOM SAWYER AND
HUCKLEBERRY
FINN
Published by Heritage Press
One volume, hardbound,
eight illustrations

1953:
FORD AT FIFTY: AN
AMERICAN STORY
Published by Simon &
Schuster, Inc.
Hardbound, dust jacket,
two illustrations

1954:
DEN CHIEF'S DENBOOK
Published by National Cub
Scout Council, 1954, 1959,
and 1965
[fig. 3-5]

3-5

1954:
Nevins, Allan
FORD: THE TIMES, THE
MAN, THE COMPANY
Published by Charles
Scribner's Sons, 1954
Illustration on reverse
of dust jacket

1954:
THE SATURDAY
EVENING POST
TREASURY
Published by the Curtis
Publishing Company
Reprinted by Simon &
Schuster, Inc., 1974
Includes several *Post* covers

1958:
The Saturday Evening Post
CARNIVAL OF HUMOR
Published by the Curtis
Publishing Company

1958:
Yates, Elizabeth
THE LADY FROM
VERMONT
Published by the Stephen
Greene Press, 1958 and 1971
One illustration (cover)

1959:
Boy Scouts of America
THE GOLDEN
ANNIVERSARY BOOK OF
SCOUTING
Published by Golden Press,
Cover illustration
[fig. 3-6]

3-6

1960:
SCOUTMASTERS
HANDBOOK
Published by Boy Scouts

1961:
Rockwell, Norman
THE NORMAN
ROCKWELL ALBUM
Published by Doubleday
& Company, Inc.
Many illustrations

1964:
Franklin, Benjamin
POOR RICHARD: THE
ALMANACKS FOR THE
YEARS 1733-1758
Published by George Macy
Companies, Inc. for the
Limited Editions Club
(1,500 copies) in 1964;
published by Paddington
Press, Ltd., 1976.
Six paintings, 40 drawings
[fig. 3-7]

1966:
Hallmark
CHRISTMAS TREASURES
Published by Hallmark
Cards, Inc.
Three illustrations

1966:
Krepps, Robert W.
STAGECOACH
Published by Fawcett, Inc.
Paperback with cover
illustration

1967:
Rockwell, Molly and
Norman
WILLIE WAS DIFFERENT
Published by Funk
and Wagnall
Hardbound, dust jacket,
many illustrations

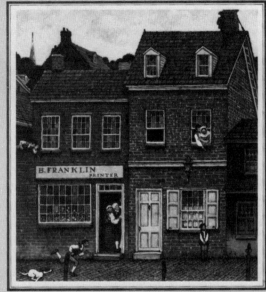

3-7

3-8

1974:
Twain, Mark
THE ADVENTURES OF
TOM SAWYER and THE
ADVENTURES OF
HUCKLEBERRY FINN
Published by American
Heritage Publishing
Company
Hardbound, two volumes,
slipcased
[fig. 3-9]

3-9

1975:
CHILDCRAFT: WORLD
BOOK
Published by World Book
Encyclopedia
One illustration

1975:
THE J. C. LEYENDECKER
POSTER BOOK
Published by Watson-Guptill
Publications, Inc.
Introduction and one illus-
tration by Norman Rockwell

1975:
Schau, Michael
ALL-AMERICAN GIRL
Published by Watson-Guptill
Publications
Contains Rockwell portrait
of illustrator Coles Phillips

1975:
OFFICIAL BASEBALL
RULES
Published by Sporting
News Publishing Company

1976:
Mendoza, George
NORMAN ROCKWELL'S
AMERICANA A B C
Published by Noble,
paperback edition by Dell

1976:
NORMAN ROCKWELL'S
BOYS AND GIRLS
AT PLAY
Published by Harry N.
Abrams, Inc.

1976:
The Saturday Evening Post
THE AMERICAN STORY
Published by Curtis
Publishing Company
Forty-two illustrations
[fig. 3-10]

3-10

1976:
Schau, Michael
NORMAN ROCKWELL
POSTER BOOK
Published by Watson-Guptill
Publications, Inc.

1976:
Turgeon, Charlotte and
F. A. Birmingham
THE SATURDAY
EVENING POST
ALL-AMERICAN
COOKBOOK
Published by Curtis
Publishing Company and
Thomas Nelson,
Inc.
Eight illustrations
[fig. 3-11]

3-11

1976:
THE SATURDAY
EVENING POST
CHRISTMAS BOOK
Published by Curtis
Publishing Company
Twenty-seven illustrations
[fig. 3-12]

3-12

3-13

1977:
Finch, Christopher
ONE HUNDRED TWO
FAVORITE PAINTINGS
BY NORMAN ROCKWELL
Published by Crown
Publishers, Inc., revised
edition, 1978

1977:
Hillcourt, William
NORMAN ROCKWELL'S
WORLD OF SCOUTING
Published by Harry N.
Abrams, Inc.
Many reproductions of
earlier Boy Scout paintings

1977:
Holden, Donald (editor)
THE SECOND
NORMAN ROCKWELL
POSTER BOOK
Published by Watson-Guptill
Publications

1977:
Rockwell, Molly Punderson
(editor)
NORMAN ROCKWELL'S
CHRISTMAS
Published by Harry N.
Abrams, Inc.

1977:
Taborin, Glorina
NORMAN ROCKWELL'S
COUNTING BOOK
Published by Harmony

1977:
THE SATURDAY
EVENING POST
AUTOMOBILE BOOK
Published by Curtis
Publishing Company
Six illustrations
[fig. 3-13]

1977:
THE SATURDAY
EVENING POST
MOVIE BOOK
Published by Curtis
Publishing Company
Seven illustrations
[fig. 3-14 next page]

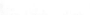

3-14

1977:
THE SATURDAY
EVENING POST
NORMAN ROCKWELL
BOOK
Published by Curtis
Publishing Company
Many illustrations
[fig. 3-15]

1978:
Finch, Christopher
FIFTY NORMAN
ROCKWELL FAVORITES
Published by Crown
Publishers, Inc.

1978:
POST SCRIPTS-HUMOR
FROM THE SATURDAY
EVENING POST
Published by Curtis
Publishing Company
Cover illustration
[fig. 3-16]

1978:
THE SATURDAY
EVENING POST
ANIMAL BOOK
Published by Curtis
Publishing Company
Three illustrations
[fig. 3-17]

1978:
THE SATURDAY
EVENING POST
BOOK OF THE SEA
AND SHIPS
Published by Curtis
Publishing Company
Eight illustrations
[fig. 3-18]

3-15

3-16

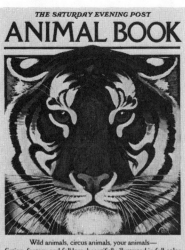

3-17

3-18

4
Advertisements

At one time, at least, it was Norman Rockwell's practice to charge twice as much for an advertising picture as for a magazine cover or illustration. Even the most prestigious publications could not compete with the sums big business was willing to pay good illustrators. Rockwell was good, so good that by the mid-'40s his income from publication art was sufficient to allow him to be somewhat indifferent to the lure of advertising art.

On occasion he would yield to the persuasion of big business, especially when given a free rein to use his talents on canvas. Crest Toothpaste, Massachusetts Mutual Life Insurance Company, and Ford Motor Company are examples of companies he worked with over a long period of time. It is most difficult to determine the exact number of advertisements Rockwell produced. By his own admission, for example, he drew in backgrounds—trees, grass, people—on almost one hundred photographs of tombstones for a catalog when he was eighteen. Ironically, among his last published ads was a series for Rock of Ages Corporation.

His first signed, published advertisement was for H. J. Heinz Pork and Beans. It appeared in the 1914 *Boy Scout Handbook.*

The rebirth of *The Saturday Evening Post* ignited a renewed interest in America's most loved artist. Old ads are now being reissued with new sales appeal. The reader's primary interest, however, is in the advertisements Rockwell was commissioned to create. Therefore, no attempt has been made here to include all the many recent advertisements that incorporate *Post* covers or other previously published Rockwell paintings in what are actually new advertisements.

Because there are so many of them, the Massachusetts Mutual Life Insurance Company advertisements are listed separately in the next chapter.

ADVERTISING ART
Magazine:

1933, Jan.:
Listerine, Picture Puzzles

AMERICAN Magazine:

1921, Jan.:
"The U.S. Army Teaches Trades"

1921, June:
Lime Crush, "The Bribe"

1921, Aug.:
Lemon Crush, "Home Run"

1922, Jan.:
Pratt & Lambert

1922, Dec.:
Pratt & Lambert

1923, March:
Jell-O, "It's So Simple"

1923, Dec.:
Pratt & Lambert

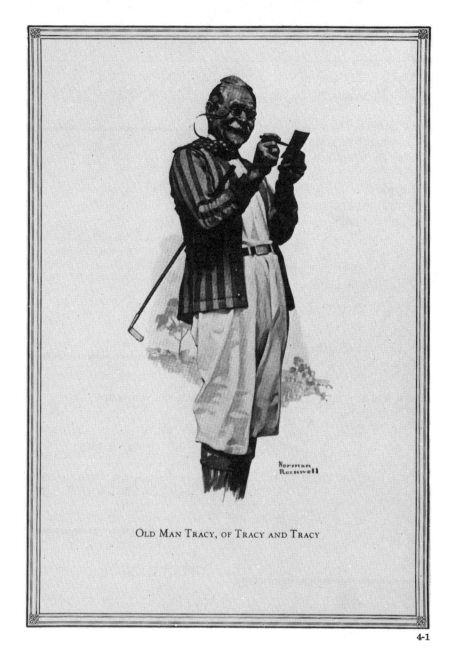

OLD MAN TRACY, OF TRACY AND TRACY

4-1

4-2

1924, May:
Colgate Toothpaste,
"If Your Wisdom Teeth—"

1924, May:
Pratt & Lambert

1924, Dec.:
Pratt & Lambert

1925, June:
Pratt & Lambert

1925, Aug.:
Post Bran Flakes, "Grocer"

1926, July:
Dutchess Trousers,
"Golfer"
[fig. 4-1]

1926, Oct.:
Dutchess Trousers,
"Boy and a Dog"
[fig. 4-2]

1926, Nov.:
Dutchess Trousers,
"Surveyor"

1928, June:
Coca-Cola, "Wholesome
Refreshment"

1929, April:
Mennen Shave Cream,
"Norman Rockwell Tells
Jim Henry"

1929, Dec.:
Listerine, "The Same
Advice I Gave Your Dad"
(unsigned)

1931, March:
Listerine, "The Same
Advice I Gave Your Dad"
(unsigned)

1937, June:
Beech-Nut Gum,
"Worth Stopping For"

1939, Aug.:
General Motors Installment Plan, "Just A Minute Young Feller"

1940, Nov.:
Norman Rockwell says, "I'll Take Wine"

1943, Sept.:
Listerine, "The Same Advice I Gave Your Dad"

1949, March:
A. T & T., "He Helps to Get the Message Through."

1953, Oct.:
A. T. & T., "He Helps to Get the Message Through."

AMERICAN ARTIST:

1940, May:
"Norman Rockwell Recommends Schmincke Artists' Oils"

1950, March:
Norman Rockwell for Schiva paints

1956, June:
"They Drew Their Way"

1970, Summer:
"Norman Rockwell Says, 'Permalba' "

1971, Dec.:
Famous Artists School

1976, July:
"Happy Birthday America" Limited Edition Prints

AMERICAN BOY Magazine:

1917, June:
Fisk Rubber Company, Fisk Bicycle Club

1917, Aug.:
Fisk Rubber Company, Fisk Bicycle Club

1918, May:
Fisk Rubber Company, "The Winner"

1919, May:
Fisk Rubber Company, Fisk Bicycle Club

1919, July:
Fisk Rubber Company, "Always Something Doing . . . "

1920, April:
Goodrich Bicycle Tires, "Hey Fellers!"

1920, May:
Fisk Rubber Company

1921, June:
Lemon Crush, "Home Run"

AMERICAN COOKERY:

1922, Oct.:
Jell-O, "It's So Simple"

AMERICAN HOME:

1940, Dec.:
General Motors Installment Plan, "Just a Minute Young Feller"

AMERICAN LEGION WEEKLY:

1920, Nov. 19:
"U.S. Army Teaches Trades"

AMERICAN NEEDLEWOMAN:

1923, Dec.:
Jell-O, A little girl and her doll, "It's So Simple"

1949:
A. T. & T., "He Helps to Get The Message Through"

ARGOSY Magazine:

1976, April:
Budweiser, "When Gentlemen Agree," (one Rockwell in a reproduced series of 26 miniature ads)

ART DIGEST:

1940, May:
Norman Rockwell recommends M. Grumbacher paints.

ATLANTIC MONTHLY:

1923, March:
Romance Chocolates, (young couple on sofa) [fig. 4-3]

4-3

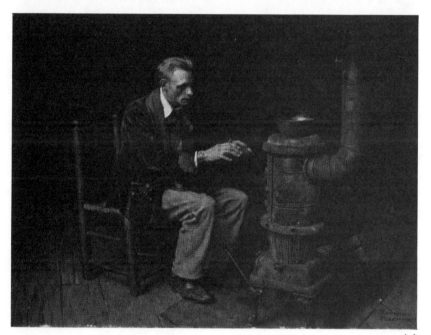

4-4

1929, Dec.:
 Listerine, "The Same
 Advice I Gave Your Dad"

1935, Feb.:
 Listerine, "Listerine
 for You Young Man"

1950, Dec.:
 Du Mont Laboratories, Inc.,
 "Enchanted Lady"

1951, Dec.:
 Plymouth, "Merry
 Christmas Grandma!"

1958, Oct.:
 Crest Toothpaste,
 "Douglas Morgan"

1974, Nov.:
 Crest Toothpaste,
 "Douglas Morgan"
 [fig. 4-5]

4-5

1923, June:
 Lowe Brothers Paint,
 "Good for Another
 Generation"

BETTER HOMES
& GARDENS:

1929, March:
 Anaconda

1929, April:
 Capitol Boilers, "The
 Melody Stilled by Cold"
 [fig. 4-4]

BETTER LIVING:

1935, March:
 Swift's Baby Food

BOYS' LIFE Magazine:

1917, Feb.:
 Fisk Rubber Company,
 "Plan now for your summer"

1917, June:
Fisk Rubber Company,
"Fisk Club News"

1918, May:
Fisk Rubber Company

1918, July:
Fisk Rubber Company

1919, July:
Fisk Rubber Company,
three boys swimming

1919, Sept.:
Fisk Rubber Company,
boy on bicycle

1919, Nov.:
Kanee Shirt Company,
"Make You Look All
Dressed Up"

1926, May:
"Boys and Girls First
Aid Week"

1929, Jan.:
"The Spirit of America,"
Boy Scout Calendar

1929, June:
Coca-Cola, "Wholesome
as Play"

BOY SCOUT HANDBOOK:

1914:
H. J. Heinz Company,
Pork and Beans
(first published
advertisement)

CENTURY Magazine:

1923, March:
Romance Chocolates,
"From the Most Critical
Group in America"

1923, April:
Romance Chocolates,
(girl on the steps)

CHRISTIAN HERALD:

1917, July 4:
Fisk Rubber Company,
Fisk Bicycle Clubs
[fig. 4-6]

4-6

1924, April 19:
Quaker Puffed Wheat,
"That Million Dollar
Boy of Yours"

COLLEGE HUMOR Magazine:

1929, June:
Mennen Shave Cream,
"Norman Rockwell tells
Jim Henry"

COLLIER'S:

1924, March 22:
Fisk Rubber Company
[fig. 4-7]

1924, Aug. 23:
Fisk Rubber Company
[fig. 4-8]

1929, Aug. 31:
Ticonderoga Pencil Company
[fig. 4-9]

1930, Dec. 13:
Brunswick Billiards

1932, July 30:
Crowell Publishing Company

1935, May 4:
Campbell's Tomato Juice
[fig. 4-10]

1936, Dec. 12:
Cream of Kentucky whiskey
(Schenley Industries, Inc.),
"How Keen are Your Eyes?"

1937, Feb. 13:
Cream of Kentucky,
"Are Your Eyes as Keen
as a Colonel's?"

1937, Jan. 5:
Cream of Kentucky,
"Have You Eyes?"

1937, March 13:
Cream of Kentucky, "Have
You Enthusiastic Eyes?"

1937, Sept. 11:
Cream of Kentucky,
"Have You the Thinker's
Eyes?"

1937, Oct. 9:
Cream of Kentucky,
"Earmarks of a Host"

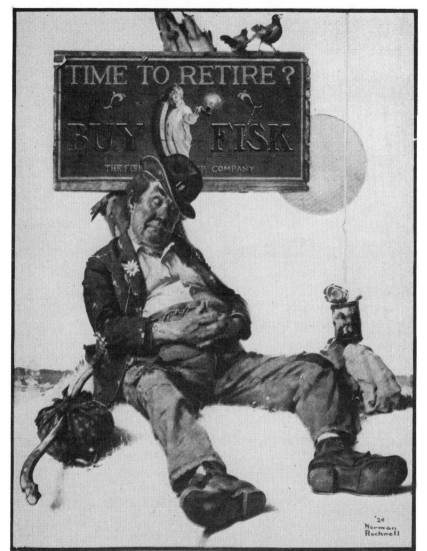

4-7

4-8

4-9

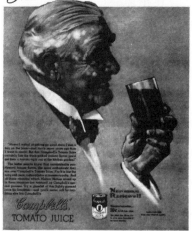

"That's the real tomato flavor!"

4-10

1937, Nov. 6:
 Cream of Kentucky,
 "Have You Eyes Like
 Frank Buck's?"

1937, Dec. 4:
 Cream of Kentucky,
 "James Barton"

1937, April 10:
 Cream of Kentucky,
 "Are You a Type with
 Imagination?"

1937, May 8:
 Cream of Kentucky,
 "Have You Eyes that
 Spot the Real Thing?"

1937, Sept. 11:
 Cream of Kentucky,
 "A Type Who Thinks Out"

1938, April 2:
 Cream of Kentucky, "The
 Face of Watson Barratt"

1938, Dec. 24:
 Cream of Kentucky,
 "If You Are This Type
 You'll Like This—"

1938, April 30:
Cream of Kentucky,
"Has Your Face These
Marks of Merit?"

1938, Feb. 5:
Cream of Kentucky,
"The Face of Jack
Buchanan"

1938, March 5:
Cream of Kentucky,
"Have You The Eyes?"

1938, June 25:
Cream of Kentucky,
"Double Rich"

1938, Oct. 15:
Cream of Kentucky,
"If You Have A Weather
Eye"

1939, Jan. 28:
Cream of Kentucky,
"Getting the Message"

1939, Feb. 25:
Cream of Kentucky,
"If You are this Type"

1939, March 18:
Cream of Kentucky, "Taste
The Record Breaking—"

1939, April 22:
Cream of Kentucky,
"Saving"

1939, May 20:
Cream of Kentucky,
"Double Rich"

1939, June 17:
Cream of Kentucky,
"Double Rich"

1939, Aug. 12:
Cream of Kentucky,
"Blindfolded"

1939, July 22:
Cream of Kentucky,
"Are You this Type?"

1939, Sept. 9:
Cream of Kentucky,
"Mint Julep"

1939, Nov. 9:
Cream of Kentucky,
"That Type's Bound To
Go Places"

1939, Dec. 2:
Cream of Kentucky,
"If You're High Spirited"

1939, Dec. 23:
Cream of Kentucky,
"There's a Double Reason"

1940, Feb. 24:
Cream of Kentucky,
"For Double Reason"

1940, March 23:
Cream of Kentucky,
"For Double Reason"

1940, April 20:
Cream of Kentucky,
"Look Forward to Pleasure"

1940, May 18:
Cream of Kentucky,
"The Kentucky Favorite"

1940, June 15:
Cream of Kentucky,
"Set Your Course"

1940, July 13:
Cream of Kentucky,
"Make Your Pleasure"

1940, Aug. 31:
General Motors Installment
Plan, "Just a Minute
Young Feller"

1940, Oct. 26:
Wine Advisory Board,
"I'll Take Wine"

1941, June 14:
Mobilgas, "Her Hero"
[fig. 4-11]

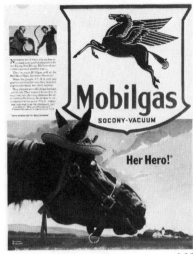

4-11

1945, Oct. 20:
Cream of Kentucky

1945, Oct. 20:
Listerine,
"Would a Veteran
Find You Here?"

1948, April 17:
Cream of Kentucky,
"Does Your Face. . .?"

1948, June 12:
Cream of Kentucky

1948, July 2:
Cream of Kentucky

1949, March 5:
A.T. & T.,
"He Helps to Get the
Message Through"

1950, Dec. 30:
Plymouth, "Merry
Christmas Grandma!"

1951, Dec. 29:
Plymouth, "Oh Boy!"

1955, Dec. 9:
 Sheaffer Pen

CONNOISSEUR Magazine:

1968, May:
 The Sporting Gallery,
 "The Piano Player"

CORONET Magazine:

1955, Dec.:
 Sheaffer Pen,
 "Home for Christmas"

COSMOPOLITAN:

1919, July:
 Post Grape-Nuts Cereal

1921, May:
 Orange Crush, "An Orange
 Crush"

1921, June:
 Lemon Crush, "Home Run"

1928, June:
 Coca-Cola, "Wholesome
 Refreshment"

1934, July:
 Budweiser, "When Gentle-
 men Agree" (unsigned)

1937, May:
 Beech-Nut Gum, "Worth
 Stopping For"

Now you'll like Bran!

4-12

4-13

COUNTRY GENTLEMAN:

1922, March 18:
 Cover contest

1923, March 3:
 Jell-O, "They Make It
 So Easy"

1925, Oct.:
 Post Bran Wheat Flakes

1925, Nov.:
 Post Bran Wheat Flakes
 [fig. 4-12]

1930, Dec.:
 Goodyear, "Think a Moment,
 Can You Stop?"
 [fig. 4-13]

1949, Sept. 12:
 Watchmakers of Switzerland

COUNTRY LIFE:

1924, May:
 Fisk Rubber Company,
 the hobo

1924, July:
 Fisk Rubber Company, boy,
 a dog and a fishing pole

1924, Sept.:
 Fisk Rubber Company, a dog
 chasing a cat

1924, Oct.:
 Fisk Rubber Company,
 sleeping sheriff

DELINEATOR:

1918, May:
 Borden's *Eagle Brand*
 Condensed Milk

ESQUIRE:

1937, May:
 Beech-Nut Gum, "Worth
 Stopping For"

EVERYWOMAN'S
Magazine:

1956, April:
 "Gratitude"

FAMILY CIRCLE:

1941, March 21:
 Niblets Corn, "His
 First"

1945, July 6:
 Film "Along Came
 Jones"

FAMOUS ARTIST
Magazine:

1962, Spring:
 Famous Artists School,
 "Talent Hunt Compe-
 tition"

FARM JOURNAL:

1955:
 Rock of Ages Memorial
 Stones, "Douglas"
 [fig. 4-14]

4-14

FARMER'S WIFE:

1923, Nov.:
 Jell-O, "They Make It
 So Easy"

1927, Nov.:
 Sun-Maid Raisins

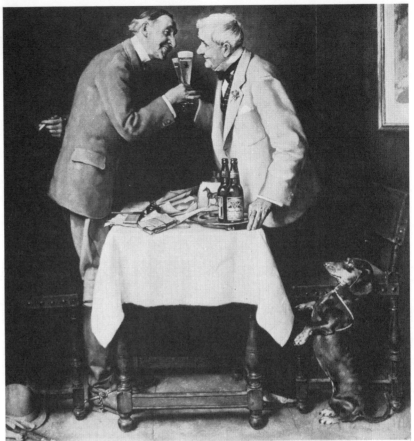

4-15

FORTUNE

1934, July:
 Budweiser, "When Gentle-
 men Agree" (unsigned)
 [fig. 4-15]

1934, Dec.:
 Campbell's Tomato Juice,
 "That's the Real Tomato"

1953, May:
 Roebling Wire, "There's
 Only One Reason"

1968, Feb.:
 Sharon Steel Corporation
 (East Coast edition only)

1968, March:
 Sharon Steel Corporation

1968, April:
 Sharon Steel Corporation

1968, May:
 Sharon Steel Corporation

1968, June:
 Sharon Steel Corporation

1968, July:
 Sharon Steel Corporation

1968, Aug.:
 Sharon Steel Corporation

1968, Sept.:
 Sharon Steel Corporation

1968, Oct.:
 Sharon Steel Corporation

1968, Nov.:
 Sharon Steel Corporation

1968, Dec.:
Sharon Steel Corporation

GOOD HOUSEKEEPING:

1917, Jan.:
Perfection Oil Heaters,
"Slipper Time is Father's
Resting Time"

1923, June:
Lowe Brothers Paint and
Varnish, "Good for
Another Generation"

1923, June:
Holmes and Edwards
Silver Co.

1924, April:
Pratt & Lambert

1924, Nov.:
Pratt & Lambert

1925, March:
Edison Mazda Lamps

1925, May:
Edison Mazda Lamps

1925, Oct.:
Edison Mazda Lamps,
"What a Convenience"

1925, Oct.:
Post Bran Flakes

1925, Dec.:
Edison Mazda Lamps

1925, Dec.:
Pratt & Lambert

1926, May:
Pratt & Lambert

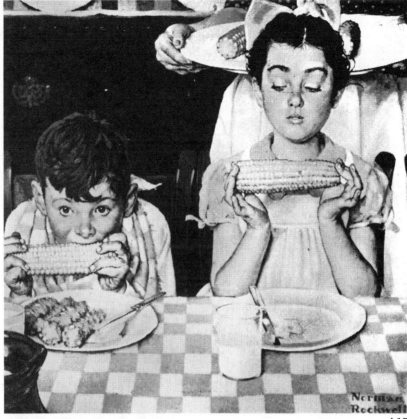

4-17

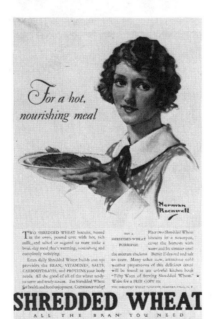

4-16

1926, Dec.:
Nabisco Shredded Wheat,
"For a hot, nourishing meal"
[fig. 4-16]

1926, Dec.:
Sun-Maid Raisins

1929, June:
Pratt & Lambert, "If
the neighbors can
stand it"

1940, May:
Niblets Corn, "Who's
Having More Fun?"
[fig. 4-17]

1941, April:
Niblets Corn, "His
First Corn on the Cob"

1950, Dec.:
Du Mont Laboratories, Inc.

1953, Feb.:
Heritage Book Club

1958, Sept.:
Crest Toothpaste

GRAPHIS:

1950, Aug.:
Du Mont Laboratories, Inc.

HARPER'S MONTHLY:

1917, Sept.:
Recreation Magazine
with Boy Scout in ad

1923, Feb.:
Jell-O, "It's So
Simple"

1923, March:
Romance Chocolates

1923, April:
Romance Chocolates

1923, June:
Lowe Brothers Paint
and Varnish, "Good
for Another
Generation"

1950, Aug.:
Du Mont Laboratories, Inc.,
"Enchanted Lands"

1953, Feb.:
Heritage Book Club

1953, July:
Ford Motor Company,
"American Road Series"

HOLIDAY Magazine:

1956, Oct.:
Pan American World
Airways, "The Thing to do
with Life is Live it."

HOUSE & GARDEN:

1928, Oct.:
Anaconda, N. R. and
his home

HOUSE BEAUTIFUL:

1922, Nov.:
Pratt & Lambert, "The
Cradle"
[fig. 4-18]

4-18

1923, June:
Lowe Brothers Paint
and Varnish

1923, Nov.:
Pratt & Lambert

1924, May:
Pratt & Lambert

1924, Nov.:
Pratt & Lambert

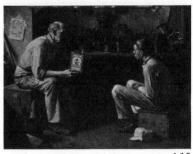
4-19

1925, June:
Pratt & Lambert
[fig. 4-19]

1926, June:
Pratt & Lambert

1926, June:
Elgin Watch Company,
"She Said It for a
Lifetime"

HOUSEHOLD Magazine:

1926, Dec.:
Nabisco Shredded Wheat,
"For That Nourishing Meal"

1927, May:
Sun-Maid Raisins, "The
More Raisins, the Better
the Pudding"

1927, Oct.:
Sun-Maid Raisins, "Lucky
the Sack's So Big"

1927, Nov.:
Sun-Maid Raisins, "The
More Raisins, the Better
the Pudding"

1928, March:
Sun-Maid Raisins, "Lucky
the Sack's So Big"

1930, Jan.:
 Listerine, "The Same
 Advice I Gave Your Dad"

1931, Dec.:
 Listerine, "The Same
 Advice I Gave Your Dad"

INDUSTRY WEEK:

1974, April 8:
 Sharon Steel Corporation
 [fig. 4-20]

1974, May 27:
 Sharon Steel Corporation

1974, June 3:
 Sharon Steel Corporation

1974, June 24:
 Sharon Steel Corporation

1974, July 8:
 Interlake, Inc., "The
 Gossips"

1974, Aug. 19:
 Sharon Steel Corporation

1974, Sept. 16:
 Interlake, Inc., "The
 Gossips"

1974, Sept. 30:
 Sharon Steel Corporation

1974, Oct. 21:
 Sharon Steel Corporation

1974, Nov. 11:
 Sharon Steel Corporation
 [fig. 4-21]

1974, Nov. 18:
 Sharon Steel Corporation
 [fig. 4-22]

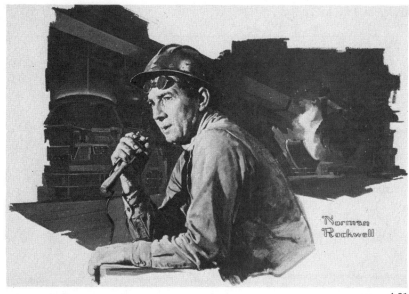

4-21

4-22

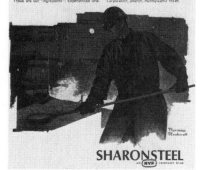

SHARONSTEEL

4-20

4-23

4-24

1974, Dec. 16:
 Sharon Steel Corporation

1975, Jan. 6:
 Sharon Steel Corporation
 [fig. 4-23]

1975, Jan. 20:
 Sharon Steel Corporation
 [fig. 4-24]

INLAND PRINTER:

1928, Feb.:
Dutchess Trousers
Company, "Old Man
Tracy"

INTERNATIONAL STUDIO
Magazine:

1923, Sept.:
Devoe Artist Materials

LADIES' HOME
JOURNAL:

1918, Sept.:
Borden's *Eagle Brand*
Condensed Milk

1920, Oct.:
Fleischmann Yeast Co.,
"Bread and Ambition"
[fig. 4-25]

1922, June:
Edison Mazda Lamps,
"The Party After the
Party"
[fig. 4-26]

1922, Aug.:
Edison Mazda Lamps

1922, Oct.:
Edison Mazda Lamps,
"The Children's Hour"

1922, Dec.:
Ladies' Home Journal,
Santa illustration

1923, Nov.:
Jell-O, "It's So
Simple"

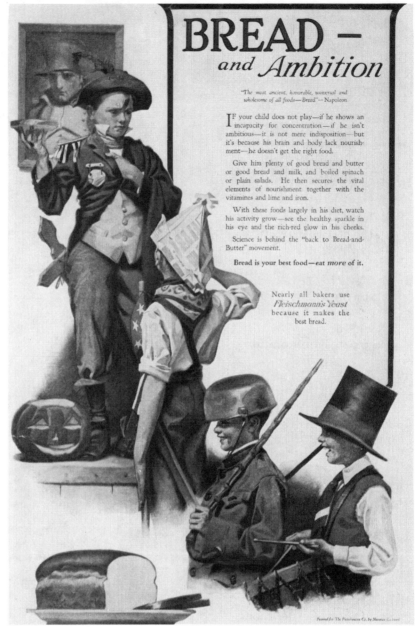

4-25

1924, June:
Quaker Puffed Wheat,
"That Million Dollar
Boy of Yours"

1924, July:
Colgate Toothpaste, "If
Your Wisdom Teeth
Could Talk"

1925, April:
Edison Mazda Lamp, "What
a Difference!"

1925, Sept.:
Edison Mazda Lamps, "But
You Have Light"

1925, Oct.:
Post Bran Flakes, "Now
You'll Like Bran"

4-26

4-27

4-28

4-29

1925, Oct.:
Edison Mazda Lamps, "The Candlemaker"
[fig. 4-27]

1925, Nov.:
Edison Mazda Lamps, "What a Convenience Electric Light is"

1926, June:
Elgin Watch Company, "She Said it for a Lifetime"

1926, Sept.:
Allen-A Hosiery, two boys singing

1926, Dec.:
Sun-Maid Raisins, "Seeded Raisins and Not Sticky!"

1927, April:
Nabisco Shredded Wheat

1927, May:
Wallace Silver Plate Company, "Up in the Hills"

1928, March:
Edison Mazda Lamps

1929, Dec.:
Listerine, "The Same Advice I Gave Your Dad"

1930, Aug.:
"Girls Club"

1934, Jan.:
Swift Baby Food "Delight"
[fig. 4-28]

1937, June:
Beech-Nut Gum, "Worth Stopping For!"

1939, May:
Niblets Corn, "Gee Whiz"

1943, Sept.:
Listerine (unsigned)

1944, Jan.:
Film, "Song of Bernadette," with Jennifer Jones

1956, Feb.:
Swift Baby Food, "Harmony"
[fig. 4-29]

1956, May:
Swift Baby Food, "Enjoyment"

1956, March:
Swift Baby Food, "Gratitude"

1956, July:
Swift Baby Food, "Afterglow"

1956, Aug.:
Swift Baby Food, "Delight"

1956, July:
Famous Artists Schools

1957, Aug.:
Crest Toothpaste, "Jimmy Ryan"

1957, Oct.:
Crest Toothpaste, "Danny Fay"

1957, Nov.:
 Crest Toothpaste, "Ronda
 Tupper"

1957, Dec.:
 Crest Toothpaste, "Bobby
 Banks"

1958, Feb.:
 Crest Toothpaste,
 "Patricia Patterson"

1958, April:
 Crest Toothpaste, "Mike
 Hayward"

1958, May:
 Crest Toothpaste, "Barbara
 Sullivan"

1958, June:
 Crest Toothpaste, "Janie
 Carroll"

1958, July:
 Crest Toothpaste, "Mark
 Barnett"

1958, Aug.:
 Crest Toothpaste, "Laura
 Webber"

1960, Jan.:
 Famous Artists Schools

1963, June:
 Skippy Peanut Butter

1974, Oct.:
 Crest Toothpaste, "Douglas
 Morgan"

1975, May:
 Crest Toothpaste, "Douglas
 Morgan"

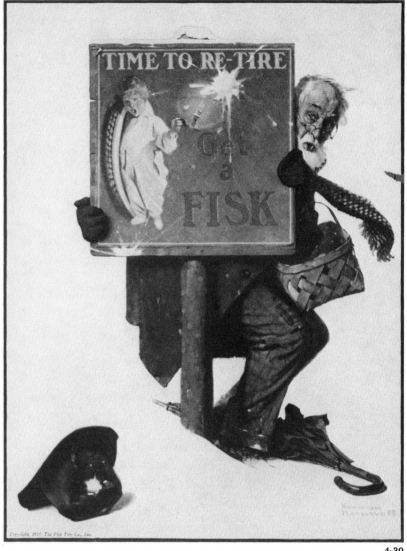

4-30

LIBERTY Magazine:

1924, May 10:
 Fisk Rubber Company,
 sleeping hobo

1925, Feb. 28:
 Fisk Rubber Company,
 "Time to Retire"
 [fig. 4-30]

1926, Sept. 4:
 Ticonderoga Pencil
 Company, "His First
 Pencil"

1928, May 26:
 Coca-Cola, "Wholesome
 Refreshment"

1929, Sept. 7:
 Ticonderoga Pencil
 Company, "You're
 A Lucky Lad"

1930, Sept. 13:
 Ticonderoga Pencil
 Company, "Ethan Allen
 and His Boys"

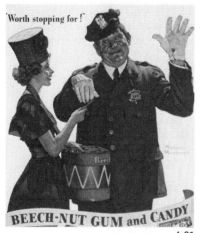

4-31

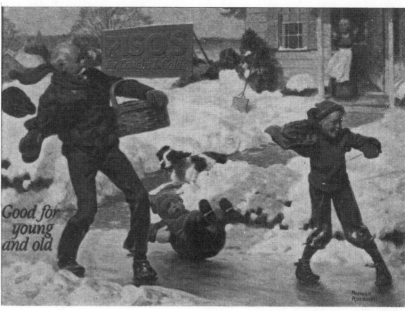

4-32

1937, April 10:
 Beech-Nut Gum, "Worth
 Stopping For"
 [fig. 4-31]

1938, Jan. 22:
 Cream of Kentucky, "Are
 You the Artistic Type?"

1938, April 16:
 Cream of Kentucky

1939, June 3:
 Cream of Kentucky, "If You
 Are This Type"

1939, June 10:
 General Motors
 Installment Plan

1939, Oct. 21:
 Cream of Kentucky

1939, Dec. 23:
 Cream of Kentucky,
 "Double Rich"

1949, Aug. 31:
 General Motors
 Installment Plan

1942, March 28:
 Cream of Kentucky, "Are
 You the Discriminating
 Type?"

LIFE (Humor Magazine):

1919, March 13:
 Life Subscription

1921, Feb. 17:
 Piso's Cough Syrup, Grandpa
 carrying basket
 [fig. 4-32]

1924:
 Fisk Rubber Company,
 "Time To Retire"

LIFE Magazine (New):

1937, Feb. 22:
 Cream of Kentucky, "Are
 Your Lips as Keen as a
 Colonel's?"

1937, March 8:
 Cream of Kentucky, "Have
 You Enthusiastic Eyes?"

1937, March 15:
 Cream of Kentucky, "Have
 You Eyes That Dream?"

1937, March 22:
 Cream of Kentucky, "Have
 You Lips That Make Good?"

1937, April 19:
 Cream of Kentucky,
 "Are You a Type
 With Imagination?"

1937, May 17:
 Cream of Kentucky,
 "Have You Eyes
 That Recognize News?"

1937, June 14:
 Cream of Kentucky, "Have
 You Knowing Eyes?"

1937, July 12:
 Cream of Kentucky, "Are
 You the Enthusiastic Type?"

1937, Aug. 30:
 Cream of Kentucky, "Do
 Your Lips Tell the World?"
 [fig. 4-33 *next page*]

1937, Oct. 4:
 Cream of Kentucky, "Have
 You an Eye for Good
 Business?"

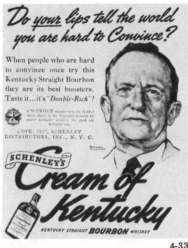

4-33

4-34

4-35

4-36

1937, Nov. 8:
Cream of Kentucky,
"Have You an Eye for
Good Business?"

1937, Nov. 22:
Cream of Kentucky, "Have
You The Eyes of A Great
Entertainer?"
[fig. 4-34]

1937, Dec. 27:
Cream of Kentucky,
"Are Your Ears Sensitive
to Applause?"

1939, June 19:
General Motors Installment
Plan, "I'll Figure"

1940, Feb. 12:
Cream of Kentucky, "For
Double Reason"

1940, March 25:
Cream of Kentucky, "For
Double Reason"

1940, April 29:
Cream of Kentucky, "Look
Forward to Pleasure With
Double-Rich Kentucky
Bourbon"
[fig. 4-35]

1940, May 27:
Cream of Kentucky,
"Way Out Front"
[fig. 4-36]

1940, June 10:
Cream of Kentucky,
"Set Your Course for
Double Rich"

1940, July 8:
Cream of Kentucky, "Make
Your Pleasure Double Rich"

1940, Aug. 12:
Cream of Kentucky, "Enjoy
A Frosty, Double Rich Mint
Julep"
[fig. 4-37]

1940, Aug. 26:
General Motors Installment
Plan, "I'll Figure"

1940, Nov. 4:
Norman Rockwell Says,
"I'll Take Wine"

1940, Nov. 4:
General Motors Installment
Plan, "Makes Good Sense
to Me"

1940, Nov. 11:
General Motors Installment
Plan, "Makes Good Sense
to Me"

1941, March 24:
Niblets Corn, "His First
Corn on the Cob"
[fig. 4-38]

1941, May 26:
Mobilgas, "Her Hero"

1942, Jan. 26:
Cream of Kentucky, "Are
You the Skeptical Type?"

1942, March 9:
Cream of Kentucky, "Are
You the Enthusiastic Type?"

1942, March 23:
Niblets Corn, "Boyhood
Eating Thrill—1893"

1942, April 6:
Cream of Kentucky

1942, May 4:
Cream of Kentucky,
"Are You the Type
Who Mixes Well?"

4-37

4-39

His First Corn on the Cob

How does this boy feel?
How did Columbus feel when he sighted San Salvador?
How did Edison feel when that light bulb glowed?
Notice the rapt look and repressed excitement in that face—
the expression of those hands.

When did you discover your first corn on the cob?
Have you discovered the modern, streamlined kind—with
all the gold of grandmaw's, but without the cob?
See next page for more about Niblets Brand Whole
Kernel Corn . . .

4-38

1949, Oct. 17:
Cream of Kentucky, "Have
You A Friendly Face?"

1949, Oct. 31:
Cream of Kentucky, "Does
Your Face Show Good
Judgment?"

1950, Aug. 7:
Du Mont Laboratories, Inc.

1950, Aug. 28:
Watchmakers of
Switzerland, "What
Makes It Tick?"

1950, Dec. 25:
Plymouth, "Merry
Christmas Grandma!"

1951, Dec. 24:
Plymouth, "Oh Boy!"

1952, Sept. 5:
Watchmakers of
Switzerland, "What
Makes It Tick?"

1953, Jan. 19:
Budweiser, man and woman
with groceries (unsigned)

1953, Jan. 26:
Ford Motor Company, "The
American Road Series"
[fig. 4-40]

1953, Feb. 16:
Kellogg's, "Again Invites
You" contest

1953, May 25:
Aqua Velva, "A Luxury"

1953, June 15:
Aqua Velva, "A Luxury"

1953, June 15:
Ford Motor Company, "The
American Road Series"

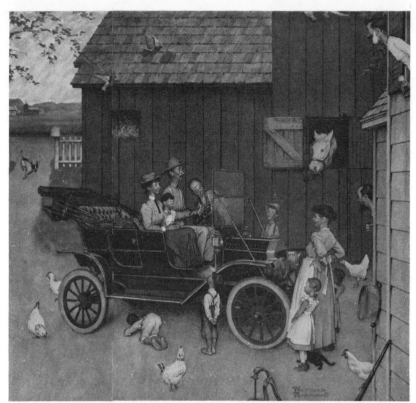

4-40

4-41

1953, Aug. 3:
Ford Motor Company, "The American Road Series" [fig. 4-41]

1953, Nov. 30:
Hallmark Cards, Inc.

1954, Aug. 30:
Kellogg's Corn Flakes, "Out at Home" (2 pages)

1954, Sept. 6:
Watchmakers of Switzerland, "It's Watch Inspection Time"

1954, Sept. 20:
Kellogg's Corn Flakes, "Where'd They All Go?"

1955, March 7:
Watchmakers of Switzerland, "Your Modern Wonderland of Time"

1955, Aug.:
Kellogg's Corn Flakes, "They Go Fast"

1955, Dec. 12:
Sheaffer Pen, "What a Wonderful Surprise!"

1956, May 21:
Pan American World Airways, "My Sketch Book"

1956, Oct. 29:
Pan American World Airways, "Pan American World Airways Was My Magic Carpet"

1956, Nov. 12:
Pan American World Airways, Pilot John Mattis portrait, "Eyes That See Around the World"

1960, Dec. 12:
Film, "Cinderfella" with Jerry Lewis

1963, Sept. 7:
Watchmakers of Switzerland, "What Makes It Tick?"

1966, April 8:
Rock of Ages Corporation

─────────────

LITERARY DIGEST:

1917, July 21:
Fisk Rubber Company, "What the Fisk Bicycle Club is Doing"

1917, Sept. 29:
Perfection Oil Heaters, "Slipper Time is Father's Resting Time"

1917, Nov. 3:
Perfection Oil Heaters, the shower

1917, Nov. 24:
Perfection Oil Heaters, the baby's bath

1917, Dec. 8:
Perfection Oil Heaters, "Merry Christmas"

1918, Dec. 7:
Perfection Oil Heaters, "Warmth for Cold Corners"

1919, Nov. 22:
Overland Automobile, "The Main Thing on Main St." (2 pages, unsigned)

1919, Dec. 20:
Advertising, "Topics of the Day"

1921, June 11:
Lime Crush, "The Bribe"

1921, July 16:
Orange Crush, "Like Oranges?"

1924, May 10:
Colgate Toothpaste, "If Your Wisdom Teeth"

1925, Nov. 28:
Encyclopedia Britannica, being read to

1928, May 12:
Coca-Cola, "Wholesome Refreshment"

1929, Dec. 14:
Listerine, "The Same Advice I Gave Your Dad"

─────────────

LOOK Magazine:

1940, Sept. 10:
General Motors Installment Plan

1949, March 29:
A.T.& T., "He Helps to Get the Message Through"

1949, March 29:
Cream of Kentucky, "Have You A Face"

1952, Sept. 23:
Watchmakers of Switzerland, "What Makes It Tick?"

1955, March 8:
Watchmakers of Switzerland, "Your Modern Wonderland of Time"

1960, Dec. 20:
 Film, "Cinderfella," with
 Jerry Lewis

1966, March 8:
 Film, "Stagecoach," with
 Bing Crosby

1968, Aug. 6:
 Crowell Publishing,
 Assassination of R.F.K.
 (dustjacket)

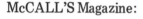

McCALL'S Magazine:

1919, July:
 Post Grape-Nuts Cereal

1921, July:
 Post Grape-Nuts Cereal

1924, Sept.:
 Quaker Puffed Wheat, "That
 Million Dollar Boy of Yours"

1926, Dec.:
 Sun-Maid Raisins, Grandma
 and small girl

1941, May:
 Niblets Corn

1957, Oct.:
 Crest Toothpaste, "Look
 Mom!" (Bobby Brooks)
 [fig. 4-42]

1957, Nov.:
 Crest Toothpaste,
 "Mrs. Tupper"

1957, Dec.:
 Crest Toothpaste,
 "Mrs. Banks"

1958, Feb.:
 Crest Toothpaste

1958, March:
 Crest Toothpaste

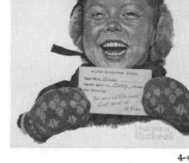

4-42

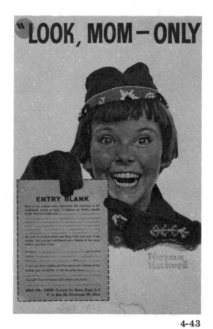

4-43

1958, May:
 Crest Toothpaste

1958, June:
 Crest Toothpaste,
 "Janie Carroll"

1958, Sept.:
 Crest Toothpaste,
 contest entry blank
 [fig. 4-43]

1958, Oct.:
 Crest Toothpaste,
 "Nancy Kay"

4-44

4-45

1958, Nov.:
 Crest Toothpaste,
 "Johnnie Bolton"

1959, Jan.:
 Crest Toothpaste,
 "Becky Olmsted"
 [fig. 4-44]

1959, March:
 Crest Toothpaste,
 "Look Mom"

1959, April:
 Crest Toothpaste,
 "Terry Williams"
 [fig. 4-45]

1962, Jan.:
Crest Toothpaste

1962, Jan.:
Famous Artists School

1964, Nov.:
Famous Artists School

1965, Jan.:
Famous Artists School

1974, May:
Insurance Companies of
America, "Getting
A Shot"

1974, Sept:
Crest Toothpaste

Medical Journals:

1971-1972:
Merck Sharp & Dohme
Pharmaceutical used two
pencil sketches by Norman
Rockwell to advertise in
various medical journals
the availability of
mumps vaccine.
[fig. 4-46]

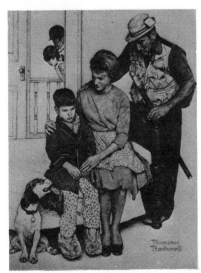

4-46

MODERN PRISCILLA:

1924, May:
Colgate Toothpaste
(unsigned)

1926, Dec.:
Sun-Maid Raisins

1929, Dec.:
Listerine, "The Same
Advice I Gave Your Dad"

MOTION PICTURE HERALD:

Norman Rockwell illustra-
tions appeared in this
bi-monthly publication.
Exact dates unavailable.

MOVIE Magazine:

1947, Jan.:
Film, "The Razor's Edge"

NATIONAL GEOGRAPHIC:

1924, May:
Colgate Toothpaste

1950, Aug.:
Watchmakers of Switzerland

1950, Aug.:
Du Mont Laboratories, Inc.

1950, Dec.:
Sheaffer Pen, "What a
Wonderful Surprise!"
[fig. 4-47]

1950, Dec.:
Plymouth, "Merry
Christmas Grandma!"

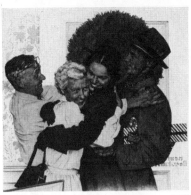

4-47

1950, Dec.:
Du Mont Laboratories, Inc.

1955, May:
Rock of Ages Corporation,
"Douglas"

1955, Nov.:
Sheaffer Pen, "What a
Wonderful Surprise!"

1971, Oct.:
A-T-O Inc., "The American
LaFrance is Here"

NEEDLECRAFT Magazine:

1924, Oct.:
Quaker Puffed Wheat,
"That Million Dollar Boy
of Yours"
[fig. 4-48 next page]

1926, Nov.:
Sun-Maid Raisins, "The
More Raisins, the Better
the Pudding"

1927, April:
Sun-Maid Raisins, "Lucky
the Sack's So Big"

1929, Dec.:
Listerine, "The Same
Advice I Gave Your Dad"

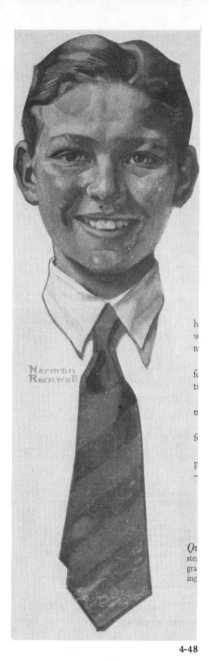

4-48

1933, Jan.:
Listerine, "Gargle With
Listerine"

NEWSWEEK:

1952, Dec. 22:
Big Brother Week

1953, Jan. 19:
Ford Motor Company,
"American Road Series"

1953, April 6:
Ford Motor Company,
"American Road Series"

1953, June 15:
Ford Motor Company,
"American Road Series"

1957, April 29:
Cotton Fiber Paper, Norman
Rockwell comments

NEW YORK TIMES
Newspaper:

1974, Jan. 27:
Ticonderoga Pencil
Company

NEW YORKER Magazine:

1937, Jan. 16:
Cream of Kentucky, "Have
You Eyes That Dream?"

1953, June 13:
Ford Motor Company,
"Revolution That Started
In A Shed"

1968, May:
Williamsburg, Virginia,
Peyton Randolph House
[fig. 4-49]

1968, June:
Williamsburg, Virginia,
Wetherburn's Tavern
[fig. 4-50]

This is the Peyton Randolph House.
You remember Peyton Randolph,

4-49

American history is not only
interpreted in this building,
some of it happened here.

4-51

200 years ago, James Geddy
fashioned neat silver work here.

4-52

1968, Oct.:
Williamsburg, Virginia,
College of William and Mary
[fig. 4-51]

1968, Nov.:
Williamsburg, Virginia,
James Geddy House
[fig. 4-52]

After 200 years,
Wetherburn's Tavern
is open again.

4-50

1927, Dec.:
 Sun-Maid Raisins

PEOPLE'S POPULAR
MONTHLY:

1927, April:
 Sun-Maid Raisins

1927, Dec.:
 Sun-Maid Raisins, "These
 Raisins That You Get"
 [fig. 4-53]

4-53

OLD CARS Newspaper:

1972, Feb.:
 Ford Life magazine
 features "Ford Triple
 Portrait"

PATHFINDER:

1950, Dec. 13:
 Plymouth, "Oh Boy!"

1953, Feb. 4:
 Ford Motor Company

PEOPLES HOME
JOURNAL:

1923, Oct.:
 Jell-O, little girl
 feeding doll

1926, Nov.:
 Sun-Maid Raisins

1926, Dec.:
 Sun-Maid Raisins

1926, Dec.:
 Nabisco Shredded Wheat

1927, April:
 Nabisco Shredded Wheat

1927, April:
 Sun-Maid Raisins

PHILADELPHIA ENQUIRER:

1976, Nov. 14:
 Lancaster Turkeys

PICTORIAL REVIEW:

1920, May:
 Paramount Pictures, "Four
 Please"

1923, April:
 Jell-O, "It's So Simple"

1924, May:
 Jell-O, "They Make it
 so Easy"

1926, Dec.:
Nabisco Shredded Wheat

1927, April:
Nabisco Shredded Wheat

1929, Dec.:
Listerine, "The Same
Advice I Gave Your Dad"

PRINTER'S INK
MONTHLY:

1926, April:
Harris Offset Presses for
catalog covers

1926, Dec.:
Sun-Maid Raisins, "Seeded
Raisins and Not Sticky"

1927, Oct.:
Interwoven Socks, "No
Holes to Darn"
[fig. 4-54]

4-54

1941, April:
Upjohn, "All-American
Display Winner"

1941, April:
Brentwood Sportswear Mills

1941, May:
Upjohn, "All-American
Display Winner"

READER'S DIGEST:

1937, Nov.:
"Make Up Your
Gift List Now"

1955, Aug.:
Watchmakers of
Switzerland, "What
Makes It Tick?"

1957, April:
Watchmakers of
Switzerland, "What
Makes It Tick?"

1957, Aug.:
Crest Toothpaste, "Mrs.
Ryan"

1957, Sept.:
Crest Toothpaste,
"Janie Carroll"

1957, Oct.:
Crest Toothpaste,
"Mrs. Fay"

1957, Nov.:
Crest Toothpaste,
"Mrs. Tupper"

1957, Dec.:
Crest Toothpaste,
"Mrs. Banks"

1958, Jan.:
Crest Toothpaste,
"Patricia Patterson"

1958, March:
Crest Toothpaste,
"Mike Hayward"

1958, April:
Crest Toothpaste,
"Mrs. Sullivan"

1958, June:
Crest Toothpaste,
"Janie Carroll"

1958, July:
Crest Toothpaste,
"Mark Barnett"

1958, Sept.:
Crest Toothpaste,
"Jeffrey Marks"

1958, Oct.:
Crest Toothpaste,
"Nancy Kay"

1958, Nov.:
Crest Toothpaste,
"Johnnie Bolton"

1959, Jan.:
Crest Toothpaste,
"Becky Olmsted"

1959, Feb.:
Famous Artists School,
"Rags to Riches"

1959, April:
Crest Toothpaste,
"Ben Hotchkiss"

1959, Nov.:
Parker Pens, "She Gave
Me a Parker 61"

1959, Dec.:
Parker Pens, "They Gave
Each Other a Parker 61"

1969, Dec.:
Amway Corporation,
"Amway is an Idea"
[fig. 4-55]

4-56

4-58

4-55

4-57

4-59

REDBOOK:

1921, June:
Lemon Crush,
"The Home Run"

RELAX Magazine:

1974, Jan.:
A-T-O Inc.,
"Adirondack Winter"

ST. NICHOLAS Magazine:

1918, April:
The Fisk Rubber Company,
"The Winner"
[fig. 4-56]

1918, May:
The Fisk Rubber Company,
"A Typical Fisk Club"

1918, June:
Borden's *Eagle Brand*
Condensed Milk,
"Conscience & Cornbread"
[fig. 4-57]

1918, June:
The Fisk Rubber Company,
"Start Right Now"
[fig. 4-58]

1919, March:
The Fisk Rubber Company,
"Are You Ready Boys?"

1919, April:
The Fisk Rubber Company,
"Where Will We Go
From Here?"
[fig. 4-59]

4-60

1919, May:
The Fisk Rubber Company,
"He Sure Has Lots To Do"
[fig. 4-60]

1919, June:
The Fisk Rubber Company,
"Start Your Bicycle
Club Now"

1919, July:
 The Fisk Rubber Company,
 "Always Something To Do"

1919, Sept.:
 Jell-O, "See How Easy It Is"

1919, Oct.:
 Jell-O, "It's So Simple"

1920, April:
 Goodrich Bike Tire Contest,
 "Hey Fellers!"

1920, June:
 Goodrich Bike Tire Contest,
 "Boys Book of Sports"

1920, Oct.:
 Goodrich Bike Tire Contest,
 "Winners"

1923, Feb.:
 Jell-O, "See How Easy It Is"

SATURDAY EVENING POST:

1917, Jan. 13:
 Fisk Rubber Company,
 Ford auto in winter scene

1917, Aug. 25:
 Black Cat Hosiery,
 "Real Boys"

1917, Sept. 15:
 Perfection Oil Heaters,
 man winding clock
 [fig. 4-61]

1917, Oct. 6:
 Perfection Oil Heaters,
 family at table
 [fig. 4-62]

1917, Oct. 27:
 Perfection Oil Heaters,
 man ready for shower

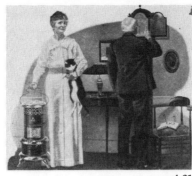

4-61

4-62

4-63

1917, Dec. 1:
 Perfection Oil Heaters,
 cat on chair
 [fig. 4-63]

1918, Jan. 26:
 Del Monte Foods,
 "Uncle Sam"
 [fig. 4-64]

1918, Feb. 23:
 Del Monte Foods,
 "I cannot tell a lie"

1918, Aug. 17:
 Black Cat Hosiery,
 "For children's play"
 [fig. 4-65]

1919, April 26:
 Black Cat Hosiery,
 boy with kite (unsigned)

1919, Aug. 30:
 Bauman Clothing
 [fig. 4-66]

1920, Jan. 3:
 Carnation Milk
 [fig. 4-67]

1920, March 20:
 Adams Black Jack Gum,
 "Quenches Thirst"
 [fig. 4-68]

1920, March 20:
 Edison Mazda Lamps,
 "The Stuff of Which
 Memories are Made"

1920, April 3:
 Paramount Pictures,
 "Four Please"

1920, April 17:
 Edison Mazda Lamps,
 "And Every Lad May
 Be Aladdin"
 [fig. 4-69]

1920, May 15:
 Edison Mazda Lamps,
 "The Melody of Music"

1920, June 12:
 Edison Mazda Lamps,
 "What a Difference
 Light Makes"

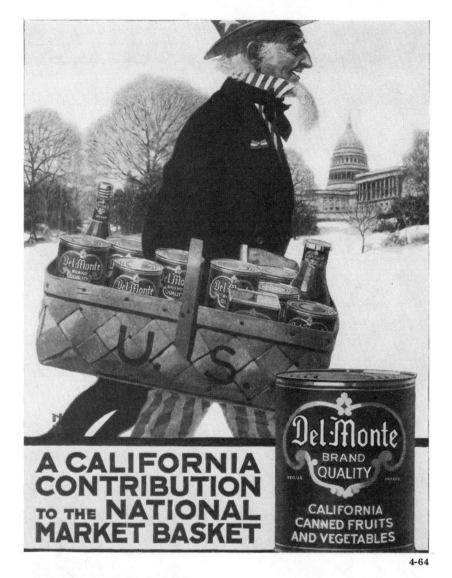

A CALIFORNIA CONTRIBUTION TO THE NATIONAL MARKET BASKET

Del Monte BRAND QUALITY CALIFORNIA CANNED FRUITS AND VEGETABLES

4-64

4-67

4-68

4-69

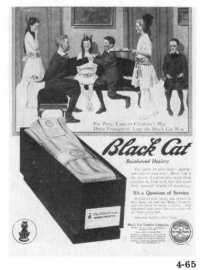

4-65

4-66

1920, July 10:
Edison Mazda Lamps,
"More Light for Each Year
of Life"

1920, Aug. 7:
Edison Mazda Lamps,
"A Symbol"

1920, Aug. 14:
Goulds Pumps,
"Two straws are
better than one"

1920, Sept. 4:
Edison Mazda Lamps,
"The College of the
Lighted Lamp"
[fig. 4-70]

1920, Oct. 2:
Edison Mazda Lamps,
"She Was a Queen and I Was
King"
[fig. 4-71]

1920, Oct. 30:
Edison Mazda Lamps,
"In Life's Evening Time"

1920, Nov. 27:
Edison Mazda Lamps,
"This is the Room That
Light Made"
[fig. 4-72]

1921, April 2:
Cycle Trades of America,
"School This Year
Means More"
[fig. 4-73]

1921, July 16:
Goulds Pumps,
[fig. 4-74]

1921, Dec. 31:
Paint Varnish and Allied
Interests, "$1,000 in
prizes" contest
[fig. 4-75]

4-70

4-74

4-71

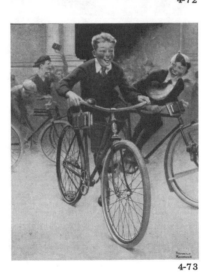

4-72

4-75

4-73

4-76

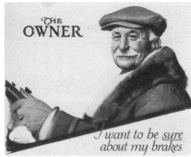

4-77

4-78

4-79

4-80

4-81

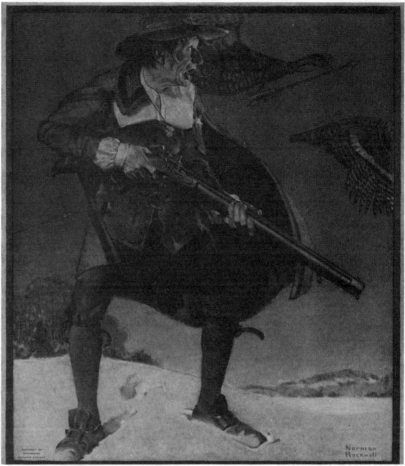

4-82

1922, Jan. 7:
Edison Mazda Lamps,
"All's Right"
[fig. 4-76]

1922, Jan. 7:
The Raybestos Company,
the owner
[fig. 4-77]

1922, March 4:
The Raybestos Company,
the mother
[fig. 4-78]

1922, April 1:
The Raybestos Company,
the policeman
[fig. 4-79]

1922, Aug. 26:
Interwoven Hose,
"The Golfer"

1922, Sept. 9:
The Raybestos Company,
the busdriver
[fig. 4-80]

1922, Oct. 7:
The Raybestos Company,
the farmer
[fig. 4-81]

1922, Nov. 11:
Pratt & Lambert,
"The Cradle"

1922, Nov. 18:
Interwoven Hose,
"The Pilgrim"
[fig. 4-82]

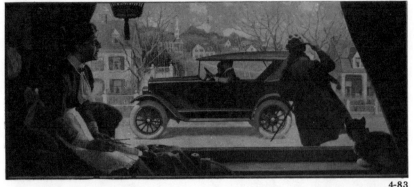

4-83

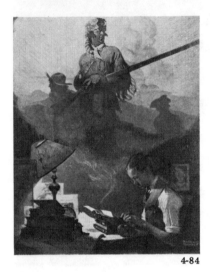

4-84

4-85

4-86

1923, Feb. 17:
Valentine's Valspar Varnish,
reprint of *Life* cover,
ladies gossiping over tea

1923, Feb. 24:
Romance Chocolates,
girl offering boyfriend
a chocolate

1923, March 17:
Willys-Overland Automobile
Co., Inc. (2 pages)
[fig. 4-83]

1923, March 17:
Romance Chocolates,
boy playing banjo
for girlfriend

1923, April 23:
Romance Chocolates,
"And Now In Every City"

1923, May 5:
Lowe Brothers Paint and
Varnish, "Good for Another
Generation"

1923, July 7:
Lifebuoy Soap,
"Mothers—Let's be
frank" (unsigned)

1923, Oct. 13:
Underwood Typewriter,
"Daniel Boone comes to life"
[fig. 4-84]

1923, Oct. 27:
Valentine's Valspar Varnish,
"Valspar is
Hallowe'en-proof"
[fig. 4-85]

1923, Nov. 3:
Pratt & Lambert
[fig. 4-86]

1923, Nov. 24:
Romance Chocolates,
young couple on sofa

1923, Dec. 1:
Jell-O, "It's So Simple"

1924, Jan. 12:
The Raybestos Company,
"Comfort in Safety"

1924, Feb. 9:
Allen-A Hosiery

1924, April 5:
Fisk Rubber Company,
"The Hobo"

1924, April 5:
Pratt & Lambert

1924, April 5:
Valentine's Valspar Varnish

1924, May 17:
Jell-O, "See How
Easy It Is"

1924, June 7:
Fisk Rubber Company
[fig. 4-87]

1924, Aug. 9:
Interwoven Socks,
"Traveling Man"

1924, Aug. 23:
Allen-A Hosiery, "Pirates"

1924, Nov. 1:
Pratt & Lambert,
"Glowing Memories"
[fig. 4-88]

1925, Feb. 7:
Fisk Rubber Company,
"Get A Fisk"

4-87

4-88

4-89

4-90

1925, March 21:
 Edison Mazda Lamps,
 "What a Difference"
 [fig. 4-89]

1925, April 18:
 Edison Mazda Lamps,
 "Filling the Lamp"

1925, June 6:
 Pratt & Lambert,
 "For thirty-five years
 veteran painters"

1925, July 4:
 Post Bran Flakes,
 "Now you'll like bran"

1925, Sept. 12:
 Edison Mazda Lamps,
 "The Candlemaker"

1925, Oct. 17:
 Edison Mazda Lamps,
 "What a Protection Electric
 Light Is"
 [fig. 4-90]

4-91

4-94

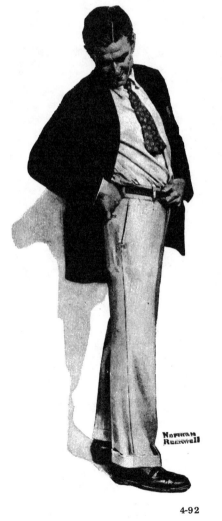

4-92

4-93

4-95

1926, April 3:
Pratt & Lambert,
"If The Neighbors Can
Stand It"
[fig. 4-91]

1926, May 1:
Bauer and Black,
"First Aid Week"

1926, June 5:
Dutchess Trousers,
"Old man Tracy"

1926, June 26:
Rogers Brothers Silver,
"To the man of action"

1926, July 3:
Dutchess Trousers,
young man, side view
[fig. 4-92]

1926, July 17:
Elgin Watch,
"She said it for a lifetime!"
[fig. 4-93]

1926, Sept. 4:
Allen-A Hosiery,
6 schoolboys
[fig. 4-94]

1926, Sept. 11:
Dutchess Trousers,
boy in knickers with dog

1926, Oct. 9:
Dutchess Trousers,
man in work clothes
holding set of plans

1927, Jan. 8:
Dutchess Trousers,
working man peeling apple

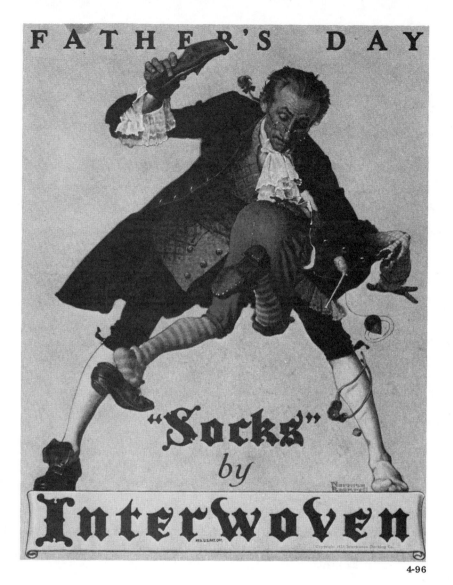

FATHER'S DAY

"Socks" by Interwoven

4-96

1927, July 2:
Interwoven Socks,
"Still Good"

1928, Feb. 11:
Interwoven Socks,
"The Burglar"

1928, May 5:
Coca-Cola,
"Wholesome Refreshment"

1928, Dec. 1:
Parker Pens,
man with Santa mask

1929, Feb. 2:
Capitol Boilers,
"The Melody Stilled
by Cold"

1929, March 2:
Capitol Boilers,
"The Melody Stilled
by Cold"

1929, April 6:
Arrow Shirts,
"Airtone"

1929, May 25:
Tillyer Lenses,
"Today your boy, your . . ."

1929, Aug. 17:
Tillyer Lenses,
"Your eyes work even when
you play"

1929, Sept. 14:
Tillyer Lenses,
"Help your eyes do the
harder work they have
to do today"
[fig. 4-95]

1929, Oct. 12:
Tillyer Lenses,
"Can't you *see*!"

1929, Nov. 9:
Tillyer Lenses,
"Is it play for eyes, too?"

1929, Dec. 14:
Parker Pen,
"No Christmas
Problem Now"

Listerine,
"The Same Advice I
Gave Your Dad"

Tillyer Lenses,
"If your eyesight controls"

Brown & Bigelow,
calendar

1930, Nov. 15:
Goodyear Tires,
"Think a moment!
Can you stop?"

1931, Jan. 31:
Listerine

1935, April 6:
Campbell's Tomato Juice,
"That's the real tomato
flavor"

1935, June 15:
Interwoven Socks,
"Father's Day"
[fig. 4-96]

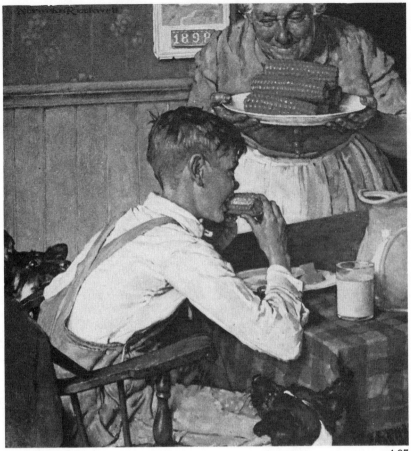

"Just a minute young feller!"

I'll figure the financing cost *myself*"

4-98

4-99

4-97

1935, Sept. 28:
Campbell's Soup,
"On the Air"
(unsigned)

1935, Dec. 28:
Campbell's Soup,
"A Christmas Carol"

1936, Dec. 26:
Campbell's Soup,
"On the Air Christmas Day"
(unsigned)

1937, April 24:
Beech-Nut Gum,
"Worth Stopping For"

1938, April 9:
Niblets Corn,
"An Then Ma or Grandma
Brought Em In"
[fig. 4-97]

1939, June 17:
General Motors Installment
Plan
[fig. 4-98]

1940, Sept. 14:
General Motors Installment
Plan

1940, Nov. 9:
General Motors Installment
Plan, "Makes Good Sense
to Me"
[fig. 4-99]

1940, Dec. 14:
General Motors Installment
Plan, "Makes Good Sense
to Me"

1941, June 14:
Mobilgas, "Her Hero"

1942, April 11:
Willie Gillis Says,
"For Victory, Buy U.S.
Savings Bonds"
[fig. 4-100]

1943, Aug. 14:
Listerine (unsigned)

1943, Sept. 4:
Upjohn, "When Your Doctor
Treats Your Child"

WILLIE GILLIS SAYS:

4-100

1945, Nov. 17:
 Ipana Toothpaste,
 "Would a Veteran
 Find You Here?"
 [fig. 4-101]

1946, March 16:
 Niblets Corn,
 "You Can See This Boy Is
 In Love With His Work"

1947:
 Upjohn, "He's Going to be
 Taller than Dad"
 [fig. 4-102]

1948, June 12:
 Interwoven Socks,
 "Don't Forget. . .Father's
 Day"

1948, Nov. 6:
 Hallmark Cards, Inc.

1949, March 5:
 A.T. & T.,
 "He Helps To Get the
 Message Through"
 [fig. 4-103]

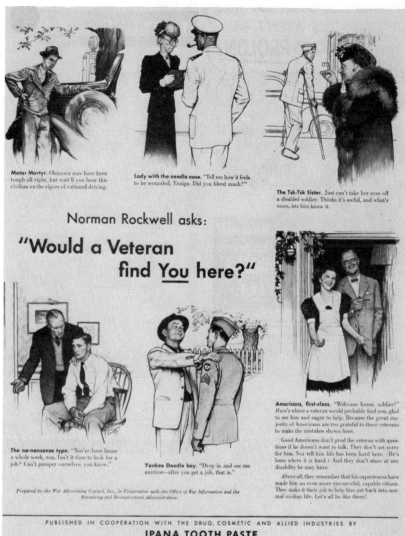

4-101

4-102

4-103

4-104

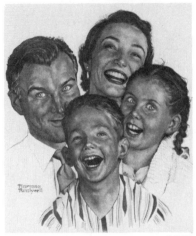

4-105

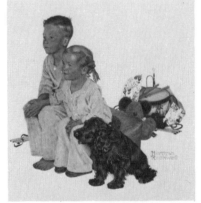

4-106

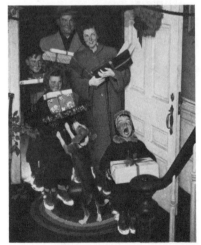

4-107

1949, Sept. 10:
 Watchmakers of
 Switzerland, "What
 Makes it Tick?"
 [fig. 4-104]

1950, Feb. 18:
 Dictaphone

1950, Aug. 19:
 Du Mont Laboratories, Inc.
 [fig. 4-105]

1950, Sept. 2:
 Watchmakers
 of Switzerland

1950, Dec. 9:
 Du Mont Laboratories, Inc.
 [fig. 4-106]

1950, Dec. 23:
 Plymouth, "Merry
 Christmas Grandma!"
 [fig. 4-107]

1951, Dec. 22:
 Plymouth, "Oh Boy!"

1952, Sept. 13:
 Watchmakers of
 Switzerland, "What
 Makes it Tick?"

1953, Jan. 17:
 Ford Motor Company,
 "The American Road Series"
 [fig. 4-108]

1953, Jan. 31:
 Aqua Velva,
 "A Luxury That Actually
 Does You Good"
 [fig. 4-109]

1953, Feb. 7:
 Famous Artists School

1953, Feb. 21:
 Aqua Velva,
 "A Luxury That Actually
 Does You Good"

1953, March 28:
 Ford Motor Company,
 "The American Road Series"
 [fig. 4-110]

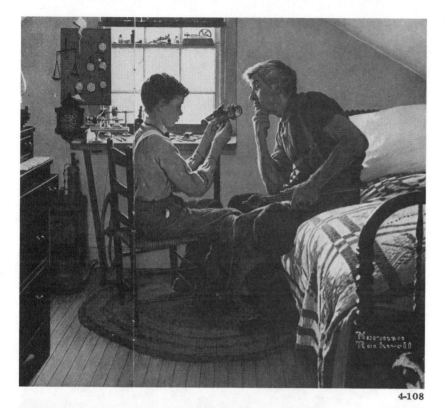

4-108

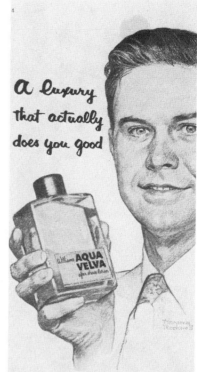

4-109

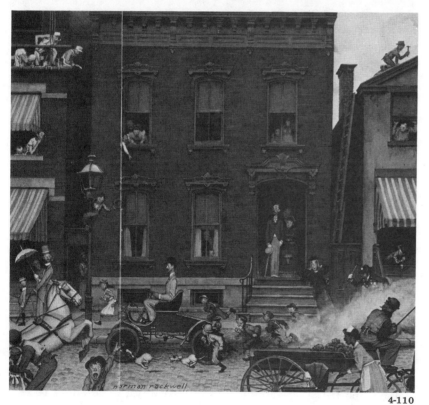

4-110

1953, April 25:
 Aqua Velva,
 "A Luxury That Actually
 Does You Good"

1953, June 13:
 Ford Motor Company,
 "Henry Ford's Workshop"

1953, June 20:
 Aqua Velva,
 "A Luxury That Actually
 Does You Good"

1953, Sept. 5:
 Aqua Velva,
 "A Luxury That Actually
 Does You Good"

1953, Sept. 12:
 Watchmakers of
 Switzerland, "What
 Makes it Tick?"

1953, Oct. 3:
 Famous Artists School

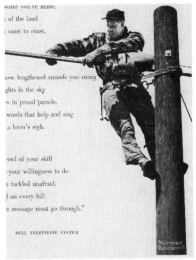

4-111

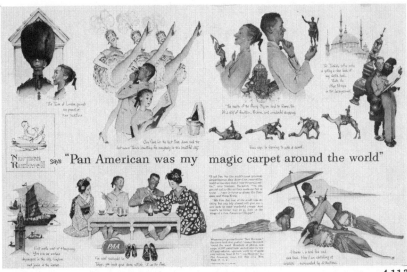

4-113

4-112

4-114

1953, Oct. 3:
A.T. & T., "Lines to a Lineman"
[fig. 4-111]

1954, Jan. 23:
Famous Artists School

1954, March 13:
Watchmakers of Switzerland, "He's a Specialist"

1954, Sept. 11:
Famous Artists School

1954, Sept. 11:
Watchmakers of Switzerland, "What Makes It Tick?"

1954, Dec. 11:
Magnavox (unsigned)

1955, Jan. 1:
Famous Artists Talent Test

1955, March 12:
Famous Artists School "We're looking for people"

1955, March 12:
Watchmakers of Switzerland, "Your Modern Wonderland of Time"

1955, March 26:
Rock of Ages Corporation, "Douglas" (color)

1955, May 21:
Rock of Ages Corporation, "Douglas"

1955, June 18:
Chase Manhattan Bank, "Bright Future for Banking"
[fig. 4-112]

1955, Oct. 15:
Niblets Corn, "Right Off Your Pantry Shelf"

1956, March 17:
Pan American World Airways, "Pan American Was My Magic Carpet Around the World"
[fig. 4-113]

1956, June 2:
Pan American World Airways, "My Sketch Book Proves You Can See More When You Fly Pan Am."

1956, Oct. 20:
Pan American World Airways, "The Thing To Do With Life Is Live It"
[fig. 4-114]

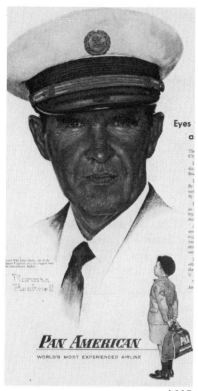

4-115

1956, Nov. 10:
 Pan American World
 Airways, Portrait of Pilot,
 J. Mattis, "Eyes That See
 Around the World"
 [fig. 4-115]

1959, May 9:
 Parker Pens, "She Gave Me a
 Parker 61. . ."

1959, Oct. 3:
 Parker Pens, "He Sent Me
 a Parker 61. . ."
 [fig. 4-116]

1959, Nov. 28:
 Parker Pens, "She Gave Me
 a Parker 61. . ."
 [fig. 4-117]

1959, Dec. 5:
 Parker Pens, "They Gave
 Each Other a Parker"
 [fig. 4-118]

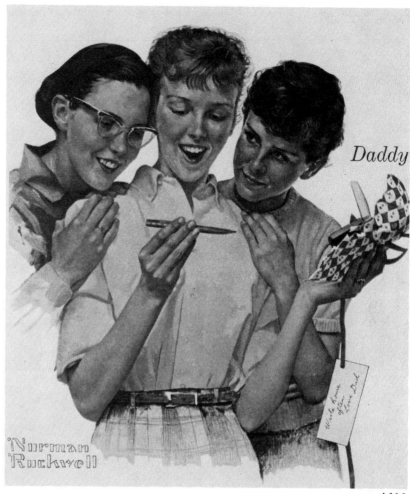

4-116

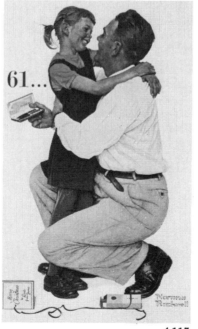

4-117

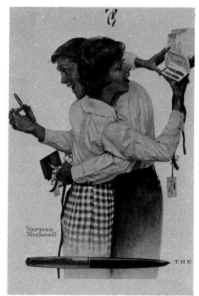

4-118

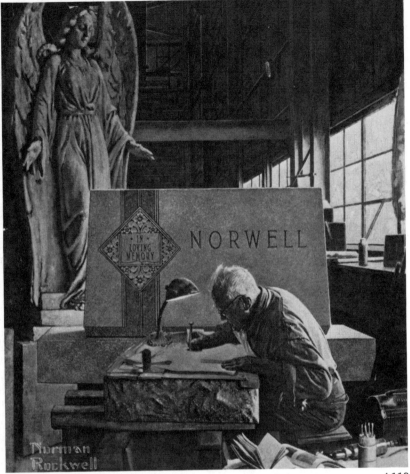

4-119

4-120

1964, March 14:
 Rock of Ages Corporation,
 "Newton"

1964, April 25:
 Skippy Peanut Butter,
 "Sweepstakes"

1965, April 10:
 Rock of Ages Corporation,
 "Newton"

1967, Oct. 7:
 Purina, "Win A Norman
 Rockwell Portrait of You
 and Your Cat"

STAR WEEKLY:
 (Toronto, Canada)

1960, Jan. 9:
 Red Rose Tea, "Quick"
 [fig. 4-121]

4-121

1963, March 23:
 American Red Cross, "Give
 to the Red Cross"
 J. F. K. Portrait

1963, March 23:
 Rock of Ages Corporation,
 "Norwell"
 [fig. 4-119]

1963, May 18:
 Skippy Peanut Butter,
 "Sweepstakes"
 [fig. 4-120]

1960, Date Unknown:
 Red Rose Tea,
 "Smart Move"

1961, Dec. 23:
 Famous Artists School

1962, Sept. 8:
 Peace Corps

SUNDAY Magazine:

1959, Sept. 27:
 Knox Gelatin,
 "Lose Weight Easier. . .Feel
 Better"

THEATRE Magazine:

1923:
 The Fisk Rubber Company,
 hobo

1924, Oct.:
 The Fisk Rubber Company,
 sleeping sheriff

THIS WEEK Magazine:

1940, March 12:
 Niblets Corn,
 "Who's Having More Fun?"

1959, Oct. 4:
 Knox Gelatin,
 "Lose Weight Easier. . .Feel
 Better"

TIME Magazine:

1936, Nov. 8:
 Cream of Kentucky,
 "Have You Eyes. . .?"

1936, Dec. 7:
 Cream of Kentucky,
 "How Keen Are
 Your Eyes?"

1943, June 21:
 Cream of Kentucky,
 "I Like to Please People"

4-122

1950, Dec. 25:
 Plymouth, "Oh Boy!"

1974, May 27:
 Life and Health Insurance

1974, June 10:
 Life and Health Insurance

1974, June 24:
 Life and Health Insurance

1976, Feb. 2:
 Anheuser-Busch, Inc.,
 (mini *Fortune* magazine
 ad July 1934)

TODAY'S HOUSEWIFE:

1919, July:
 Post Grape-Nuts Cereal

TRUE DETECTIVE:

1937, June:
 Beech-Nut Gum,
 "Worth Stopping For"

TRUE STORY Magazine:

1955, June:
 Swift Baby Food,
 "After Glow"

1955, Aug.:
 Swift Baby Food,
 "Relaxes"

1955, Sept.:
 Swift Baby Food,
 "Contentment"
 [fig. 4-122]

1955, Dec.:
 Swift Baby Food,
 "Contentment"

1956, March:
 Swift Baby Food,
 "Harmony"

1956, June:
 Swift Baby Food,
 "Enjoyment"

1956, Aug.:
 Swift Baby Food,
 "After Glow"

VANITY FAIR:

1921, March:
 Arrow Shirt Company,
 "His First Dress Shirt"

1925, March:
 Fisk Rubber Company,
 grandpa hiding behind a sign

1926, Nov.:
 Dutchess Trousers,
 "Hair Splitter Evans"

WOMAN'S DAY:

1974, Oct.:
 Crest Toothpaste

WOMAN'S HOME
COMPANION:

1921, July:
 Post Grape-Nuts Cereal

1923, March:
 Jell-O, "It's So Simple"

1924, July:
 Colgate Toothpaste

1926, Dec.:
 Sun-Maid Raisins

1926, Dec.:
 Nabisco Shredded Wheat

1927, May:
 Wallace Silver Plate
 Company, "Up in
 the Hills"

1929, Dec.:
 Listerine, "The Same Advice
 I Gave Your Dad"

1938, Aug.:
 Quaker Puffed Rice,
 "That Million Dollar Boy"

1945, Nov.:
 Bourjois

1955, May:
 Swift Baby Food,
 "Enjoyment"

1955, Oct.:
 Swift Baby Food,
 "Contentment"

WOMAN'S WORLD:

1926, Dec.:
 Sun-Maid Raisins,
 grandma, boy and dog

1937, May:
 Sun-Maid Raisins,
 grandpa, girl, doll and cat

WORLD'S WORK:

1919, July:
 Post Grape-Nuts Cereal,
 "Every Golden Granule"
 [fig. 4-123]

4-123

1923, Feb.:
 Jell-O, "It's So Simple"

1923, March:
 Romance Chocolates,
 "From the Most Critical
 Group In America"

1923, April:
 Romance Chocolates,
 girl eating chocolates
 on steps

YOUTH'S COMPANION:

1917, May 31:
 The Fisk Rubber Company
 [fig. 4-124]

1917, July 26:
 The Fisk Rubber Company

1918, Sept. 12:
 The Fisk Rubber Company

1918, Sept. 12:
 Borden's *Eagle Brand*
 Condensed Milk,
 "Head of the Class"

1921, June 2:
 Lemon Crush,
 "The Home Run"
 [fig. 4-125]

4-124

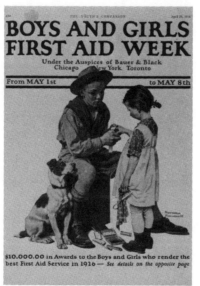

4-127

1924, March 13:
 Quaker Puffed Rice,
 "That Million Dollar
 Boy of Yours"

1924, May 22:
 Hood Shoes,
 "Now Comes
 Hood Shoe Time"

1926, April 29:
 Bauer and Black,
 "First Aid Week"
 [fig. 4-128]

4-125

4-128

4-126

1923, Feb. 1:
 Jell-O,
 "See How Easy It Is"
 [fig. 4-126]

1923, June 21:
 Hood Shoes,
 "My Idea of Shoes"
 (unsigned)

1923, Nov. 1:
 Jell-O,
 "It's So Simple"
 [fig. 4-127]

5
Massachusetts Mutual Advertisements

Over a period of a decade and a half Norman Rockwell created 79 family scenes for a series of consumer advertisements sponsored by the Massachusetts Mutual Life Insurance Company of Springfield, Massachusetts. The first appeared in 1950; the last, in 1964. The first, a painting, was reproduced in color; the others were pencil sketches reproduced in black and white.

Some proved so popular with the public that they were reprinted again and again.

Lasting appeal seems to stem from the fact that all of the situations depicted are ones nearly every family experiences at one time or another, as well as the fact that the characters—all drawn from life—are so believable. Most of the models were friends and neighbors of the Rockwells in Stockbridge.

Massachusetts Mutual owns the originals of the drawings and frequently loans out part of the collection for exhibitions in different parts of the country.

The advertisements are listed here by the numbers Massachusetts Mutual uses to identify them; the date indicates the first time the advertisement appeared in the magazine.

1. His First Day at School
 The Saturday Evening Post,
 Sept. 23, 1950
 [fig. 5-1]

2A. Triple Portrait
 The Saturday Evening Post,
 Feb. 7, 1953
 [fig. 5-2A]

2B. Family Portrait
 The Saturday Evening Post,
 Sept. 13, 1952
 Time, June 13, 1955
 [fig. 5-2B]

2C. Breakfast Table
 The Saturday Evening Post,
 Feb. 27, 1954
 [fig. 5-2C]

3. Report Card
 The Saturday Evening Post,
 April 25, 1953
 Time, May 25, 1953
 [fig. 5-3]

4. First Formal
 The Saturday Evening Post,
 July 18, 1953
 Time, Aug. 17, 1953
 Newsweek, May 5, 1954
 [fig. 5-4]

5. Father Reading to Daughter
 The Saturday Evening Post,
 June 6, 1953
 Time, July 6, 1953
 [fig. 5-5]

6. Child on Father's Shoulders
 The Saturday Evening Post,
 March 21, 1953
 Time, April 6, 1953
 [fig. 5-6]

7. Circus
 The Saturday Evening Post,
 Aug. 13, 1955
 Time, July 11, 1955
 Newsweek, July 18, 1955
 Reader's Digest, June, 1955
 [fig. 5-7]

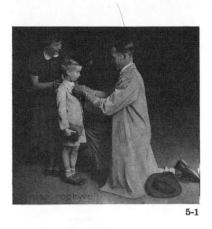

5-1

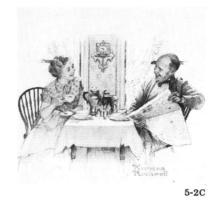

5-2C

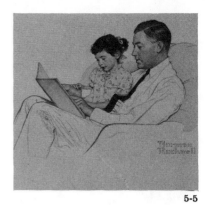

5-5

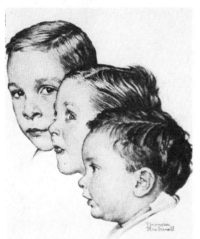

5-2A

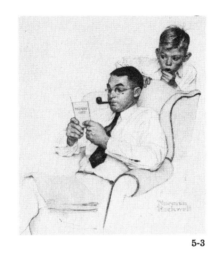

5-3

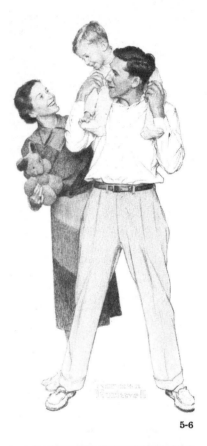

5-6

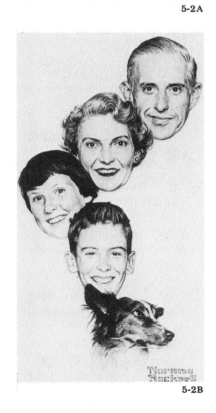

5-2B

5-4

5-7

5-8

5-9

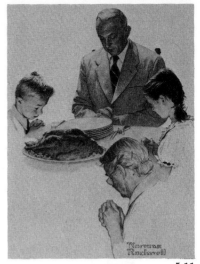

5-11

5-10

8. Christmas
 The Saturday Evening Post,
 Dec. 12, 1953
 Time, Dec. 14, 1953
 Newsweek, Dec. 21, 1953
 [fig. 5-8]

9. Soap Box Racer
 The Saturday Evening Post,
 Sept. 12, 1953
 Time, Sept. 28, 1953
 Newsweek, Oct. 12, 1953
 [fig. 5-9]

10. Girl in Front of Mirror
 The Saturday Evening Post,
 March 5, 1955
 Time, March 7, 1955
 Newsweek, March 21, 1955
 [fig. 5-10]

11. Thanksgiving
 The Saturday Evening Post,
 Nov. 15, 1952
 Time, Nov. 25, 1952
 Newsweek, Nov. 12, 1956
 [fig. 5-11]

12. Father Holding New Baby
 The Saturday Evening Post,
 Jan. 21, 1956
 Time, Feb. 16, 1956
 Newsweek, Jan. 16, 1956
 Reader's Digest, Jan., 1956
 [fig. 5-12]

5-12

5-13

5-14

13. Family Planting Tree
The Saturday Evening Post,
May 17, 1958
Time, May 26, 1958
Newsweek, June 16, 1958
Life, June 30, 1958
[fig. 5-13]

14. Off to College
The Saturday Evening Post,
Oct. 13, 1956
Time, Sept. 10, 1956
Newsweek, Sept. 24, 1956
Reader's Digest, Oct., 1956
[fig. 5-14]

15. Doctor's Office (never
published)
[fig. 5-15]

5-15

5-16

16. Boy at Mirror
The Saturday Evening Post,
Feb. 28, 1959
Time, Feb. 9, 1959
Newsweek, Feb. 16, 1959
[fig. 5-16]

17. Maternity Scene
The Saturday Evening Post,
Oct. 4, 1958
Time, Sept. 15, 1958
Newsweek, Sept. 29, 1958
[fig. 5-17]

18. Fishing (grandfather and
boy)
The Saturday Evening Post,
July 10, 1954
Time, July 26, 1954
Newsweek, Aug. 9, 1954
[fig. 5-18]

19. Mother with Two Children
in Kitchen
The Saturday Evening Post,
June 27, 1959
Time, July 6, 1959
Newsweek, July 20, 1959
[fig. 5-19]

5-17

5-18

5-19

20. Children Looking Out
the Window
The Saturday Evening Post,
Jan. 31, 1959
Time, Jan. 12, 1959
Newsweek, Jan. 19, 1959
[fig. 5-20]

21. Family with Pups
The Saturday Evening Post,
Jan. 28, 1958
Time, Feb. 3, 1958
Newsweek, Feb. 10, 1958
Life, Jan. 27, 1958
[fig. 5-21]

5-20

5-25

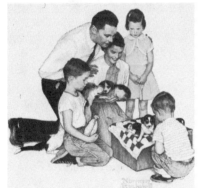

5-21

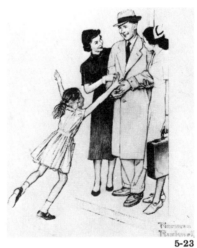

5-23

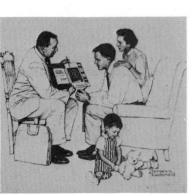

5-22

5-24

22. Agent Interview
 The Saturday Evening Post,
 June 9, 1956
 Time, May 14, 1956
 Newsweek, May 28, 1956
 [fig. 5-22]

23. Leaving Hospital
 The Saturday Evening Post,
 May 22, 1954
 Time, June 7, 1954
 Newsweek, June 21, 1954
 [fig. 5-23]

24. Father Helping Son with
 Homework
 The Saturday Evening Post,
 July 12, 1958
 Time, July 28, 1958
 Newsweek, Aug. 18, 1958
 [fig. 5-24]

25. Policeman with Boys
 The Saturday Evening Post,
 1957
 Reader's Digest, April, 1957
 [fig. 5-25]

5-26

26. Mother Reading to
Children
The Saturday Evening Post,
Feb. 22, 1958
Time, March 3, 1958
Newsweek, March 17, 1958
Life, April 14, 1958
[fig. 5-26]

27. Easter
The Saturday Evening Post,
April 9, 1955
Time, April 4, 1955
Newsweek, April 4, 1955
[fig. 5-27]

28. Little Shaver
The Saturday Evening Post,
Oct. 31, 1953
Time, Nov. 9, 1953
Newsweek, Nov. 23, 1953
[fig. 5-28]

29. Little Leaguer
The Saturday Evening Post,
April 10, 1954
Time, April 19, 1954
Newsweek, April 26, 1954
[fig. 5-29]

30. Dog's Bath
The Saturday Evening Post,
Oct. 9, 1954
Time, Oct. 18, 1954
Newsweek, Oct. 25, 1954
[fig. 5-30]

5-27

31. Tucking Children in Bed
The Saturday Evening Post,
Jan. 22, 1955
Time, Jan. 10, 1955
Newsweek, June 10, 1957
Coronet, Feb. 1, 1955
[fig. 5-31]

32. Off to School
The Saturday Evening Post,
Sept. 27, 1952
Time, Oct. 20, 1952
Newsweek, Sept. 27, 1954
[fig. 5-32]

33. Baby's First Step
The Saturday Evening Post,
Nov. 1, 1958
Time, Oct. 13, 1958
Newsweek, Oct. 20, 1958
[fig. 5-33]

34. Lemonade Stand
The Saturday Evening Post,
Aug. 11, 1955
Time, July 16, 1955
Newsweek, July 30, 1955
Reader's Digest, June, 1955
[fig. 5-34]

5-28

5-30

5-31

5-32

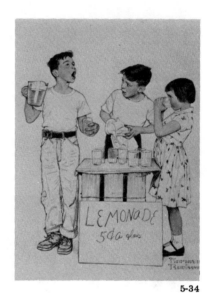

5-34

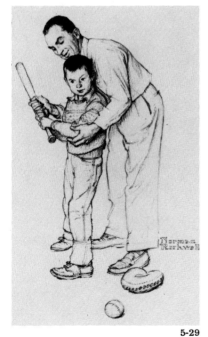

5-29

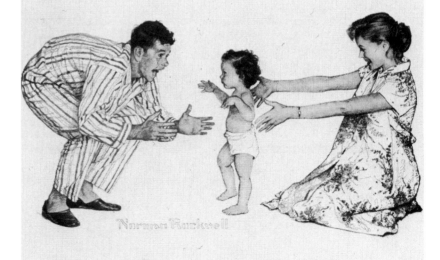

5-33

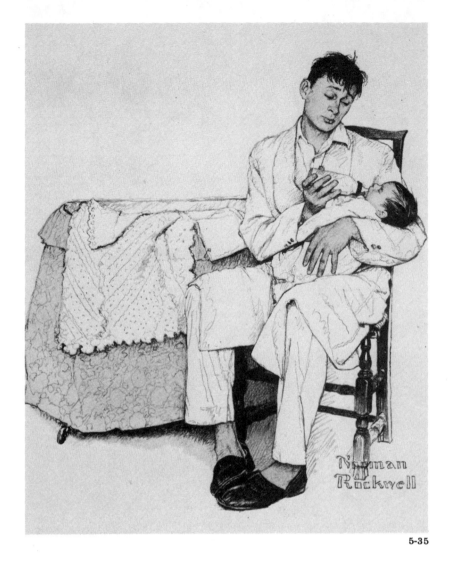

5-35

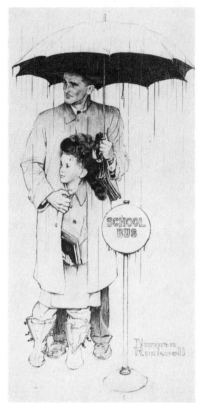

5-36

5-38

35. Father Feeding Infant
 The Saturday Evening Post,
 March 9, 1957
 Time, Feb. 8, 1957
 Newsweek, March 11, 1957
 Reader's Digest, April, 1957
 [fig. 5-35]

36. Bus Stop
 The Saturday Evening Post,
 Jan. 26, 1956
 Time, Jan. 7, 1956
 Newsweek, Jan. 14, 1956
 Reader's Digest, Jan., 1956
 [fig. 5-36]

5-37

5-39

5-40

5-41

5-42 and 5-55

5-44

5-43

37. Grocery Shopping
The Saturday Evening Post,
March 3, 1955
Time, April 16, 1955
Newsweek, April 30, 1955
Reader's Digest, April, 1955
[fig. 5-37]

38. Newlyweds
The Saturday Evening Post,
May 14, 1960
Time, May 2, 1960
Newsweek, June, 1960
[fig. 5-38]

39. Boy and Dad on Dock
The Saturday Evening Post,
June 8, 1960
Time, June 13, 1960
Newsweek, June 27, 1960
[fig. 5-39]

40. Moving Furniture
The Saturday Evening Post,
Nov. 9, 1959
Time, Oct. 12, 1959
Newsweek, Oct. 19, 1959
[fig. 5-40]

41. Family in Auto
The Saturday Evening Post,
Jan. 16, 1954
Time, Jan. 25, 1954
[fig. 5-41]

42. Woman at Office
and Home
The Saturday Evening Post,
Aug. 1, 1959
Time, Aug. 17, 1959
Newsweek, Aug. 24, 1959
[fig. 5-42]

43. First Haircut
The Saturday Evening Post,
May 9, 1959
Time, May 18, 1959
Newsweek, May 5, 1959
[fig. 5-43]

44. Grandfather Painting
Granddaughter
The Saturday Evening Post,
Oct. 3, 1959
Time, Sept. 14, 1959
Newsweek, Sept. 28, 1959
[fig. 5-44]

5-45

5-46

45. Family at Dinner Table
(never published)
[fig. 5-45]

46. Doll Lullaby
The Saturday Evening Post,
Jan. 30, 1960
Time, Jan. 11, 1960
Newsweek, Jan. 18, 1960
[fig. 5-46]

47. Space Ship
The Saturday Evening Post,
March 26, 1960
Time, Feb. 29, 1960
Newsweek, Feb. 14, 1960
[fig. 5-47]

48. Teenager Studying
The Saturday Evening Post,
Feb. 20, 1960
Time, Feb. 8, 1960
Newsweek, Feb. 15, 1960
[fig. 5-48]

49. Football Hero
The Saturday Evening Post,
Sept. 16, 1961
Time, Sept. 22, 1961
Newsweek, Oct. 2, 1961
[fig. 5-49]

50. Juvenile Cowboy
The Saturday Evening Post,
Aug. 6, 1960
Time, July 11, 1960
Newsweek, Aug. 15, 1960
[fig. 5-50]

51. Birthday (never
published)
[fig. 5-51]

52. High School Graduate
The Saturday Evening Post,
June 17, 1961
Time, May 26, 1961
Newsweek, June 5, 1961
[fig. 5-52]

53. Dinosaur
The Saturday Evening Post,
March 2, 1963
Time, Feb. 15, 1963
Newsweek, Feb. 25, 1963
[fig. 5-53]

54. Daughter Welcoming
Father
The Saturday Evening Post,
May 13, 1961
Time, April 14, 1961
Newsweek, May 1, 1961
[fig. 5-54]

5-47

5-48

5-49

5-50

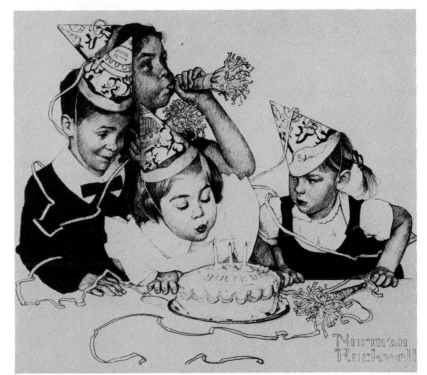

5-51

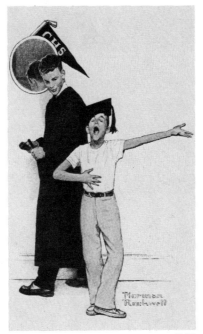

5-52

5-53

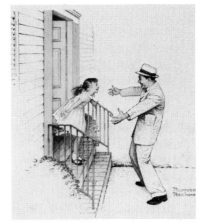

5-54

5-56

5-57

5-58

5-59

55. Woman at Home
[see 42, fig. 5-42]

56. Agent's Prestige
The Saturday Evening Post,
Oct. 1, 1960
Time, Sept. 12, 1960
Newsweek, Sept. 19, 1960
[fig. 5-56]

57. Father and Son Playing
Checkers
The Saturday Evening Post,
April 4, 1958
Time, April 13, 1958
Newsweek, April 20, 1955
[fig. 5-57]

58. Grandfather Wheeling Baby
The Saturday Evening Post,
Aug. 18, 1962
Time, July 27, 1962
Newsweek, Aug. 6, 1962
[fig. 5-58]

59. Boy with Barbell
The Saturday Evening Post,
Feb. 4, 1961
Time, Jan. 13, 1961
Newsweek, Jan. 23, 1961
[fig. 5-59]

60. Welcome Mat
The Saturday Evening Post,
March 24, 1962
Time, March 2, 1962
Newsweek, March 19, 1962
[fig. 5-60]

61. Norman Rockwell in
Voting Booth
The Saturday Evening Post,
Nov. 5, 1960
Time, Nov. 7, 1960
Newsweek, Nov. 7, 1960
[fig. 5-61]

5-60

5-62

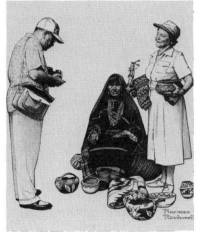

5-63

5-61

5-64

62. Boys Fishing
 The Saturday Evening Post,
 Aug. 26, 1961
 Time, Aug. 11, 1961
 Newsweek, Aug. 21, 1961
 [fig. 5-62]

63. Trading Post
 The Saturday Evening Post,
 July 22, 1961
 Time, June 30, 1961
 Newsweek, July 17, 1961
 [fig. 5-63]

64. Paying Family Bills
 The Saturday Evening Post,
 Jan. 27, 1962
 Time, Jan. 19, 1962
 Newsweek, Jan. 8, 1962
 [fig. 5-64]

5-65

5-67

5-69

5-66

5-68

5-70

65. Family Picnic
The Saturday Evening Post,
Oct. 6, 1962
Time, Sept. 14, 1962
Newsweek, Sept. 24, 1962
[fig. 5-65]

66. Dinner Jacket
The Saturday Evening Post,
Jan. 19, 1963
Time, Jan. 11, 1963
Newsweek, Jan. 28, 1963
[fig. 5-66]

67. For Dad's Approval (never
published)
[fig. 5-67]

68. Planting the Garden
The Saturday Evening Post,
July 14, 1962
Time, June 22, 1962
Newsweek, June 11, 1962
[fig. 5-68]

69. Cookout
The Saturday Evening Post,
Oct. 28, 1961
Time, Oct. 6, 1961
Newsweek, Oct. 16, 1961
[fig. 5-69]

70. Doghouse (never published)
[fig. 5-70]

71. Midnight Oil
The Saturday Evening Post,
Feb. 10, 1962
Time, Feb. 9, 1962
Newsweek, Feb. 12, 1962
[fig. 5-71]

72. Planning Estate
The Saturday Evening Post,
May 26, 1962
Time, May 4, 1962
Newsweek, May 14, 1962
[fig. 5-72]

73. Locomotive (never
published)
[fig. 5-73]

74. Best Brains
The Saturday Evening Post,
Nov. 10, 1962
Time, Oct. 12, 1962
Newsweek, Oct. 29, 1962
[fig. 5-74]

75. Retirement
The Saturday Evening Post,
May 11, 1963
Time, May 3, 1963
Newsweek, May 20, 1963
[fig. 5-75]

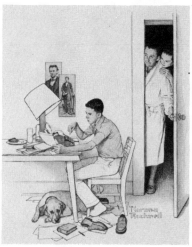

5-71

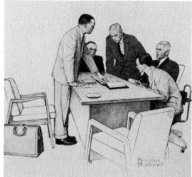

5-72

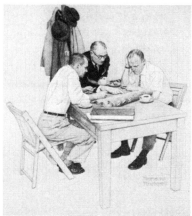

5-74

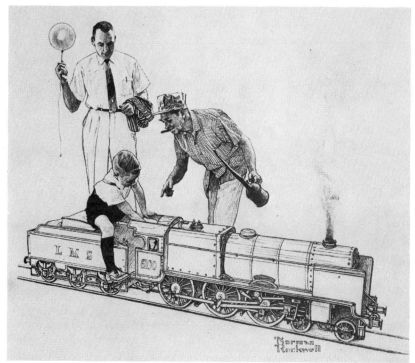

5-73

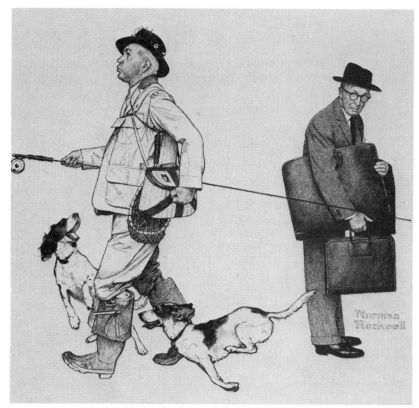

5-75

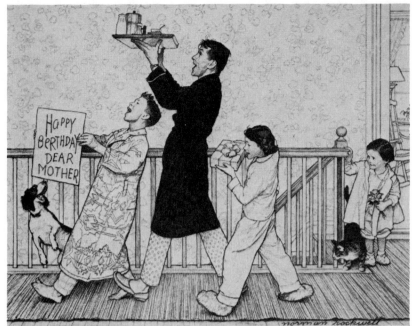

5-76

5-77

76. Mother's Birthday
 The Saturday Evening Post,
 June 29, 1963
 Time, June 7, 1963
 Newsweek, June 17, 1963
 [fig. 5-76]

77. Specialist
 Time, July 12, 1963
 Newsweek, Aug. 12, 1963
 [fig. 5-77]

78. Is There a Best Year?
 (6 illustrations)
 The Saturday Evening Post,
 Sept. 28, 1963
 Time, Sept. 20, 1963
 Newsweek, Sept. 9, 1963
 [fig. 5-78]

5-78

6
Portraits and Self-Portraits

Norman Rockwell painted and sketched portraits of fellow Navy personnel while serving during 1917-1918. It is not known how many portraits he painted in those early years, but one of his earliest was recently discovered in Carmel, California. The subject was Clyde Forsythe, friend and studio partner of young Rockwell in New Rochelle, New York. Done in about 1915, the portrait bears the inscription, "to good ole Clyde," signed, "Norman."

The presidential portraits by Rockwell are, for the most part, excellent examples of this art form. Rockwell especially enjoyed painting President Eisenhower because of his range of expression.

Although he painted a substantial number of portraits, Rockwell did not generally enjoy this art medium because he was often restrained from the application of "visual truth."

He painted the cast of characters in the film, "Stagecoach." He did Walter Brennan and John Wayne for the National Cowboy Hall of Fame. He painted Gary Cooper twice, Bob Hope, Jack Benny and many other notables of the entertainment world.

Norman Rockwell was perhaps his own best model. He painted or sketched himself at least 25 times between 1938 and 1976. Many of these self-portraits are incidental characters within an illustration, sometimes a figure in a crowd scene. Always, Rockwell does justice to his own mobile and expressive features.

At the age of 81 Rockwell produced his last self-portrait. He painted himself tying a ribbon around the Liberty Bell (see fig. 10-1C). He will most often be remembered for his now famous "Triple Self-Portrait," a whimsical introspect of the artist's image of himself (see fig. 1-416).

PORTRAITS:

1915:
Forsythe, Clyde, cartoonist/friend of Rockwell

1918:
Ellis, Captain Mark St. Clair (civilian dress)

Ellis, Captain Mark St. Clair (in uniform)

1921:
Phillips, Coles, illustrator

1930:
Cooper, Gary, actor [see fig. 1-235]

1936:
Smith, Governor Alfred E.

1939:
Garland, Judy, actress/singer

1943:
McLaughlin, Thomas, Post executive

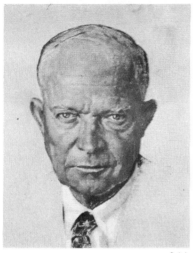

6-1A

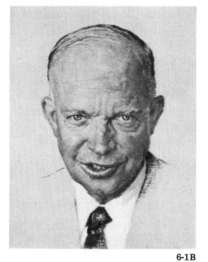

6-1B

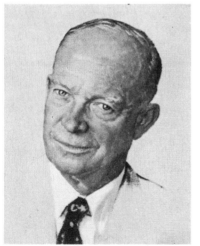

6-1C

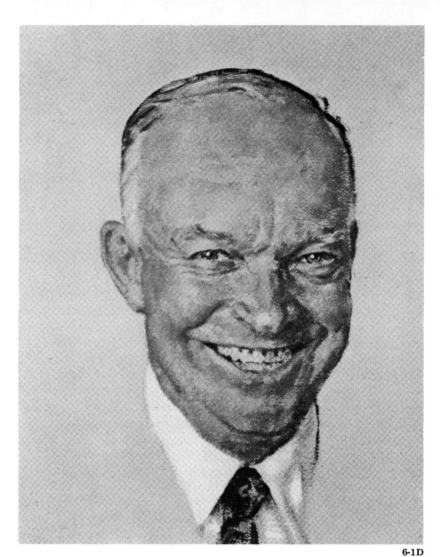

6-1D

6-1E

1945:
Cooper, Gary, actor

Stuart, Kenneth,
Post editor

1946:
Ayres, Colonel Henry
Fairfax, friend

1950:
Rockwell, Tom, Jerry
and Peter, Rockwell's
children

6-2

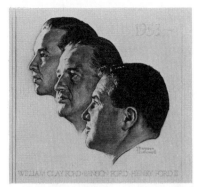

6-3

6-4

1952:
Eisenhower, President
Dwight D.
[fig. 6-1A-E, *see
also fig. 1-383*]

Eisenhower, Mrs.
Dwight D.
[fig. 6-2]

1953:
Ford, Benson, Clay
and Henry II, for
Ford Motor Company
[fig. 6-3]

Ford, Henry II, for
Ford Motor Company
[fig. 6-4]

Ford, Henry, Edsel
and Henry II, for
Ford Motor Company
[see fig. 8-37]

1954:
Hope, Bob,
actor/comedian
[see fig. 1-389]

1955:
Godfrey, Arthur,
entertainer

1956:
Eisenhower, President
Dwight D.
[see fig. 1-400]

Mattis, John, pilot
for Pan American
[see fig. 4-115]

Stevenson, Governor
Adlai E.
[see fig. 1-399]

1957:
Arab man

English policeman

Williams, Ted,
professional baseball
player

1958:
Arcaro, Eddie, jockey
[see fig. 1-408]

1959:
Rockwell, Mary Barstow,
Rockwell's wife

1960:
Kennedy, President
John F.
[fig. 6-5, *see
also fig. 1-420*]

6-5

Nixon, Richard M.
[see fig. 1-421]

1961:
McKesson, William,
Los Angeles District
Attorney

Rockwell, Gail,
Rockwell's daughter-
in-law

1962:
Ethiopian man

Indian art student
(New Delhi)

Indian boy

Miller, Mitch,
composer/musician

6-6

Nixon, Richard M.
[fig. 6-6]

Tibetan refugee, man

Tibetan refugee, teacher

Tibetan refugee, woman

1963:
Benny, Jack, comedian
[see fig. 1-428]

Kennedy, President
John F. (sketch for
American Red Cross)
[fig. 6-7]

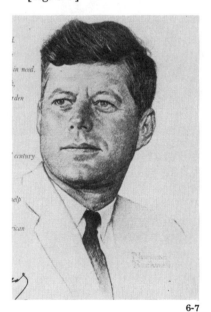

6-7

Kennedy, President
John F.
[see fig. 1-429]

Kennedy, Mrs. John F.
[see fig. 2-84]

Nasser, President
Abdul Gammel
[see fig. 1-430]

Nehru, Prime Minister
Jawaharlal
[see fig. 1-427]

Robinson, Brooks,
professional baseball
player

1964:
Goldwater, Senator
Barry
[fig. 6-8]

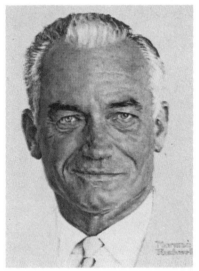

6-8

Goldwater, Mrs.
Barry

Johnson, President
Lyndon B.
[fig. 6-9]

Johnson, Mrs.
Lyndon B.
[see fig. 9-12]

Mongolian man

Russian author

Russian boy

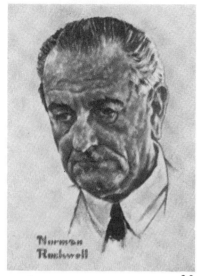

6-9

Russian intellectual, boy

Russian interpreter, man

Russian interpreter, woman

Russian man

1966:
Ann-Margret, actress

Buttons, Red, actor

Conners, Michael, actor

Cord, Alex, actor

Crosby, Bing, actor/singer

Cummings, Robert, actor

Heflin, Van, actor

Pickens, Slim, actor

Powers, Stephanie, actress

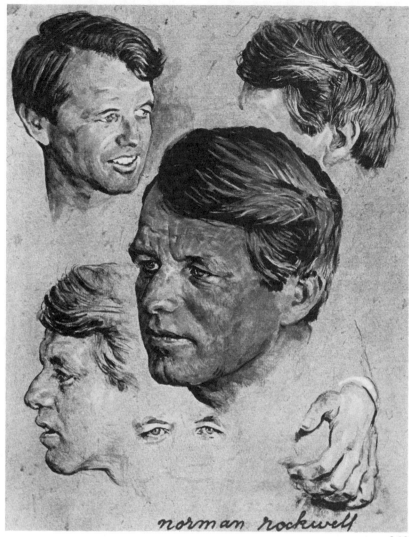

6-10

Wynn, Keenan, actor

1967:
An astronaut
[see fig. 2-35A]

Rockwell, Norman and wife, Molly

Russell, Bertrand, philosopher/author
[see fig. 2-41]

1968:
Humphrey, Vice-President Hubert H.

Johnson, President Lyndon B.

Kennedy, Senator Robert F.
[fig. 6-10]

McCarthy, Senator Eugene
[fig. 6-11 next page]

Nixon, President Richard M.
[fig. 6-12 next page]

Reagan, Governor Ronald

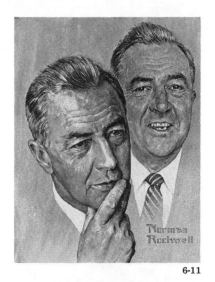

6-11

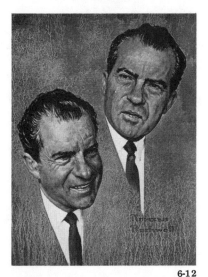

6-12

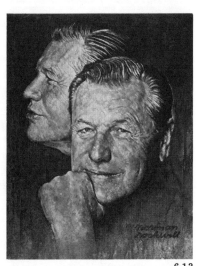

6-13

Rockefeller, Vice-President Nelson
[fig. 6-13]

1969:
Apollo 11 Space Team,
astronauts, crew, etc.

Nixon, President
Richard M.

1970:
Agnew, Vice-President
Spiro T.

Brennan, Walter, actor
[fig. 6-14]

6-14

Carson, Johnny, entertainer

1972:
Eisenhower, President
Dwight D.

McGovern, Senator and
Mrs. George
[fig. 6-15]

Nixon, President and
Mrs. Richard M.
[fig. 6-16]

Rojas-Lombardi, Felipe,
author

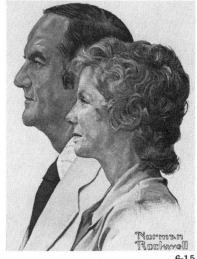

6-15

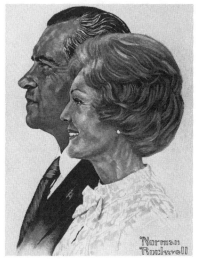

6-16

1973:
Sanders, Harlan,
businessman

Sinatra, Frank,
actor/singer

1974:
Erikson, Dr. Erik H.

Palmer, Arnold,
professional golfer

Walton, Donald,
businessman

Wayne, John, actor
[fig. 6-17]

Date unknown:
Clapper, Mr.

Lamone, Ann,
friend

Massey, Raymond,
actor

Rockwell, Mary Barstow,
Rockwell's wife

Rockwell, Norman
and Mary with
children, Tom, Jerry
and Peter, includes
dog "Raleigh"

SELF-PORTRAITS:

1938, Oct. 8:
The Saturday Evening Post
cover, "Artist Faced with
Blank Canvas"

1940, Nov. 2:
The Saturday Evening Post
story illustration, "Black-
smith's Boy—Heel and Toe"

1943, July 17:
The Saturday Evening Post
feature, "My Studio Burns"

1943, Nov. 13:
The Saturday Evening Post
feature, "So You Want to
See the President"

1944, July 15:
The Saturday Evening Post
feature, "Norman Rockwell
Visits a Ration Board"

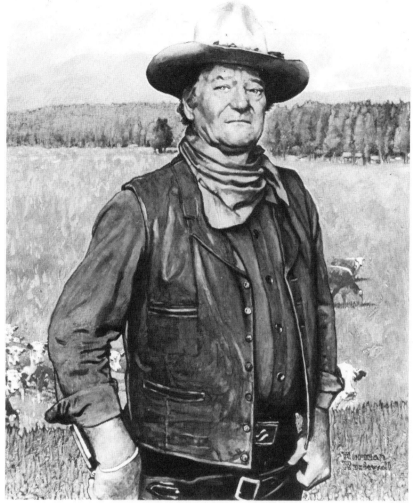

6-17

1946, May 25:
The Saturday Evening Post
feature, "Norman Rockwell
Visits a Country Editor"

1948, March 6:
The Saturday Evening Post
cover, "The Gossips"

1948, Dec. 25:
The Saturday Evening Post
cover, "Christmas
Homecoming"
(Rockwell and two sons)

1956, March 17:
Pan American Airlines
advertisement

1959, Feb. 14:
The Saturday Evening Post
cover, "The Holdout"

1960, Feb. 13:
The Saturday Evening Post
cover, "Triple Self-
Portrait"

1960, Aug. 27:
*The Saturday Evening
Post* cover, "The
University Club"

1960, Nov. 5:
Massachusetts Mutual
ad #61, "Norman
Rockwell in Voting
Booth"

1963:
 Poor Richard's Almanack,
 "Almanack Scenes" (book
 illustration)

1964, Oct. 20:
 Look Magazine feature,
 "Rockwell at the
 Barbershop"

1964, Oct. 20:
 Look Magazine feature,
 "Rockwell and Barry
 Goldwater"

1966:
 Film, "Stagecoach"
 (wagon trail scene)

1966, Oct.:
 McCall's story illustra-
 tion, "The Saturday People"

1967:
 Boy Scout calendar

1967:
 Norman and Molly Rockwell

1968, Aug. 20:
 Look Magazine feature,
 "The Right to Know"

1971, June 1:
 Look Magazine feature,
 "Spring in Stockbridge"

1976, July:
 American Artist Magazine,
 cover, "Celebration"
 [see fig. 10-1C]

7
Greeting Cards

Norman Rockwell began his illustrious career by painting four Christmas cards in 1911. Busy with other things, he did not devote much more effort to this area of illustration until 1948 when he was commissioned by Hallmark Cards Incorporated of Kansas City to create a series of Christmas cards. These proved to be extremely popular and in 1975 Hallmark commissioned Rockwell to create a new series.

Of special interest as curiosities are the Christmas, Easter, and Valentine's Day telegram forms designed by Rockwell for Western Union. These appeared in 1935 and 1936 and were used for some years thereafter. Each has a full-color decorative heading suitable for the season.

HALLMARK CHRISTMAS CARDS:

1948:
"The Christmas Trio"

"The Dancers"

"Ring-Around the Book Man"

"Santa's Helpers"

1949:
"Homecoming"

1950:
"And the Angels Sing"
[fig. 7-1 *next page*]

"Bass Fiddler"
[fig. 7-2]

7-2

"Bringing Home the Tree"
SOX923-1
[fig. 7-3]

"The Carolers"
50X922-1
[fig. 7-4 *next page*]

7-3

"The Choirboy"

"A Christmas Prayer"

"Edgar A. Guest"
75X912-5

"Jolly Postman"

7-5

7-8

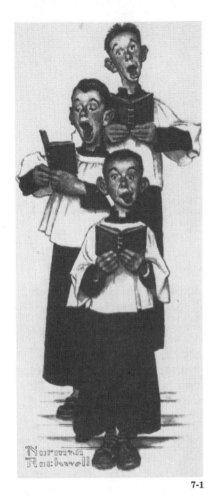

7-1

7-6

"Santa Holding Quill"
250BX15-2A
[fig. 7-6]

"Santa Slumped in
Chair"
275BX3-3C
[fig. 7-7]

"Santa with Book and
Telescope"
275BX3-3B
[fig. 7-8]

"Santa's Surprise"
[fig. 7-9]

"Two Kids Asleep"
257BX3-3A
[fig. 7-10]

1975:
"Especially For You"
face in wreath
912-5
[fig. 7-11]

"God Bless You"
child kneeling
910-2
[fig. 7-12]

"Merrie Christmas"
913-5

"Remembering You"
913-2

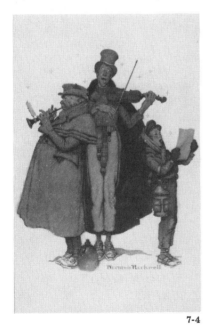

7-4

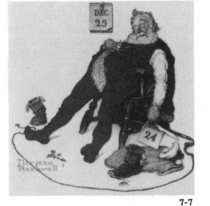

7-7

"Red Cape and Mistletoe"
50X921-4
[fig. 7-5]

"Red Mittens"

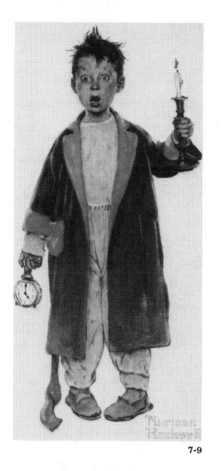

7-9

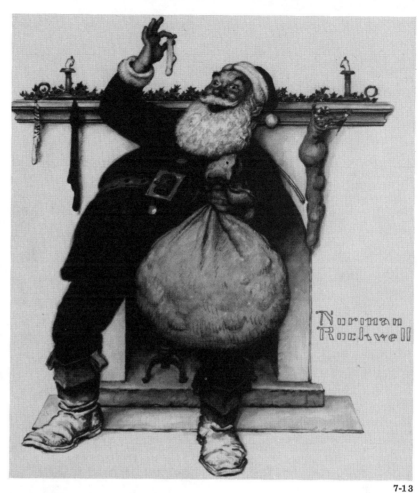

7-13

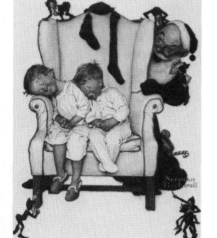

7-10

7-11

7-12

"Thinking of You"
915-5

"To Someone Special"
tiny stocking
912-2
[fig. 7-13]

7-14

"To A Special Friend"
914-2
[fig. 7-14]

"Warmhearted Wishes"
Salvation Army Santas
911-2
[fig. 7-15]

"With Love"
putting star on tree
910-5
[fig. 7-16]

"With Loving Memories"
fitting Santa's suit
915-2
[fig. 7-17]

"You're Nice to Know"
911-5

1976:
 "Patchwork Quilt"
 350-PX-416-9

1977:
 "Dress Rehearsal"
 325-BX-1-2

1978:
 "Dress Rehearsal"
 375-PX-87-2

 "The Musicians"
 550-PX-4-6

7-15

"Santa's Arrival"
45C-DX-10-6

HALLMARK BOXED
 CHRISTMAS CARDS:

1975:
 "Bringing Home the
 Tree," "Santa and
 Children," "Child
 Kneeling"
 350BX-7-7

7-16

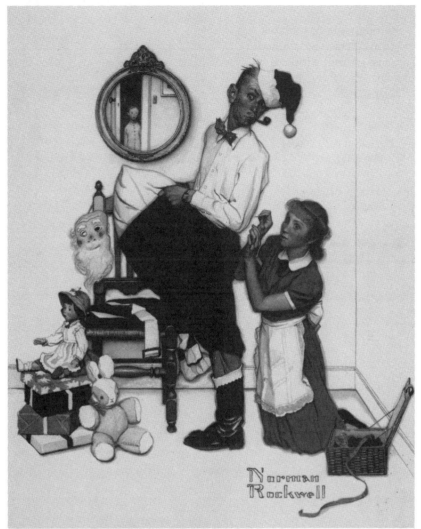

7-17

7-18

7-19

1970:
 Guideposts Associates
 Christmas card, stained
 glass church window
 with choirboys holding
 hymnals

Date unknown:
 Personal notepaper,
 "The Dugout"

 "Happy Birthday"
 postcard

7-20

1947:
 American Heritage
 Christmas card (Four
 Seasons) "Grandpa
 and Me"
 [fig. 7-19]

1964:
 Peter Lind Hayes post-
 card, "All the Best"
 [fig. 7-20]

8
Calendars

Norman Rockwell's earliest calendar art appeared in 1918 for *Life* magazine entitled, "You Can Trust Me, Dad."

Rockwell began illustrating Boy Scout calendars in 1925 and, with the exception of the years 1928 and 1930, produced one every year thereafter. The last was "The Spirit of '76." Many of his nearly 50 works for this organization also appeared on the covers of *Boys' Life*.

Perhaps the most popular of his calendar works are his "Four Seasons" illustrations for Brown & Bigelow which feature four Rockwell paintings in each edition. They first appeared in 1947, were published on a regular basis for 17 years, and have been republished in various styles and sizes since 1964.

The "Triple Portrait" of Henry Ford, his son, Edsel, and grandson, Henry II, was done for the Ford Motor Company's 50th anniversary commemorative calendar and was later used to commemorate the 75th. By far the most reproduced Rockwell, this illustration appeared on every piece of paper used by the Ford Motor Company during the year 1953.

In recent years several companies have reproduced Rockwell's previously published work on calendars. They are not included herein.

1918:
Life Patriotic Calendar, "You Can Trust Me, Dad"

1920:
De Laval Separators, "Painting the Kite" [fig. 8-1 *next page*]

1922:
Warren National Bank, "The Music Master"

Save the surface campaign of the paint industry, boy painting birdhouse

1925:
Boy Scouts of America, "A Good Scout" [fig. 8-2]

8-2

1926:
Boy Scouts of America, "Good Turn" [fig. 8-3]

8-3

8-1

8-4

8-5

1927:
 Boy Scouts of America,
 "Good Friends"
 [fig. 8-4]

1929:
 Boy Scouts of America,
 "Spirit of America"
 [fig. 8-5]

1930:
 Brown & Bigelow

1931:
 Boy Scouts of America,
 "Scout Memories"
 [fig. 8-6]

 Coca-Cola, Tom Sawyer
 drinking a Coke
 [fig. 8-7]

1932:
 Boy Scouts of America,
 "A Scout is Loyal"
 [fig. 8-8]

Coca-Cola, boy and dog
rest on well
[fig. 8-9]

1933:
 Boy Scouts of America,
 "An Army of Friendship"
 [fig. 8-10]

1934:
 Boy Scouts of America,
 "Carry On"
 [fig. 8-11]

 Coca-Cola, "Southern
 Comfort"
 [fig. 8-12 *next page*]

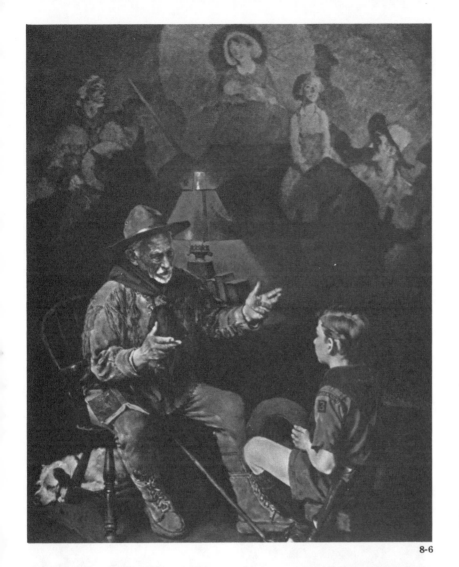

8-6

8-9

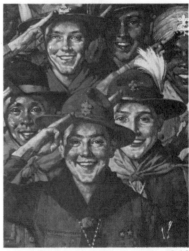

8-10

8-7

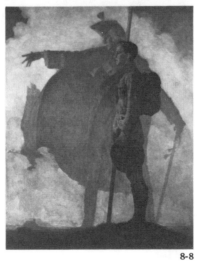

8-8

8-11

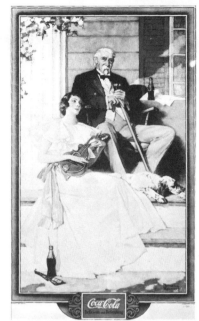

8-12

8-13

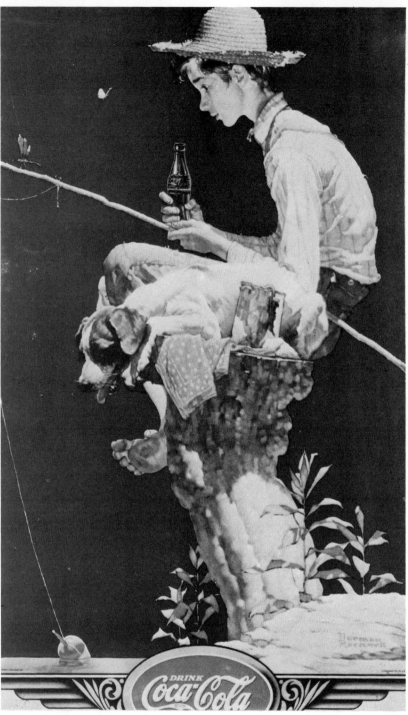

8-14

1935:
Boy Scouts of America,
"A Good Scout"
[fig. 8-13]

Keniper-Thomas Co.,
"Midst the Magic Dreams
of Childhood"

Coca-Cola, boy and dog
fishing
[fig. 8-14]

1936:
Boy Scouts of America,
"The Campfire Story"
[fig. 8-15]

1937:
Boy Scouts of America,
"Scouts of Many Trails"
[fig. 8-16]

8-15

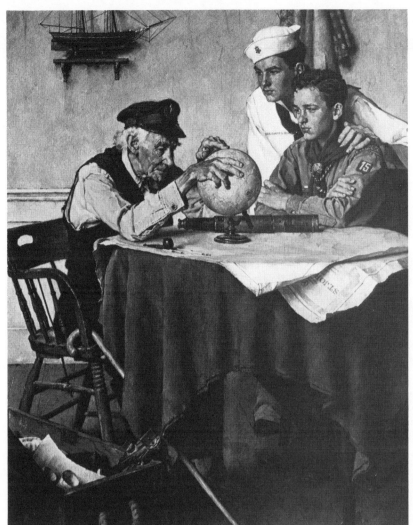

8-17

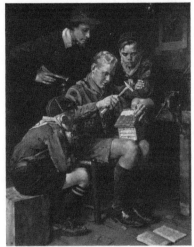

8-16

1938:
 Boy Scouts of America,
 "America Builds for
 Tomorrow"
 [fig. 8-17]

1939:
 Boy Scouts of America,
 "The Scouting Trail"
 [fig. 8-18]

1940:
 Boy Scouts of America,
 "A Boy Scout is
 Reverent"
 [fig. 8-19]

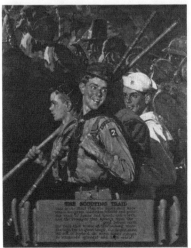

8-18

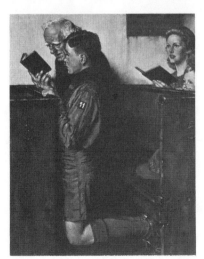

8-19

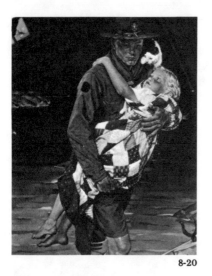

8-20

8-23

8-21

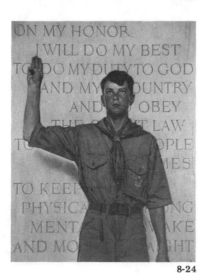

8-24

8-22

8-25

1941:
Boy Scouts of America,
"A Scout is Helpful"
[fig. 8-20]

1942:
Boy Scouts of America,
"A Scout is Loyal"
[fig. 8-21]

1943:
Boy Scouts of America,
"A Scout is Friendly"
[fig. 8-22]

1944:
Boy Scouts of America,
"We Too Have a Job
To Do"
[fig. 8-23]

1945:
Boy Scouts of America,
"I Will Do My Best"
[fig. 8-24]

American Fire Insurance
and Indemnity Group,
"American Way"

Brown & Bigelow, "The
Land of the Free"

1946:
Boy Scouts of America,
"A Guiding Hand"
[fig. 8-25]

First National Bank of
South River, New
Jersey, Memory
Calendar, "O'er the Land
of the Free"
[fig. 8-26]

John Morrell & Co.'s
Tom Sawyer calendar with
illustrations similar to
those in the book THE
ADVENTURES OF TOM
SAWYER (1936)
[fig. 8-27A-J,
I and J on next page]

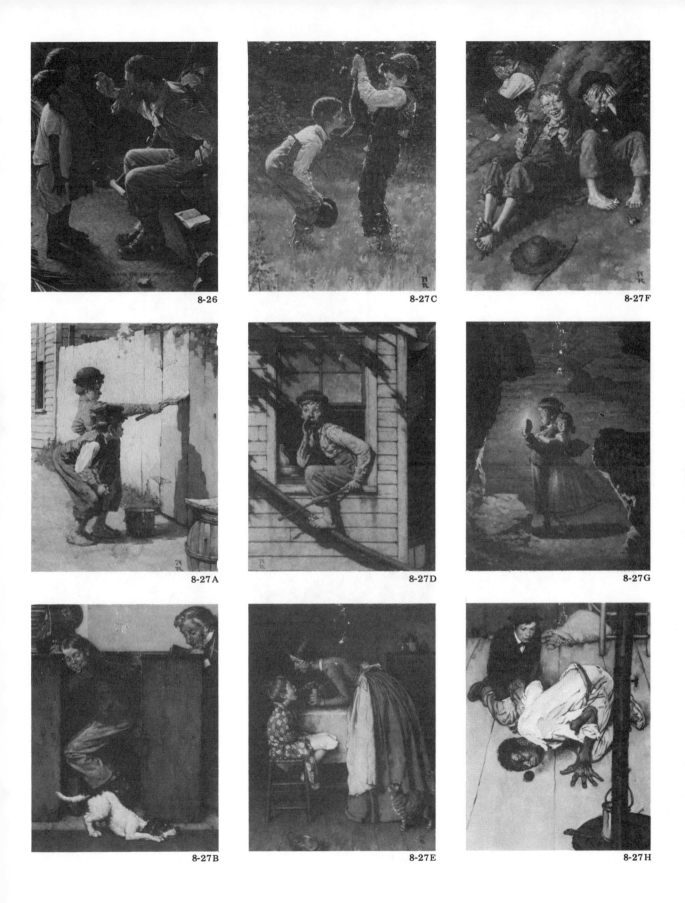

8-26

8-27C

8-27F

8-27A

8-27D

8-27G

8-27B

8-27E

8-27H

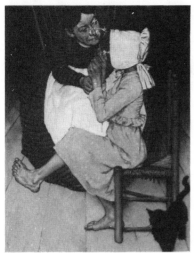

8-27I

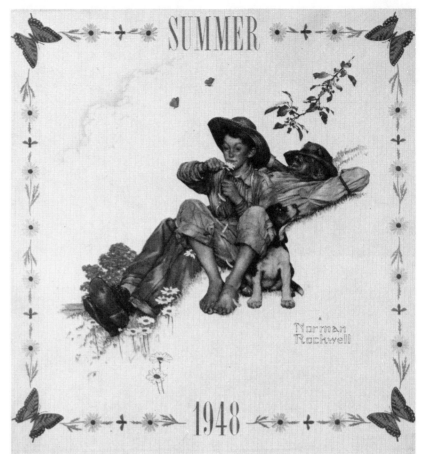

SUMMER

1948

8-30A

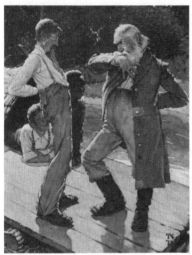

8-27J

8-28

8-29

8-31

1947:
 Boy Scouts of America,
 "All Together"
 [fig. 8-28]

Brown & Bigelow, Four
Seasons

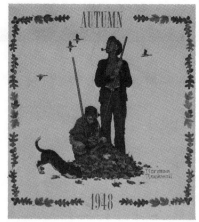

8-30B

1948:
Boy Scouts of America,
"Men of Tomorrow"
[fig. 8-29]

Brown & Bigelow, Four
Seasons
[fig. 8-30 A, B]

1949:
Boy Scouts of America,
"Friend in Need"
[fig. 8-31]

Brown & Bigelow, Four
Seasons

1950:
Boy Scouts of America,
"Our Heritage"
[fig. 8-32]

Brown & Bigelow, Four
Seasons

1951:
Boy Scouts of America,
"Forward America"
[fig. 8-33]

Brown & Bigelow, Four
Seasons, "Four Boys"

1952:
Boy Scouts of America,
"The Adventure Trail"
[fig. 8-34]

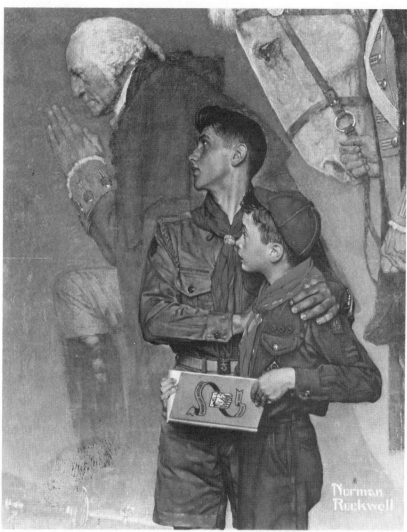

8-32

8-33

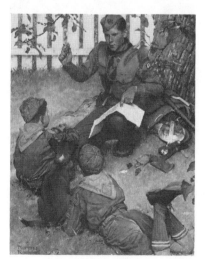

8-34

8-35A

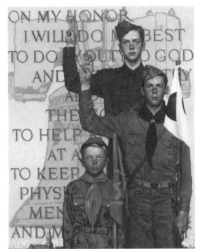

8-36

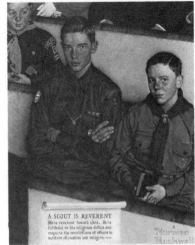

8-38

8-35B

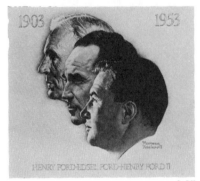

8-37

1955:
 Boy Scouts of America,
 "The Right Way"
 [fig. 8-39]

 Brown & Bigelow, Four
 Seasons, "Four Ages
 of Love"

1956:
 Boy Scouts of America,
 "The Scoutmaster"
 [fig. 8-40]

 Brown & Bigelow, "Two
 Old Friends"

1957:
 Boy Scouts of America,
 "High Adventure"
 [fig. 8-41]

 Brown & Bigelow, Four
 Seasons

 "Top of the Mountain"

1958:
 Boy Scouts of America,
 "Mighty Proud"
 [fig. 8-42]

8-35C

Brown & Bigelow, Four
Seasons, "Grand Pals"
[fig. 8-35A, B, C]

1953:
 Boy Scouts of America,
 "On My Honor"
 [fig. 8-36]

 Brown & Bigelow, Four
 Seasons

 Ford Motor Company,
 "50th Anniversary of
 the Ford Motor Company"
 [fig. 8-37]

1954:
 Boy Scouts of America,
 "A Scout is Reverent"
 [fig. 8-38]

 Brown & Bigelow, Four
 Seasons

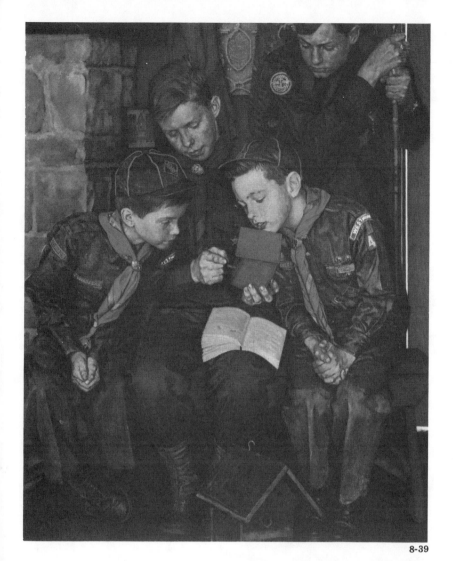

8-39

8-41

8-42

Brown & Bigelow, Four
Seasons

1959:
 Boy Scouts of America,
 "Tomorrow's Leader"
 [fig. 8-43]

 Brown & Bigelow, Four
 Seasons, "Young Love"

 General Electric Company,
 researchers in laboratory

8-40

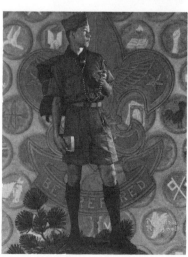

8-43

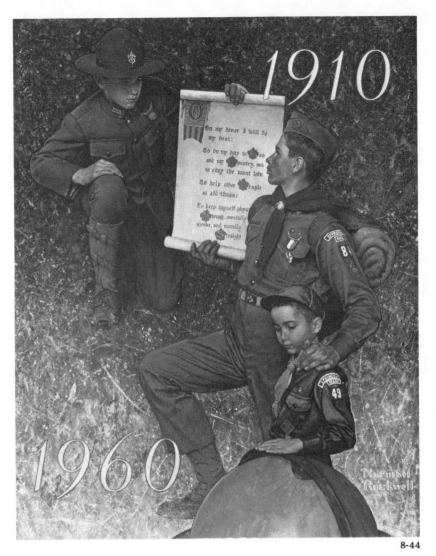

8-44

8-47

8-48

8-45

8-46

8-49

8-50

1960:
 Boy Scouts of America,
 "Ever Onward"
 [fig. 8-44]

 Brown & Bigelow, Four
 Seasons

 "Preparing for Winter"

1961:
 Boy Scouts of America,
 "Homecoming"
 [fig. 8-45]

 Brown & Bigelow, Four
 Seasons

1962:
 Boy Scouts of America,
 "Pointing the Way"
 [fig. 8-46]

 Brown & Bigelow, Four
 Seasons

1963:
 Boy Scouts of America,
 "A Good Sign All Over
 the World"
 [fig. 8-47]

8-51

1964:
 Boy Scouts of America,
 "To Keep Myself
 Physically Strong"
 [fig. 8-48]

 Brown & Bigelow, Four
 Seasons

1965:
 Boy Scouts of America,
 "A Great Moment"
 [fig. 8-49]

 Brown & Bigelow, Four
 Seasons

1966:
 Boy Scouts of America,
 "Growth of a Leader"
 [fig. 8-50]

 Brown & Bigelow, Four
 Seasons

1967:
 Boy Scouts of America,
 "Breakthrough for
 Freedom"
 [fig. 8-51]

 Brown & Bigelow, Four
 Seasons

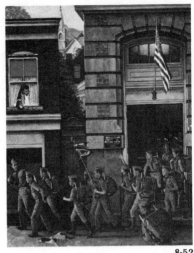

8-52

Norman Rockwell

appointment calendar
1975

8-53C

8-53A

8-53D

8-53F

8-53B

8-53E

8-53G

8-53H

8-53I

8-53J

1970:
 Boy Scouts of America,
 "Come and Get It"

 Brown & Bigelow, Four
 Seasons

1971:
 Boy Scouts of America,
 "America's Manpower
 Begins with Boypower"

 Brown & Bigelow, Four
 Seasons

1972:
 Boy Scouts of America,
 "Can't Wait"

 Brown & Bigelow, Four
 Seasons

1973:
 Boy Scouts of America,
 "From Concord to
 Tranquility"

 Brown & Bigelow, Four
 Seasons

 Ben Franklin's "Success
 and Happiness" calendar,
 cartoons by Norman
 Rockwell

1974:
 Boy Scouts of America,
 "We Thank Thee, O
 Lord"

 Brown & Bigelow, Four
 Seasons

1975:
 Boy Scouts of America,
 "So Much Concern"

 Brown & Bigelow, Four
 Seasons, "Four Ages
 of Love"
 [fig. 8-53A-J]

1968:
 Boy Scouts of America,
 "Scouting is Outing"
 [fig. 8-52]

 Brown & Bigelow, Four
 Seasons

1969:
 Boy Scouts of America,
 "Beyond the Easel"

 Brown & Bigelow, Four
 Seasons

8-54

8-55B

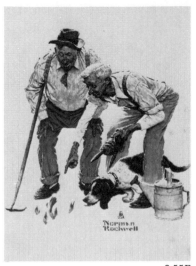

8-55E

8-55A

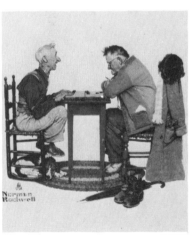

8-55C

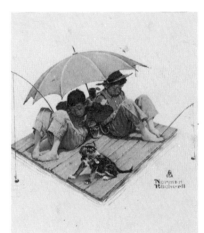

8-55F

8-55D

8-55G

8-55H

1976:
 Boy Scouts of America,
 "The Spirit of '76"
 [fig. 8-54]

 Brown & Bigelow, Four
 Seasons, "Young Love"

1977:
 Brown & Bigelow, Four
 Seasons Postcard
 Calendar
 [fig. 8-55A-H]

1978:
 Brown & Bigelow, Four
 Seasons

Date unknown:
 Brown & Bigelow, "Mrs.
 O'Leary and Her Cow"

9
Other Work

Probably the best-known of Rockwell's booklet illustrations is the silhouette of two college students done for the Berkshire Community College. The front and back cover illustrations of the Jell-O booklet, done in 1922, also appear as magazine ads. The two-page centerfold illustration is, however, a little known work.

The Top Value Stamp catalog covers are the most numerous of Rockwell's catalog illustrations and perhaps the best known. He turned out eight of these between the years 1965 and 1973. He also illustrated two of the popular Sears and Roebuck catalogs.

The mural depicting Yankee Doodle arriving at the Nassau Tavern in Princeton, New Jersey, can be viewed in that same location today. "Yankee Doodle," approximately thirteen feet long, took Rockwell more than nine months to complete.

One of Rockwell's most striking posters is "Stagecoach" which advertised the western film of the same name. The "Four Freedoms," originally a feature series in *The Saturday Evening Post*, were later reproduced as posters to promote the sale of war bonds during World War II.

The sheet music illustrations for "Over There" and "Little French Mother Good-bye" were originally done as *Life* Magazine covers. Rockwell changed a few details of the little French girl on a 1918 *Judge* cover and transformed her into a little Dutch girl to illustrate "Over Yonder Where the Lilies Grow." Geoffrey O'Hara, author of that song, is remembered for having written the popular "K-K-K-Katy." The song "Lady Bird Cha Cha Cha," inspired by the First Lady's dedication to the beautification of America, has Rockwell's portrait of Lady Bird on its cover.

The "Tom Sawyer Commemorative Stamp" is an enduring tribute to two outstanding Americans: Mark Twain and Norman Rockwell. Rockwell's portrayal of Tom Sawyer's celebrated fence whitewashing episode has to date inspired many variations. The stamp commemorating the 50th Anniversary of the Boy Scouts of America had a total of 1,419,955 covers cancelled—the greatest number ever cancelled at that time for any one stamp. "The Spirit of '76," his last stamp, was the first of a series of special first day covers. In the "Stamps" list, the dates indicated are issue dates.

Of interest are some of Rockwell's lesser known commercial works listed at the end of this chapter.

Most of the illustrations in the booklets, catalogs, and murals listed in this chapter were done specifically by Rockwell for that purpose. The posters, sheet music, and stamps, however, are in some cases reprinted versions of other of Rockwell's previously published works.

BOOKLETS:

1922:
General Foods Corp.
Jell-O, three illustrations
[fig. 9-1]

1926:
The city of New Rochelle
"New Rochelle, The
City of Huguenots"
Commemorative booklet
in celebration of the
250th anniversary of the
city of New Rochelle,
New York. One
illustration

1943:
Twentieth Century-Fox
"Song of Bernadette"
Movie promotional

1969-1971:
Berkshire Community
College
Silhouette of two students,
illustrated in gold
and black

1970:
A-T-O Inc. Annual Report
"Champions Know Us"
Baseball scene

1971:
A-T-O Inc. Annual Report
"The New American
LaFrance Is Here"
Fire engine scene

1971-1973:
Berkshire Community
College
Same as 1969-71, a reverse
of the negative in
black and white
[fig. 9-2]

1972:
A-T-O Inc. Annual Report
"You've Got To
Be Kidding!"
Construction workers
and hippie

1973:
A-T-O Inc. Annual Report
"Adirondack Winter"
Sled scene

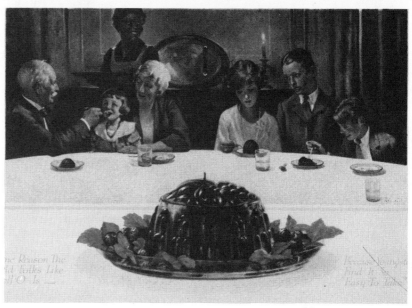

9-1

1974:
Coca-Cola Company
"The Coca-Cola Company:
Illustrated Profile"
Three illustrations

CATALOGS:

1915:
Tombstones

1925:
Montgomery Ward and
Company
"The Treasure Chest"

1932:
Sears Roebuck & Co.
"Sears and Roebuck"

1938, Nov.:
Boy Scouts of America
Equipment catalog,
Vol. I and III

1938, Nov.:
The Local Council Exchange

9-2

1939, Nov.:
Boy Scouts of America
Equipment catalog,
Vol. II and V

1939, Nov.:
The Local Council Exchange

9-3

1960:
"Books About Fords"
Same as Ford ad
"Farmer Takes A Ride"
[fig. 9-3]

1965:
Top Value Enterprises, Inc.
"Girl At The Mirror"

1966:
Top Value Enterprises, Inc.
Boy playing guitar,
girl grimacing

1967:
Top Value Enterprises, Inc.
Honeymooners studying
catalog

1968:
Danenberg Gallery
Norman Rockwell
Exhibition

1968:
Top Value Enterprises, Inc.
"Home from Camp"

1969:
Ivan Reese Company
"Home from the Fields"

1969:
Top Value Enterprises, Inc.
Girl trying on pink bonnet

1970:
Top Value Enterprises, Inc.
"Look What Time It Is"

1972:
Bamberger's
Sales catalog

1972:
Stern's Department Store

1972:
Top Value Enterprises, Inc.
"The Haircut"

1972:
Top Value Enterprises, Inc.
"The Parade"

1973:
Top Value Enterprises, Inc.
"The Bride"

1973:
Stern's Department Store

1973:
Watson-Guptill Publications
Falling boy holding
basketball

1975:
J & S Catalog
Norman Rockwell paintings
for sale, #22

1976:
Sears Roebuck & Co.
George Washington
Bicentennial Committee

MURALS:

1934:
"Land of Enchantment"
In the New Rochelle (N.Y.)
Public Library; first
appeared as a *Post*
feature Dec. 22, 1934.
Size: 75″ x 38″

1935:
"The Dover Coach" or
"The Christmas Coach"
Over the bar at the
Society of Illustrators
clubrooms, New York City;
appeared as a *Post*
feature Dec. 28, 1935.

1935:
"Yankee Doodle" in
the Nassau Tavern,
Princeton, N.J.
Size: 13′ x 15′

1959:
"Pittsfield, Massachusetts"
Hangs in the home office
of the Berkshire Life
Insurance Company in
Pittsfield.

POSTERS:

1928:
Coca-Cola Company
"Ree-Fresh Yourself is
Right"
[fig. 9-4]

9-4

9-5

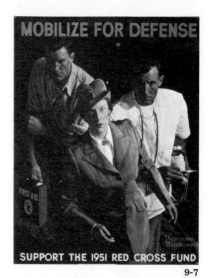

SUPPORT THE 1951 RED CROSS FUND

9-7

1931:
 Coca-Cola Company
 "OK, The Pause that
 Refreshes"
 [fig. 9-5]

1931 (circa):
 Maxwell House Coffee

1932:
 Red Cross
 "Join the Red Cross"
 [fig. 9-6]

9-6

1942:
 "Magnificent Ambersons"
 Movie promotional poster

1943:
 War Bond Drive
 "Freedom of Speech"

1943:
 Brown & Bigelow
 "O'er the Land of the Free"

1944 (circa):
 "The Spirit of St. Louis"
 In collaboration with
 John Atherton

1945:
 "Along Came Jones"
 With Gary Cooper,
 movie promotional

1946:
 "The Razor's Edge"
 With Tyrone Power,
 movie promotional

1951:
 Red Cross
 "Mobilize for Defense,
 Support the
 Red Cross Fund"
 [fig. 9-7]

1951:
 Parent Magazine
 Official Mother's Day poster

1951:
 Red Cross
 "Support
 the Red Cross
 Fund"

1961:
 Daytona Beach Florida
 Chamber of Commerce
 "Daytona Beach"

1966:
 Winchester Western
 "Stagecoach" movie
 promotion

1967:
 McCall's Magazine
 "Christmas in Stockbridge,
 Massachusetts"
 [fig. 9-8 *next page*]

1968:
 "The Right to Know"

1972:
 Boy Scouts of America
 "Boy Power"

1973:
 "Serve in the Reserve"

9-9

1976:
A.T. & T.
"The Lineman"
Reproduction of an
earlier illustration

Date unknown:
The Literary Guild
"Young Abraham Lincoln"
[fig. 9-9]

SHEET MUSIC:

1918:
"Over There"
Words and music by George
M. Cohan, published by Leo
Feist Inc. (same as *Life*
cover of Jan. 1918)
[fig. 9-10]

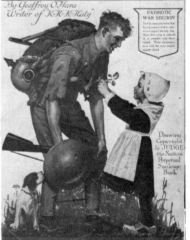

9-10

9-11

1918:
"Over Yonder Where the
Lilies Grow"
By Geoffrey O'Hara,
published by Leo Feist Inc.
(similar to *Judge*
cover of Aug. 10, 1918)
[fig. 9-11]

1918:
"Little French Mother
Goodbye"
(same as *Life* cover
of March 13, 1919)

9-8

9-13

9-12

1962:
 "Family Sing-Along With Mitch" songbook, Mitch Miller and the Gang, published by Robbins Music Corporation.

1968:
 "Lady Bird Cha Cha Cha" Words by Frank H. Keith, music by Samuel Starr, published by DeBesth Music Publishing Co. (same as portrait of Mrs. Lyndon B. Johnson) [fig. 9-12]

STAMPS:

1960, Feb. 8:
 Four-cent stamp honoring the 50th anniversary of the Boy Scouts. Designed by Rockwell, V.W. McCloskey, Jr., E. Metzl, Wm. K. Schrange. Scott #1145

1963, Oct. 14:
 Five-cent stamp honoring 100th anniversary of City Mail Delivery. First day covers. Scott #1238

1972, Oct. 13:
 "Tom Sawyer Commemorative Stamp" of the American Folklore Series. Issued in Hannibal, Missouri. Designed by Bradbury Thompson after a painting by Norman Rockwell. Scott #1470 [fig. 9-13]

1973, Nov. 16:
 Special Norman Rockwell souvenir color cachet issued from The United Nations. "Human Rights and Brotherhood." Size: 8½" x 11" Cachet print. Numbered and limited to 2,500.

1973, Nov. 16:
 Eight- and 21-cent stamps commemorating the 25th anniversary of the United Nations "Declaration of Human Rights and Brotherhood." First day covers. Scott #242 and #243.

1976, Jan. 1:
Commemorative cachet, first
issue of Postmasters of
America Philatelic First
Day Cover Series. "The
Spirit of '76" (drummer,
flag and fife). Issued in
Pasadena, California; original
issue price $2.75.

MISCELLANEOUS COMMERCIAL WORK:

1972:
Boy Scouts of America
Registration certificate

1972:
Boy Scouts of America
Sustaining member
certificate

1972:
Schmidt's Brewing Company
"The Card Players"
Playing cards

1972:
Brown & Bigelow
"The Four Seasons"
Playing cards

Date unknown:
Columbia
"Adventures Of Mike
Bloomfield And Al Hooper"
Album cover, heads of two
dark-haired men

10
Biographical Articles

Although Norman Rockwell eventually became as recognizable as one of his illustrations, such recognition came slowly. His photograph accompanied illustrations in a 1914 *Boys' Life* and in a 1919 *Century* magazine, but few biographical sketches appeared prior to 1940 in other than art magazines. *The Saturday Evening Post* first printed information about Rockwell in 1926, ten years (and 82 covers) after their association began.

Perhaps the most provocative opinion on Rockwell's work was expressed in a 1970 article in *Life* entitled: "If We All Like It, Is It Art?"

By 1978, 140 articles chronicling Rockwell's accomplishments had appeared in over 56 publications. His death in November, 1978, was reported in newspapers and periodicals throughout the world. Today his name and work are legend.

ADVERTISING AGE:

1960, March 7:
"Ad Painting Less Fun but It Pays."

AMERICAN Magazine:

1921, May:
"Interesting People: The Man Who Painted Our Cover this Month"

1930, Nov.:
"People We All Like," by Jerome Beatty

1936, May:
"Norman Rockwell Home," and an editorial by Norman Rockwell

AMERICAN ART STUDENT:

1925, Jan.:
"Story of Norman Rockwell"

AMERICAN ARTIST:

1940, May:
"Painter for America's Millions"

1941, June:
"Man, a violin and a glass of beer"

1945, Jan.:
"Norman Rockwell Palette"

1951, Sept.:
Biographical data and photograph of Norman Rockwell

1956, June:
"They Drew Their Way"

1964, Sept.:
Sketches of Norman Rockwell

1971, Nov.:
"Recommended Reading," book review

In his studio, Rockwell adjusted his ascot before posing for the reference photograph he would need in painting the cover for *American Artist*. Photo Jim Craig.

AMERICAN
ARTIST
formerly ART INSTRUCTION

Painting

Sculpture

Illustration

Advertising Art

Design

MAY 1940
55 cents

Norman Rockwell first appeared on the cover of *American Artist* in 1940. The magazine had only recently begun publication.

10-1A

Above: On a 9 x 12 sheet of paper, Rockwell made a rough oil sketch (his only color study) and placed it in a mat. Right: At his easel Rockwell referred to his materials as he painted. Photo Jim Craig.

10-1B

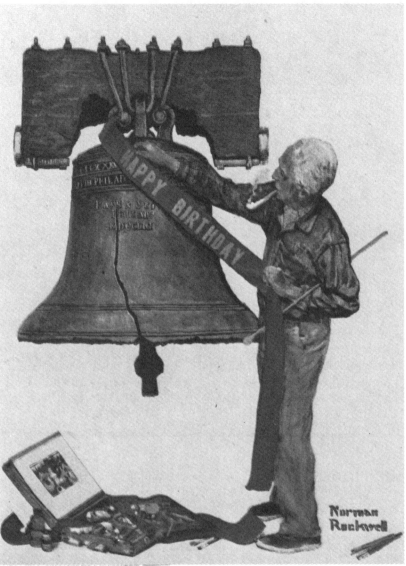

10-1C

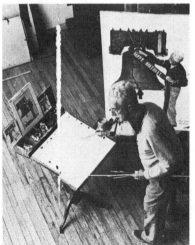

10-1D

1976, July:
 "As American as Norman
 Rockwell" by Susan E.
 Meyer
 [fig. 10-1 A, B, C, D]

AMERICAN BOY:

1920, Dec.:
 "The Boy on the Cover"
 Article about Rockwell and
 his model Eddie Carson

AMERICANA MAGAZINE:

1978, July:
 "Artistic Roots of
 Norman Rockwell"

ANNIVERSARY (Ford Motor
 Company Publications):

1953, Feb.:
 "The Rockwell Calendar"

ANTIQUE TRADER:

1976, March 9:
 "Relic Round-Up. . .Rich
 Reward for a Rockwell"

1976, April 1:
 "Collecting the Early
 Works of Norman Rockwell,"
 by Steven Lomazow, M.D.

1977, April 6:
 "Early Works of Norman
 Rockwell," by
 Steven Lomazow, M.D.

ART DIGEST

1941, Jan.:
 Praise for Norman
 Rockwell's work

1943, March:
 "Artists Interpret the
 'Four Freedoms' "

1943, July:
 "Rosie the Riveter"

ATLANTIC MONTHLY:

1957, Dec.:
 "Norman Rockwell's
 America," by W. Morris

BOSTON GLOBE:

1973, July 3:
 Front page picture story
 about Rockwell, "Into
 His Work"

BOYS' LIFE Magazine:

1914, May:
 "Illustrator at Work"
 (Norman Rockwell at his
 easel—first known published
 photograph of the artist)

CENTURY Magazine:

1919:
 Photograph of Norman
 Rockwell and seven other
 contributors to *Life*
 magazine.

CHICAGO TRIBUNE:

1976, July 4:
 "Rockwell's America:
 One Nation, Ideal"
 by John Blades

COLLECTORS NEWS:

1976, Feb.:
 "A Visit to Mark Twain's
 Home Town," by Dick
 Spiegel

DESIGN Magazine:

1947, Jan.:
 "Popular American
 Illustrator"

1947, March:
 Review of book *Norman
 Rockwell Illustrator*

1947, June:
 Biographical data

1948, Dec.:
 On designing Christmas
 Cards

1949, June:
 Best national ads of the
 year

1960, Sept.:
 "Close-up Visit With
 Norman Rockwell"

EMPIRE Magazine:

1973, Dec. 23:
 "Norman Rockwell's
 Colorado Model"

ESQUIRE:

1962, Jan.:
 "Norman Rockwell Talks
 About His Illustrating"

1971, April:
"Homage to Norman
Rockwell," by R. Borowski

FAMOUS ARTIST Magazine:

1961, Summer:
"The Thrill of My Life,"
by Linda Darnell

1962, Spring:
"Faculty Doings"

1968, Winter:
Norman Rockwell with
Harold Von Schmidt

1968, Winter:
Norman Rockwell with
Dinah Shore (photograph)

FORD LIFE Magazine:

1972, Jan.:
"Rockwell's Ford
Illustrations," by
Mary Moline

GOOD HOUSEKEEPING:

1929, Feb.:
"Norman Rockwell Studio,
New Rochelle, New York"

1943, Feb.:
"If You Were Mrs.
Norman Rockwell"

1970, Dec.:
"Norman Rockwell's
America"

1976, April:
"At Home with the
Norman Rockwells"

GRAPHIS:

1956, May:
"Norman Rockwell"
(French and German
translation)

HOLIDAY INNS:

1972, March:
Photograph of Norman
Rockwell in Indian outfit

INTERNATIONAL STUDIO
Magazine:

1923, Sept.:
"Norman Rockwell"

JOURNAL OF AMERICAN
OPTOMETRIC
ASSOCIATION:

1972, April:
Information about Rockwell
and cover painting

JOURNEY THROUGH
NEW ENGLAND:

1972:
"Norman Rockwell"

LADIES' HOME JOURNAL:

1939, Feb.:
Praise for Norman Rockwell

1939, June:
"How to be a Parlor
Psychologist"

1951, May:
Norman Rockwell asked,
"When I was Sixteen?"

10-2

1971, Nov.:
"A Rockwell Thanksgiving"
[fig. 10-2]

1971, Nov.:
"The Good New Days,"
Editor's diary

1972, Nov.:
Peter Rockwell Interviews

LIFE :

1945, Jan. 1:
"Calendars"

1970, Nov. 13:
"Norman Rockwell
Revisited: If We All Like It,
Is It Art?"
[fig. 10-3]

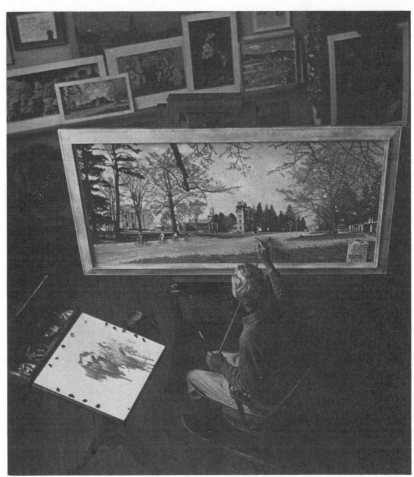

10-4A

10-3

LOOK:

1964, Oct. 20:
"I Paint the Candidates,"
by Norman Rockwell

1966, June 14:
"Behind the Scenes"

1966, March 8:
"Norman Rockwell:
Silent Film Star"

1968, May 14:
"Behind the Scenes"

1971, June 1:
"Norman Rockwell's 78th
Spring," by Allen
Hurlburt
[fig. 10-4A, B, C-next page]

10-4B

10-4C

LOS ANGELES TIMES:

1931:
"America's Genre Painter"

1961, Oct. 26:
"Artist Rockwell Weds Teacher"

1961, Nov. 14:
Picture of Dist. Atty. McKesson and Norman Rockwell

1965, Jan. 2:
"Norman Rockwell Exhibit Set"

1965, July 1:
"Rockwell Puts Radical Themes on Canvas"

1966, Jan. 7:
"Rockwell: Truisms of Tradition, Love"

1966, Jan. 16:
Photograph of "Problems We All Live With"

1967, Jan. 7:
Photograph of Lyndon B. Johnson portrait

1969, June 4:
"Artist Paints Dream in Red, White, Blue"

1971, Feb. 28:
"Rockwell is Just Like a Rockwell"

1971, June 2:
"The *Post* Returns as a Quarterly at $1"

1972, Sept. 18:
"Rockwell Display in San Francisco"

1973, Jan. 19:
An estate sale with "April Fool" painting for sale

1973, Feb. 23:
"A Brief Look at Short Subjects"

1973, March 29:
"The World of Rockwell"

1974, Feb. 3:
"Just a Hack—at $30,000 a Picture"

1974, Oct. 24:
"Painting by Rockwell Sold"

1974, Nov. 11:
"Kawasaki Takes a Ride on Norman Rockwell's Coattails"

1976, Aug. 13:
"Postscript" Interview with a Rockwell model.

1976, Aug. 15:
"View" section, "Norman Rockwell Exhibit Slated"

MODERN MATURITY:

1965, Oct. 11:
 "Painter of and for
 the People"

NATION Magazine:

1961:
 "Return of Naturalism
 as the Avant-Garde"

NATIONAL GEOGRAPHIC:

1970, Aug.:
 "Home to the Enduring
 Berkshires"

NEWARK STAR LEDGER:

1972, Nov. 19:
 "The Good Old Days"

NEWSWEEK:

1952, Dec. 22:
 "Artists with Brush and
 Talent"

1958, Sept. 8:
 "Norman Rockwell Astray"

1972, March 12:
 "Spirit of Scouting"

1974, May 6:
 "Two American Originals:
 John Wayne and
 Norman Rockwell"

NEW YORKER Magazine:

1945, March 17:
 "Norman Rockwell" Profile

1945, March 24:
 "U.S. Artist" by R. Jorman

NEW YORK SUNDAY NEWS:

1970, June 26:
 "The Vanishing America
 of Norman Rockwell"

NEW YORK TIMES:

1970, Dec. 30:
 "Momentos of Norman
 Rockwell Illustrations"

1971, Feb. 28:
 "Norman Rockwell Exactly
 Like a Rockwell"

1971, Nov. 7:
 "Remember Those Old
 Post Covers?"

1972, March 6:
 "Capitol to See Rockwell's
 Nixon"

1972, March 12:
 Norman Rockwell,
 "Spirit of Scouting"

1973, June 24:
 "Still on the Side of the
 Boy Scouts—But Why Not?"

1975, Sept. 28:
 "Admirer of Norman
 Rockwell"

OFFCALL:

1976, June:
 A review of *Norman
 Rockwell and The Saturday
 Evening Post*

PEOPLE Magazine:

1976, Feb. 23:
 "Rockwell Going Strong
 at 82"

PERSIMMON HILL:

1974, May:
 "A Portrait of Duke"

PHILADELPHIA INQUIRER:

1971, Feb. 14:
 4 pages of Rockwell

1974, Feb. 3:
 Norman Rockwell at 80

PHILADELPHIA SUNDAY
BULLETIN:

1972, March 26:
 "Norman Rockwell's
 Good Turn"

READER'S DIGEST:

1971, April:
"Norman Rockwell Album"
by W. Birnie

SAN FRANCISCO
CHRONICLE:

1972, Sept. 3:
"This World" section,
"Rockwell's View of
Average America" by
Thomas Buechner

SATURDAY EVENING POST:

1926, Dec. 18:
"Who's Who and Why?"

1935, March 2:
"Norman Rockwell and Son"
(photograph)

1936, Dec. 19:
"I Cover the Magazine"
("Keeping Posted")

1938, July 30:
"Rockwelliana"

1940, Oct. 5:
"Keeping Posted" mentions
8-24-40 cover

1941, April 12:
"Keeping Posted" mentions
3-1-41 cover

1943, Feb. 13:
"Cover Man"
[fig. 10-5 A, B, C]

1943, June 5:
"Four Freedoms World
Premier"

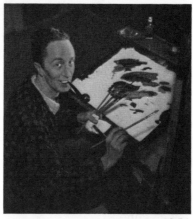

10-5A

10-5B

10-5C

1943, July 31:
"Keeping Posted"
includes portrait of retiring
Post executive
Thomas McLaughlin

1946, July 15:
"A Rockwell Bull's-Eye"

1946, Nov. 16:
"From Cover to Cover"
("Keeping Posted")

1947, July 5:
"Keeping Posted" mentions
"Family Doctor"

1948, Jan. 3:
"Local Boys Make Good"

1949, Jan. 8:
"Keeping Posted" includes
photo of Norman Rockwell
at his easel

1950, April 8:
"Keeping Posted" mentions
a 1948 *Post* cover

1951, April 7:
"Triumph of a Painter"

1951, Dec. 29:
"Letters to the Editor"
mentions Rockwell

1952, Oct. 11:
"The Day I Painted Ike"
(article)
[*see fig. 6-1A-E, 6-2*]

1953, April 4:
"Keeping Posted" includes
Eisenhower portrait

1954, March 27:
"Behind the Scenes"
Bob Hope portrait
("Keeping Posted")

1954, Aug. 21:
"Keeping Posted" includes
photo of Norman Rockwell
receiving honorary
college degree

1954, Sept. 25:
"Norman Rockwell's Two-Way Window," Rockwell's downtown Stockbridge studio ("Keeping Posted")

1955, March 12:
"A Norman Rockwell Album"—12 pages of favorite *Post* covers

1955, April 16:
"Letters to the Editor" lists more favorites

1955, June 11:
"Norman Rockwell Goes to Washington" ("Keeping Posted")

1955, July 16:
"Who Was Right About Rockwell?" ("Keeping Posted")

1955, Sept. 10:
"Keeping Posted" mentions Rockwell

1956, June 2:
"Norman Rockwell and a Raise in Pay"

1956, Oct. 6:
"Rockwell Down on Stevenson's Farm"

1956, Oct. 13:
"Painter and President"

1956, Nov. 3:
"Keeping Posted" includes photo of Rockwell

1956, Nov. 17:
"Letters to the Editor" mentions Rockwell

1957, June 29:
"Keeping Posted" mentions Rockwell

10-6A

10-6B

1958, Dec. 13:
"Letters to the Editor" mentions 11-8-58 *Post* cover

1959, June 6:
"Norman Rockwell 'Up in the Air' " ("Keeping Posted")

1960, Feb. 13-April 2:
"My Adventures as an Illustrator" (excerpts) from book) [fig. 10-6 A-D, *C and D on next page*]

10-6C

10-6D

1961, July 15:
Article about Laguna Beach
art show has photo
of Rockwell *Post*
cover tableau

1962, Dec. 22:
"They Drew Their Way
From Rags to Riches"

1967, Oct. 21:
"Fifty Years Ago" shows
a 1917 *Post* cover

1971, Summer:
"A Visit With Norman
Rockwell"
[fig. 10-7 A, B]

1972, Fall:
"New Life of Norman
Rockwell"

1973, Sept.-Oct.:
Robert Charles Howe and
Rockwell "American Boy
Scout Awards"

1973, Sept.-Oct.:
"The Care and Feeding of
Sacred Cows" written and
illustrated by Al Capp
[fig. 10-8]

10-7A

1973, Winter:
"A Norman Rockwell Idyll:
Stockbridge, Massachusetts"

1976, May:
"Face of the Nation"

1976, July-Aug.:
"I Cover the *Post*"

1977, Jan.:
"Norman Rockwell Looks
At Love"

1977, July:
"My Life As An
Illustrator"

10-7B

1972, Dec. 3:
"Norman Rockwell Comes
to Newark, New Jersey"

SUNDAY NEWS:

1972, Dec. 3:
"Norman Rockwell"

SUNSET Magazine:

1972, Oct.:
"Norman Rockwell in
San Francisco"
(a retrospective showing)

TIME Magazine:

1939, May 1:
Photo caption, "Nut-brown
heroes haunted him"

1943, June 21:
"I Like to Please People"

1961, Nov. 3:
Announcing the wedding of
Norman Rockwell and Molly
Punderson

10-8

10-9

1978, Jan.:
"Stars in My Eyes"

1978, Jan.:
"Travel Sketchbook"

1978, Jan.:
"Norman Rockwell;
Special Issue"

1978, Jan.:
"Happy Birthday Norman
Rockwell"
[fig. 10-9]

1978, July:
"Hometown Hollywood"

SCOUTING Magazine:

1960, Jan.:
"Ambassador of Boyland"

1963, Feb.:
"The Man Who Framed
Scouting" by Tom Gibson

1971, June 14:
"Return of the *Post*"

1972, Oct. 2:
Norman Rockwell and
Frank Sinatra

1973, Sept. 3:
Rockwell meets
Colonel Sanders

1976, June 7:
 Stockbridge Bicentennial
 salute to Rockwell

UNITED PRESS:

1974, March:
 Biographical data

U. S. CAMERA:

1948, Nov.:
 "Norman Rockwell Shoots
 a Cover"

VERMONT LIFE:

1947, Summer:
 "Norman Rockwell's
 Vermont"

THE WRITER Magazine:

1951:
 "Illustrating for
 The Saturday Evening Post"

Biographical Books

The most complete biographical data on Norman Rockwell is found in his own book, *My Adventures as an Illustrator*. This easy-to-read, "chatty" memoir reveals the frustrations of his youth and the pleasures he derived from his talents.

For a man of his artistic accomplishments it is noteworthy that he was not recognized in a *Current Biography* or other listing of distinguished people before 1945.

Many books make reference to Rockwell and his art. Only the major references are listed herein.

1945:
CURRENT BIOGRAPHY
Published by H. W. Wilson
Company

1946:
Guptill, Arthur L.
NORMAN ROCKWELL
ILLUSTRATOR
Published by Watson-
Guptill Publications
Paperback by Ballantine
Books, Inc., 1976
[fig. 11-1]

1946:
Watson, Ernest W.
FORTY ILLUSTRATORS
AND HOW THEY WORK
Published by Watson-Guptill
Publications
Illustrated and hardbound

11-1

1947:
Mahoney, B. E.,
Louise P. Latimer,
and Beulah Folmsbee
ILLUSTRATORS
OF CHILDREN'S
BOOKS 1744-1945
Published by the Horn Book,
Inc., 1947, 1961, and 1965

1959:
Dodd, Loring H.
CELEBRITIES AT OUR
HEARTHSIDE
Published by Dresser,
Chapman & Grimes

1959:
Karsh, Yousaf
PORTRAITS OF
GREATNESS
Published by
Thomas Nelson, Inc.

1960:
Rockwell, Norman, as told
to Thomas Rockwell
MY ADVENTURES AS AN
ILLUSTRATOR
Published by Doubleday &
Company, Inc., 1960
and 1975
Paperback by Ballantine
Books, Inc., 1972
[fig. 11-2 *next page*]

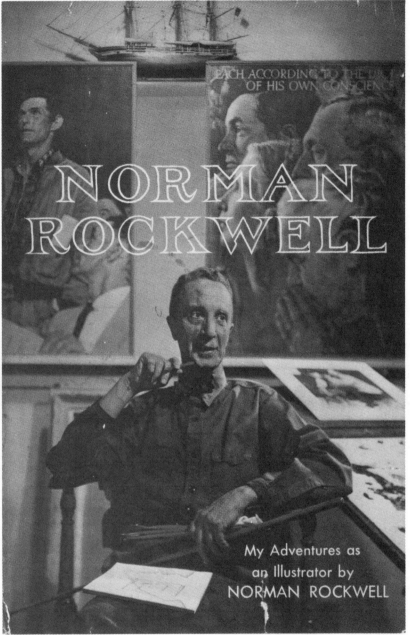

NORMAN ROCKWELL

EACH ACCORDING TO THE
OF HIS OWN CONSCIEN

My Adventures as
an Illustrator by
NORMAN ROCKWELL

11-2

1961:
THE NORMAN
ROCKWELL ALBUM
Published by Doubleday &
Company, Inc.
Limited edition in deluxe
slipcase, regular
edition hardbound with
dust jacket

1962:
Nevins, Allan and Frank Hill
FORD: DECLINE AND
REBIRTH
Published by Charles
Scribner's Sons

1964:
Greacean, Edmund
NATIONAL UNION
CATALOG OF MANUSCRIPT
COLLEC TIONS
Published in the National
Union Catalog for the period
1964-1974.

1965:
Guitar, May Anne
TWENTY-TWO FAMOUS
PAINTERS AND
ILLUSTRATORS TELL
HOW THEY WORK
Published by David McKay
Company, Inc.

1966:
Reed, Walter
THE ILLUSTRATOR
IN AMERICA
Published by Reinhold
Publishing Company

1969:
THIS FABULOUS
CENTURY: SIXTY
YEARS OF AMERICAN
LIFE 1910-1920
VOLUME II
Published by Time-Life
Books

1970:
Buechner, Thomas S.
NORMAN ROCKWELL
ARTIST
AND ILLUSTRATOR
Published by Harry N.
Abrams, Inc. Hardbound,
dust jacket, 56,000 in
first edition, later
editions do not include the
words "First Edition." Also
available is a signed and
numbered special deluxe
limited edition of 1,000
copies in slipcase. This
special edition was offered
with a limited edition col-
lotype print. The print and

the book contain the same number. Each of this special edition was signed and numbered by Norman Rockwell. [fig. 11-3]

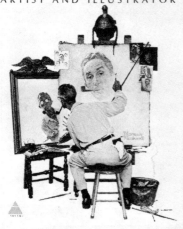
11-3

1970:
Rockwell, Thomas
NORMAN ROCKWELL'S
HOMETOWN
Published by
Windmill Books,
Simon & Schuster, Inc.,
hardbound, dust jacket

1972:
NORMAN ROCKWELL—A
SIXTY YEAR
RETROSPECTIVE
Published by Harry N.
Abrams, Inc. Contains list and
illustrations of scheduled
exhibitions of Bernard
Danenberg Galleries in two
volumes, hardbound and
paperback

1975:
Finch, Christopher
NORMAN ROCKWELL'S
AMERICA
Published by
Harry N. Abrams, Inc.
Published by Reader's
Digest Association, 1977
[fig. 11-4]

11-4

1976:
Drew, Robert A.
PORTRAIT OF JOHN
F. KENNEDY
Booklet published by
American Heritage Graphics
to accompany limited
edition prints of the
J.F.K. portrait
[fig. 11-5]

1976:
NORMAN ROCKWELL
AND THE SATURDAY
EVENING POST,
VOLUME I
Published by Four Star
Productions, hardbound,
dust jacket. Contains *The
Saturday Evening Post*
covers, May 1916-July 1928
[fig. 11-6]

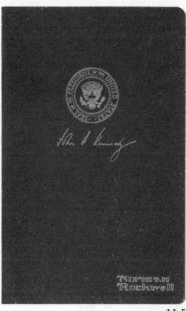
11-5

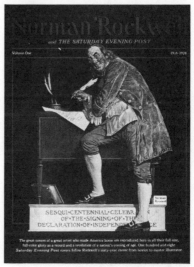
11-6

1976:
REMEMBERING NORMAN
ROCKWELL
Published by River Shore
Productions, Inc.

1977:
Pitz, Henry
200 YEARS OF
AMERICAN
ILLUSTRATION
Published by Random
House, Inc.

1978:
Meyer, Susan E.
AMERICA'S BELOVED
ILLUSTRATORS
Published by Harry N.
Abrams, Inc.

1978:
Walton, Donald
A ROCKWELL PORTRAIT
Published by Sheed, Andrews
and McMeel, Limited

Appendix

Credits

The author and the publisher wish to thank the following corporations for kindly granting permission to reproduce advertisements created by Norman Rockwell. In all cases the art is the property of the corporation and cannot be reproduced without permission.

American Telephone and
 Telegraph Corporation
Amway Corporation
Anheuser-Busch, Incorporated
Borden, Incorporated
Brooke Bond Foods, Incorporated
 (Red Rose Tea)
Campbell Soup Company
 (Campbell's Tomato Juice)
Carnation Company
Chase Manhattan Bank of
 North America
Chrysler Corporation (Plymouth)
Coca-Cola Company
CPC International, Incorporated
 (Skippy Peanut Butter)
Del Monte Corporation
Ford Motor Company
Franklin Mint
General Foods Corporation
 (Post Cereals, Maxwell
 House, Jell-O)
General Motors Corporation
Goodyear Tire and Rubber Company
Goulds Pumps, Incorporated
Green Giant Company (Niblets Corn)
House of Style (Ipana Toothpaste)
Kayser-Roth Corporation
 (Interwoven Socks)
Kendall Company (Bauer & Black)
Life Savers, Incorporated
 (Beech-Nut Gum)
Massachusetts Mutual Life
 Insurance Company
Mobil Oil Corporation (Mobilgas)
Nabisco, Incorporated
 (Shredded Wheat)

Olivetti Corporation of America
 (Underwood Typewriters)
Pan American World Airways
Parker Pen Company
Pratt & Lambert, Incorporated
Proctor & Gamble Company
 (Crest Toothpaste)
Quaker Oats Company
Raybestos-Manhattan, Incorporated
Rock of Ages Corporation
Schenley Industries, Incorporated
 (Cream of Kentucky)
Sharon Steel Corporation
Sheaffer Eaton Division of Textron,
 Incorporated (Sheaffer Pens)
Standard Brands, Incorporated
 (Fleischmann's Yeast)
Sun-Maid Growers of California
Swift & Company
Warner-Lambert Company
 (Adams Chewing Gum)
Western Union Corporation

Index